MUSICAL THEATRE, REA[

ENTERTAINMEN

ASHGATE INTERDISCIPLINARY STUDIES IN OPERA

The *Ashgate Interdisciplinary Studies in Opera* series provides a centralized and prominent forum for the presentation of cutting-edge scholarship that draws on numerous disciplinary approaches to a wide range of subjects associated with the creation, performance, and reception of opera (and related genres) in various historical and social contexts. There is great need for a broader approach to scholarship about opera. In recent years, the course of study has developed significantly, going beyond traditional musicological approaches to reflect new perspectives from literary criticism and comparative literature, cultural history, philosophy, art history, theatre history, gender studies, film studies, political science, philology, psycho-analysis, and medicine. The new brands of scholarship have allowed a more comprehensive interrogation of the complex nexus of means of artistic expression operative in opera, one that has meaningfully challenged prevalent historicist and formalist musical approaches. The *Ashgate Interdisciplinary Studies in Opera* series continues to move this important trend forward by including essay collections and monographs that reflect the ever-increasing interest in opera in non-musical contexts. Books in the series will be linked by their emphasis on the study of a single genre – opera – yet will be distinguished by their individualized and novel approaches by scholars from various disciplines/fields of inquiry. The remit of the series welcomes studies of seventeenth century to contemporary opera from all geographical locations, including non-Western topics.

Other Titles in the Series

Melodramatic Voices: Understanding Music Drama
Edited by Sarah Hibberd

Opera Indigene: Re/presenting First Nations and Indigenous Cultures
Edited by Pamela Karantonis and Dylan Robinson

Musical Theatre, Realism and Entertainment

MILLIE TAYLOR
University of Winchester, UK

Routledge
Taylor & Francis Group

LONDON AND NEW YORK

First published 2012 by Ashgate Publishing

Published 2016 by Routledge
2 Park Square, Milton Park, Abingdon, Oxfordshire OX14 4RN
711 Third Avenue, New York, NY 10017, USA

First issued in paperback 2016

Routledge is an imprint of the Taylor & Francis Group, an informa business

British Library Cataloguing in Publication Data
Taylor, Millie.
 Musical theatre, realism and entertainment. --
(Ashgate interdisciplinary studies in opera)
 1. Musical theater. 2. Musicals--History and criticism.
 3. Theater audiences--Psychology.
 I. Title II. Series
 792.6'01-dc22

Library of Congress Cataloging-in-Publication Data
Taylor, Millie.
 Musical theatre, realism and entertainment / Millie Taylor.
 p. cm. -- (Ashgate interdisciplinary studies in opera)
 Includes bibliographical references and index.
 ISBN 978-0-7546-6670-7 (hardcover)
 1. Musicals--History and criticism. 2. Musicals--Characters. 3.
Musical theater--History. 4. Music and language. I. Title.

 ML2054.T39 2011
 792.6--dc23

 2011024575

ISBN 13: 978-1-138-27953-7 (pbk)
ISBN 13: 978-0-7546-6670-7 (hbk)

Contents

Acknowledgements *vii*

Introduction 1

1 Musical Characterisation in *HMS Pinafore* and
 The Rocky Horror Show 15

2 Encoding the Voice: *Show Boat*, *Guys and Dolls*, and
 Musical Theatre Post-1960 33

3 Integration and Distance in Musical Theatre:
 The Case of *Sweeney Todd* 55

4 Layers of Representation and the Creation of Irony:
 Aufstieg und Fall der Stadt Mahagonny, *Merrily We Roll Along* and
 The Last 5 Years 73

5 Alternatives to Linearity: *Cabaret*, *Kiss of the Spider Woman* and
 Assassins 91

6 Illusions of Realism in *West Side Story* and
 Actor-Musician Performances 111

7 Experiencing Live Musical Theatre Performance:
 La Cage Aux Folles and *Priscilla, Queen of the Desert* 129

8 I've Heard that Song Before:
 The Jukebox Musical and Entertainment in *Jersey Boys*,
 Rock of Ages, *Mamma Mia* and *We Will Rock You* 149

Conclusion 167

Bibliography *173*
Index *187*

Acknowledgements

Although much of the planning and writing of this text has been a solitary activity, I have spent many happy hours in the company of other people in theatres watching musicals, and until 2001 working as a musical director. The performances I've seen have provided the catalyst for the ideas in this book, and have been fun, entertaining and thought provoking. They provide the memories and experiences that underpin the understanding of musical theatre performances discussed here. There are also very many people who have supported the writing of this book.

First, of course, are the peer reviewers and the editor of the series who helped to shape the initial proposal. This book builds on a number of articles that have been published elsewhere. The idea for this book derives from an article '"Don't Dream it, be it": Exploring Signification, Empathy and Mimesis in Relation to *The Rocky Horror Show*' published in the inaugural issue of *Studies in Musical Theatre*. Some parts of the article appear in Chapter 1, but the thinking behind the article was the starting point for many of the questions about entertainment and musical theatre that developed into this book. My thanks go to Dominic Symonds and George Burrows, editors of the journal, for their suggestions for improvements to that article and for their ongoing support.

Chapter 3 was first published as 'Integration and Distance in Musical Theatre: The Case of *Sweeney Todd*' in *Contemporary Theatre Review*. I am very grateful to the publishers for permission to adapt and reproduce the article here, and to the editors, Dan Rebellato and Dominic Symonds, and the anonymous peer reviewers for their help in developing the article.

The majority of Chapter 4 was first published as 'Layers of Representation: Instability in the Characterization of Jenny in *The Rise and Fall of the City of Mahagonny* by Brecht and Weill' in the Bertolt Brecht Special Issue of *Assaph Studies in the Theatre* 19/20 (2005): 159–76. I am pleased to be able to develop this article here, and to acknowledge the contributions of the peer reviewers, the guest editor Gad Kayner, and general editor Linda Ben-Zvi in developing the article.

Most of Chapter 7 was first published as 'Experiencing Live Musical Theatre Performance: *La Cage Aux Folles* and *Priscilla, Queen of the Desert*' in the inaugural issue of *Popular Entertainment Studies*. Before that a paper was presented to the working group on Popular Entertainment at the Lisbon meeting of the International Federation for Theatre Research in 2009. I would like to express my thanks to my peers in the working group at Lisbon for their thoughts on the paper, to Victor Emeljanow, editor of the journal and convenor of the group, for his helpful contributions to the reshaped arguments, and to the anonymous peer reviewers for their suggestions.

Several other sections of the book have been presented as conference papers. 'Illusions of Realism in the Musical' was first presented at *Song, Stage, Screen II* at Leeds University in March 2007. 'A British Tar is a Soaring Soul', which contained the analysis of *HMS Pinafore* in Chapter 1 of this book, was presented at *West End Musical Theatre 1880–1930* at Goldsmiths College, University of London in April 2008 and at *Music and the Melodramatic Aesthetic* at Nottingham University in September 2008. On all of these occasions helpful comments contributed to the subsequent development of the paper. Finally, the many delegates and contributors to the *Kinaesthetic Empathy* conference gave me the opportunity to challenge and check my understanding of neuroscience and entertainment.

I am fortunate to work in an institutional environment at the University of Winchester that offers support to my research activities. On this occasion I was awarded a semester of study leave and funding to spend two weeks in New York visiting the New York Library for the Performing Arts and seeing shows on Broadway. At the Theatre on Film and Tape collection at the library Steve Massa and Rhony Dostaly provided access to the materials I needed and made sure that I could see as much as possible during my short visit. Their patience, knowledge and good cheer was immensely helpful in making the visit extremely productive.

Then there are my colleagues and postgraduate students at Winchester with whom many of these ideas have been discussed. It is often impossible to trace the generation of an idea or the people who have assisted its germination, but they are likely to include: Cathy Turner, Synne Behrndt, Marianne Sharp, Helen Grime, Marilena Zaroulia, Yvon Bonenfant, Michael Goron, Benjamin Macpherson and Amanda Smallbone. Also from Winchester, Stephen Greenhalgh was invaluable for his detailed proof-reading and indexing.

Once drafted, the manuscript was sent to Roberta Montemorra Marvin and more anonymous peer reviewers who helped to refine my thoughts and shape the book. I am grateful for their suggestions, and for the editorial support of Heidi Bishop and Gemma Hayman.

And finally, thanks to my family and friends who are always there when needed.

Introduction

What is musical theatre? Most people would agree that it is a combination of song, visual spectacle and verbal text that is performed live in theatres. It can be difficult to be more specific, however, since there is enormous diversity in works of musical theatre. Its popularity suggests it must entertain its audiences, which provokes a supplementary question; what is it about musical theatre that audiences find entertaining? One might say something about the self-referential quality of the texts or discuss whether the plots reflect current social concerns, but how do these features relate to an understanding of what it is about musical theatre that audiences find entertaining or why musical theatre remains popular?

Musical theatre works and performances vary widely.[1] Some have very little dance, though they have spectacle of a different type, for example *The Lion King*; others tell their stories through dance, such as *Cats*. Some works are through-composed, like *Les Misérables*, while others use music diegetically or metatextually as *Cabaret* does. Some musicals contain a linear narrative that is presented in an 'integrated' or 'realistic' fashion, such as *My Fair Lady*; others dispense with linearity and use other narrative constructions, as *Assassins* does. Some performances require the vocal range and musical style of rock music, as in *The Rocky Horror Show*, or other popular music styles, such as the gospel and R'n'B influenced *Dreamgirls*. Other works rely on a nineteenth-century romantic aesthetic in tonality and vocal range, as, for example, in *Phantom of the Opera*; while still others rely on the development of a 'Broadway' vocal sound and a big-band-inspired musical language like that used in *Gypsy*. Some use stories made popular in film, for example *Beauty and the Beast*; others use literary sources – *Show Boat* for example, which is based on a novel of the same name – while yet others use biographical information to flesh out a story around the music of a well-known composer or performer, like the bio-musical *Buddy*. What these works have in common is that all of them contain some combination of sung music, narrative and live visual performance, and all are vibrant and entertaining to varying audiences. In this study I will use the term 'musical' to refer to all these types of performance, while analysing the ways in which different combinations of musical, vocal and narrative construction, signifying in association with live performance, characterisation and spectacle, contribute to the potential for musical theatre to be entertaining. The aim is to investigate how pleasure is stimulated in

[1] Musical theatre is used here as the generic form that includes musical drama, musical comedy, jukebox musicals, dance musicals and all the sub-genres that are performed live in theatres. In the rest of this book the term 'musical' will be used interchangeably with musical theatre to signify these works. The term will be assumed to exclude film musicals.

audiences by different parts of the musical theatre text and different sub-genres of musical theatre performance in order to explore the multifarious ways musical theatre functions as entertainment.

Musical Theatre

But why is this book interesting, relevant or necessary? It is, after all, possible to enjoy musical theatre performances without writing about them. Like many people I have enjoyed many evenings at the theatre watching musical theatre performances, and I have spent many more performances in the pit as a musical director. But then, after almost 20 years working in musical theatre I became an academic, a lecturer and a researcher. Some of the shows I had worked on and admired were denigrated because of their lack of political relevance, not by audiences who adored them, but by my colleagues and many in the academic establishment. A case in point is *Little Shop of Horrors*[2] whose ironic re-creation of the B-movie genre is comic and gloriously eccentric, its use of musical styles and lyrics is witty, its music well-crafted. But I didn't find this viewpoint shared in much of the literature.

David Savran suggests that 'Until very recently … historians and critics of twentieth-century theatre have obstinately (if inadvertently) endorsed the binary opposition between highbrow and lowbrow'.[3] He suggests many reasons for musical theatre's status, not the least of which is its ephemeral form, the common practice of adaptation, and its disposability. Stacy Wolf builds on Savran's arguments to discuss the 'anxious relationship' between departments of drama and other departments in the humanities, which she suggests is mirrored by a similarly anxious relationship between musical theatre courses and the rest of the curriculum.[4] There is an issue that both point to, and that is the politics of pleasure, for, as Savran says, 'no theatre form is as single-mindedly devoted to producing pleasure, inspiring spectators to tap their feet, sing along, or otherwise be carried away'.[5] Wolf agrees, suggesting that studying musical theatre texts allowed her and her students to 'think about pleasure, to talk about affect, and to use our visceral engagement with musicals as a crucial part of our analysis'.[6]

My experience, alongside Savran's and Wolf's observations, suggests that musical theatre can be provocative and entertaining, but that often either the provocation or the entertainment is overlooked. Musical theatre is denigrated as

[2] Book and Lyrics by Howard Ashman, Lyrics by Alan Menken.

[3] David Savran, 'Toward a Historiography of the Popular', *Theatre Survey*, 45/2 (2004): p. 212.

[4] Stacy Wolf, 'In Defense of Pleasure: Musical Theatre History in the Liberal Arts [A Manifesto]', *Theatre Topics*, 17/1 (2007): p. 52.

[5] Savran, 'Towards a Historiography', p. 216.

[6] Wolf, 'In Defense of Pleasure', p. 52.

'just entertainment', and yet providing entertainment is not only valuable, but difficult. As a teacher I discovered that students love musical theatre, and that its study allows them to access difficult ideas and theoretical frameworks. Wolf suggests that we should use our own and students' preferences and passions, because 'pleasure motivates'.[7] Then, as a researcher, I discovered that there are many writers and fellow academics who are interested in the form, but that the literature doesn't appear to engage with the ways in which musical theatre reaches out to and communicates with its audiences. Instead, the diverse literature tends to fall into several categories. For example, musicals can be studied as literary texts,[8] from a musical perspective – including the relationship with text and narrative structure,[9] in terms of the musical's development in history[10] or social history,[11] or by addressing the subject in relation to specific issues such as gender.[12] In addition there is a large body of work on film musicals particularly of the classic Hollywood era,[13] and another body of work on opera[14] and on voice.[15] The study of entertainment is equally problematic, with a body of literature focusing on a post-Marxist reading of its economics, and very little that questions the ways in which pleasure is generated.

But, as Savran suggested above, one of the problems of studying musical theatre and its performances is the ephemerality and the disposability of the performance texts. It is not surprising, therefore, that the study of music for film and the musical film have been more developed than the study of musical theatre, nor that study of the written texts and their histories and contexts is more common than the study of those texts in performance. However, the Lincoln Center in New York has an immensely important resource in the Theatre on Film and Tape archive in which are contained filmed copies of many of the musicals that have appeared

[7] Ibid., p. 55.

[8] For example, Sandor Goodhart (ed.), *Reading Stephen Sondheim* (New York and London, 2000).

[9] For example, Stephen Banfield, *Sondheim's Broadway Musicals* (Ann Arbor, 1993).

[10] For example, Andrew Lamb, *150 Years of Popular Musical Theatre* (New Haven and London, 2000) or William A. Everett and Paul R. Laird (eds), *The Cambridge Companion to the Musical* (Cambridge, 2002).

[11] For example, John Bush Jones, *Our Musicals, Ourselves* (Hanover and London, 2003).

[12] For example, Stacy Wolf, *A Problem like Maria* (Ann Arbor, 2002).

[13] Such as Rick Altman (ed.), *Genre: The Musical* (London and New York, 1981), Bill Marshall and Robynn Stilwell (eds), *Musicals: Hollywood and Beyond* (Exeter and Portland, 2000) and Steven Cohan (ed.), *Hollywood Musicals: The Film Reader* (London and New York, 2002).

[14] For example, Carolyn Abbate, *Unsung Voices* (Princeton, 1991) and *In Search of Opera* (Princeton, 2001).

[15] For example, Mladen Dolar, *A Voice and Nothing More* (Cambridge and London, 2006) or Michel Poizat, *The Angel's Cry* (Ithaca and London, 1992).

on Broadway in the past 30 years. There is a smaller archive at the Victoria and Albert Museum in London recording works from London's West End. While there are always issues of authority, viewpoint and authenticity attached to the study of live performance on film, this resource allows researchers to begin to address musical theatre as performance.

Realism and Integration

In the literature on musical theatre, there appears to be a lack of clarity about the term 'integration'. This term presupposes a particular construction of materials that implies, among other things, an evolution of musical theatre towards an ever-increasing focus on linear narrative as the defining feature of the combined musico-dramatic text. There is a body of scholarship that presumes a historical trajectory of the development of musical theatre from fragmentation to integration, which leads to the privileging of those musicals that support that trajectory, and an analytical process of looking first at the plot and then questioning how the songs support it. As Savran says,

> Many of the most important achievements of the pre-*Oklahoma!* era ... remain in archives and private collections, if they exist at all. Although the progress narrative that relegates all pre-*Oklahoma!* musicals to the Dark Ages is deeply problematic, Rodgers and Hammerstein were undeniably instrumental in securing the permanence and widespread dissemination of the plays ... And they did so by promoting the very progress narrative their works allegedly produced.[16]

As an example of the progress narrative, Raymond Knapp, when discussing *Anything Goes* (1934) talks of it as an example of the 'pre-"integrated" era' of the American musical – a useful shorthand to identify time and style. He suggests that 'the case can and should be made that its songs are anything but haphazard', and identifies how the songs, despite using Tin Pan Alley conventions, drive the show forward.[17] Identifying the functions of songs in driving the plots of shows is a useful analytical process, and is appropriate to Knapp's thesis. The shorthand of integration is also useful as a descriptor, but it is not the only analytical model available. This example demonstrates the canonical acceptance of integration which leads to the focus on story supported by other elements. An analytical model based on the primacy of the story fails to acknowledge the many other functions that music might have, or other analytical approaches that might be used

[16] Savran, 'Towards a Historiography', p. 214.

[17] Knapp, *The American Musical and the Formation of National Identity* (Princeton and Oxford, 2005), pp. 88–97.

particularly when addressing musicals whose story may not be the main focus of the entertainment.

However, there are recent studies of musical theatre that point to an increased interest in its dramaturgical construction and its performance, not as 'integrated' but as disjunctive and diverse. In the cover note to *The Musical as Drama* Scott McMillin suggests that 'until recently the musical has been considered as either an "integrated" form of theatre or an inferior sibling of opera'.[18] His argument is that neither of these views is accurate. The musical relies on the suspension of the plot for the song, and, since music uses a different pattern of time organisation, it necessarily incorporates a variety of time structures. It is possible therefore, that dance, song, music and dialogue explore different aspects of the action and the characters using different organisations of time. D. Miller, in *Place for Us*, proposes that the through-composed musical destroyed the structural opposition between narrative and number, which he regarded as the 'continual feats of negation that made the Broadway musical uniquely, preciously utopian'.[19] There is an understanding here of the musical as a combination of materials that are individually disjunctive.

Knapp has developed these ideas most fully in *The American Musical and the Formation of National Identity* in which he argues that 'the effect of adding music to a dramatic scene that might otherwise play naturalistically serves to exaggerate its content, adding a dimension of artificiality at the same time that it often also strives to tap into a deeper kind of reality, one accessible only through music'.[20] He suggests that music pulls in two opposing directions so the audience simultaneously pays attention to the emotional realities of the music and the performance of that music by the actor-singers on stage. He argues that the effect of this dual attention of the audience to both the acted character and the musical emotion, in connection with the removal of real time, is that the musical theatre song

> imposes a kind of suspended animation so as to intensify selected emotional moments and through this dramatic hiatus directs us all the more urgently to see behind the mask/make-up/costume of the performer – even as he or she embodies the role being played more fully through the enactment of song.[21]

Here is an understanding of the musical that is not simply founded on its narrative but on the theatricality of performance and the disjunctions it might contain. Moving even further from study of the text, Bruce Kirle's *Unfinished Show Business* makes the case for studying musical theatre as an embodied practice connecting the historical context with performance conventions and the bodies of

[18] Scott McMillin, *The Musical as Drama* (Princeton and Oxford, 2006).

[19] D. Miller, *Place for Us* (Cambridge and London, 1998), p. 57.

[20] Knapp, *The American Musical and the Formation of National Identity*, p. 12.

[21] Ibid., p. 12.

performers and spectators.[22] These texts provide the foundations and starting points for the present study, whose aim is to understand the processes of communication and engagement that operate between performers and audiences during musical theatre performances.

The integrated musical also relies on the performance of 'psychological realism' by characters in staged situations, and a continuation of this 'realism' through speech, song and dance. In the course of the following chapters both integration and realism are argued to be problematic constructs that are challenged in a number of ways. The separation of song from scene, so that each allows different aspects of plot or character to be revealed, highlights the lack of 'realism' in musical theatre performance. The musical simultaneously signifies itself as 'realistic', and is written in ways that promote the idea of integration and the suspension of disbelief, even while incorporating textual and performance strategies that undermine that framework. So empathy and its disruption might be juxtaposed in the creation of entertainment.

Other musical theatre performances deliberately challenge a fixed concept of distance between performers and audiences by a variety of means. These include juxtaposition of music and narrative or lyric, reflexive awareness between character and performer, or the alienation caused by narration and choral presentation in book musicals. These devices challenge psychological continuity for performers and readers. Non-linear and revue style musicals also require performance conventions other than those of integration or realism. They therefore need to be analysed effectively and positively; from the perspective of what they are rather than what they are not. This provides a challenge to the construction of 'realism' in musical theatre performance, and its correlation with the trope of 'integration' in its history and textual analysis. Simultaneously the diversity of form and content observable in musical theatre raises the question of how it entertains its audiences. Instead of relying only on integration there is juxtaposition, reflexivity, parody, alienation and camp to be considered in many musical theatre performances.

In her seminal study of film music, *Unheard Melodies*, Claudia Gorbman asks

> What is music doing, and how does it do it? ... What and how does music signify with the images and events of a story film? ... How does music in film narration create a *point of experience* ... for the spectator?[23]

The point of experience Gorbman refers to is important in analysing the processes by which audiences identify with performers or characters and empathise with their situations. However, the point of experience is also important when considering the ability of musical theatre to create irony or parody, to present complex webs of divergent signs for comic or political effect, or to create sensation, all of which

[22] Bruce Kirle, *Unfinished Show Business* (Carbondale, 2005).
[23] Claudia Gorbman, *Unheard Melodies* (Bloomington: Indiana University Press, 1987), p. 2.

might be factors in the process of entertaining. Several of the questions Gorbman poses in relation to film music are addressed here in relation to musical theatre, provoking analysis of the text not as integrated or realistic, but as diverse, reflexive and distancing. What is music doing and how does it do it? What and how does music signify with the images and events of a live theatrical performance? How do different musical theatre texts create different points of experience for audiences that contribute to sensations of pleasure or being entertained? These are the questions that provide the starting point for this book.

Chapter 1 explores signification in the musical theatre text, Chapter 2 traces the signification of vocal timbre and genre, Chapter 3 focuses specifically on questions of integration and distance, while Chapter 4 explores how ironic and parodic or at least disruptive meanings are created by juxtapositions in different parts of the texts. Chapters 5 and 6 begin to move away from the ways the work's structures contribute to pleasure or bliss, to focus on the performance text. Chapter 5 explores non-linear constructions in the written and performed texts that can be read both as linear narratives and complex meta-narratives, thus revealing multiple points of experience for audiences. Chapter 6 considers the issue of altered musical and dramatic time in relation to the psychological realism of performers. It is in these chapters that cognitive neuroscience is introduced to begin to account for the diversity of stimuli that audiences are reading and blending to produce a plural or complex understanding of the musical theatre performance. This leads, in Chapters 7 and 8, to a questioning of the experience of attendance at live performances. These final two chapters see musical theatre performances as events and narratives that are simultaneously understood, felt and shared, individually and communally. They build on both cognitive and theoretical frameworks to propose ways in which musical theatre entertains its audiences.

Entertainment

As established above, one of the starting points for this research is the popularity and ability of musical theatre to entertain. In this book I make a common-sense assumption about popularity based on commercial or critical success, gained through the entertainment of audiences. This provides the basis from which to explore how performances are constructed and enacted so that audiences might be entertained.

There appear to be several strands in the literature on entertainment. The first takes a post-Marxist perspective and places entertainment in an ideological

framework in a binary separation from art. In Europe Molière was a catalyst for the separation of art and entertainment.[24] He elaborated a definition of what the theatre should do: it should provide pleasure and the arbiter should be the people.[25] This separation still provides the theoretical foundation for entertainment being held in a binary relationship with art. In this ideological framework entertainment is also linked with leisure time in a binary opposition to work that relies on a notion of 'mass entertainment' provided by specialists for 'the people'. This work builds on the work of the post-Marxist, Theodor Adorno.

Adorno explored the dialectical relationship of art and entertainment, elite and popular, highbrow and lowbrow in his writings about 'the culture industry' and 'the entertainment industry'. His work was based on the structural analysis of popular cultural forms that led him to believe that the repetitive and formulaic character of cultural goods made them cosy, predictable and capable of answering to the individual's need for security and the producer's need for predictability in the market.[26] In this argument, amusement goods are designed to achieve sensation and consequently they insulate the recipient from social awareness. The possibility of resistance is destroyed and pleasure becomes a form of helplessness.[27]

Brooks McNamara, in the introduction to the 1994 *Popular Entertainments Issue* of *The Drama Review* defines '[t]raditional popular entertainments' as consisting of 'live amusements aimed at a broad, relatively "unsophisticated" audience' created for profit by professional showmen.[28] This demonstrates that the same ideological framework was still being used to promote the binary separation between entertainment and art, low and high, that Adorno had outlined. This is one of the frameworks that this book challenges, not by engaging with it, but by exploring alternatives.

The second strand of thought relates to Schechner's spiralling braid linking efficacy and entertainment. Richard Dyer argues that

> while pleasure has surely always been intended and taken in artefacts and performances, the idea of entertainment is distinctive in its emphasis on the primacy of such pleasure, ahead or even instead of practical, sacred, instructional or political aims and functions.[29]

Perhaps most musical theatre performances exist towards the entertainment end of this polarity, but Schechner asserts that no performance is either purely efficacious

[24] Richard Dyer, 'The Idea of Entertainment', in *Only Entertainment* (London and New York: Routledge, 1992), pp. 5–9.

[25] Ibid., p. 6.

[26] Robert W. Witkin, *Adorno on Popular Culture* (London and New York, 2003), p. 5.

[27] Ibid., p. 46.

[28] Brooks McNamara, 'Popular Entertainments Issue: An Introduction', *The Drama Review*, 18/1 (1974): p. 3.

[29] Dyer, *Only Entertainment*, p. 1.

or purely entertaining. He argues instead that each performance will have some features of efficacy and some of entertainment, and more importantly, that different vantage points can affect how the performance is perceived.[30] Although this strand provides a continuum along which entertainment and efficacy are connected, musical theatre performances are still seen within an ideology of social functionality, against which they are denigrated.

A third strand of thought explores pleasure and jouissance in the text, its gaps and excesses. Roland Barthes, in *The Pleasure of the Text*, identifies two types of text: the texts of pleasure and bliss.[31] The text of pleasure 'contents, fills, grants euphoria'.[32] It is linked with a comfortable practice and is typical of 'readable texts'. The pleasurable text is bound up with the consistency of the subject, confident in its values, of comfort, of expansiveness, of satisfaction.[33] This is a different subject than the alienated, isolated and manipulated subject of Adorno's discourse.

The text of bliss is referred to in some translations as jouissance and explained as relating to the sexual and the sensual. It is a 'text that imposes a state of loss, the text that discomforts ... unsettles the reader's historical, cultural, psychological assumptions, the consistency of his tastes, values, memories, brings to a crisis his relation with language'.[34] There is an excess in this text, created by events or moments that exceed social or structural function.[35] This text is outside pleasure and criticism and appears in the trace of a cut, in a 'dialectical moment of synthesis', as a 'living contradiction'.[36] Barthes explains that pleasure and bliss are parallel forces, and that a way of establishing their opposition is that 'pleasure can be expressed in words, bliss cannot'.[37]

While not wanting to propose a simplistic correlation of pleasure and bliss with types of entertainment, there may be some sort of parallel with the etymologies of entertainment. Rick Altman explores two etymologies of the term. The first relates entertainment to the French 'entretenir' meaning 'to keep up, to maintain, to foster or to feed'. This suggests connections such that 'let me entertain you' might parallel 'let me hold your interest' or 'create a bond between you and me'.[38] This version of entertainment holds the interest and draws the spectator in, fosters and

[30] Richard Schechner, *Performance Theory* (London and New York, 1988 [1977]), pp. 130–1.

[31] Roland Barthes, *The Pleasure of the Text* (New York, 1975 [1973]), p. 7.

[32] Ibid., p. 14.

[33] Roland Barthes, 'The Grain of the Voice', in *Image, Music, Text* (London, 1977), pp. 179–89.

[34] Barthes, *The Pleasure of the Text*, p. 14.

[35] Ibid., p. 19.

[36] Ibid., p. 21.

[37] Ibid., p. 21.

[38] Altman, *Genre: The Musical*, p. 175.

feeds her interest. It may be pleasurable or joyful, perhaps building an empathetic identification with character and plot.

The alternative etymology derives from the French 'divertir', related to divertimento and divertissement, meaning to divert attention or take one's mind off other things. This perhaps explains the alternative understanding of the word entertainment as related to sensationalism, fun, the parodic, spectacle, comedy and camp. This entertainment is not produced through a process of drawing the spectator into an empathetic relationship with plot and character, but through difference, juxtaposition or excess. This may be the text that is denigrated as 'only entertainment', but it may also relate to the disruptions and excesses of the text of bliss. It can also relate to ideas about utopianism, not in the production of models of utopian worlds, but in the feelings performances embody in their representational and non-representational signs.

Richard Dyer critiques the *mise-en-scène* approach to analysis of film musicals where the non-representational signs are assumed to be functions of the representational, and instead suggests analysis of the non-representational signs in their cultural and historical specificity.[39] He includes colour, texture, movement, rhythm, melody and camerawork as non-representational signs that code emotions.[40] In this thesis the utopian sensibility results from drawing attention to the contradictions and thus to the gap between what is and what could be. What film musicals do, he proposes, is to manage these contradictions so that superficially they seem to disappear.[41] The cracks that appear in the attempt at integration in a film like *Funny Face*, which contains contradictions between art and entertainment and between numbers-as-escapism and narrative-as-reality, offer a sense of a utopian possibility. Contradictions can also be identified in musical theatre between comedy and music or between narrative and number, as well as between representational and non-representational signs.

Caryl Flinn's use of the term 'utopia' is derived from Dyer's. She looks for the contradictions, disparities and gaps in multidisciplinary performance as a source for 'utopian performatives'.[42] She differs from Dyer, however, in that the utopias she proposes are created in reception rather than in production.[43] She also insists that such gaps, or the representational and non-representational elements that produce them, are not necessarily subversive, and that excess and utopian thought are not necessarily progressive. Rather they offer alternative agendas, and even then only impressionistically since they are never represented but only glimpsed and alluded to.[44]

[39] Dyer, 'Entertainment and Utopia', in *Only Entertainment*, p. 24.

[40] Ibid., p. 21.

[41] Ibid., p. 27.

[42] Caryl Flinn, *Strains of Utopia* (Princeton, 1992), p. 28.

[43] Ibid., p. 155.

[44] Ibid., pp. 155–6.

Jill Dolan also glimpses 'utopian performatives' in the gaps that are subjectively read, in this case in the experience of live performances.[45] She suggests that 'utopian performatives' are moments in which attention is drawn in ways that lift everyone slightly above the present. They are hopeful moments that are 'emotionally voluminous, generous, aesthetically striking, and intersubjectively intense'.[46] These utopian performatives are related in her theorising to 'Bertolt Brecht's notion of *gestus*, actions that crystallise social relations',[47] and they offer spectators space for critical contemplation. Here again, rather than looking for utopias as representations of a better world, she looks for moments which spring from a 'complex alchemy of form and content, context and location … as process, as never finished gestures'.[48] This thinking on the power of entertainment, whether experienced as pleasure or bliss, and whether observed in the written text, the performance text or the experience of the performance by the audience, will provide the basis for the arguments that follow. The experience of empathy with characters and the experience of ironic detachment, through meta-narratives or through camp spectacle, contribute to the sensations musical theatre performance elicits. So entertainment will be read here in relation to the pleasure of the readable text and the bliss of the disrupted utopian moments perceived in its discontinuities.

Finally, in musical theatre performance, there is also the sound of the voice, about which Barthes writes in 'The Grain of the Voice'.[49] Notwithstanding the imprecision of Barthes' writing[50] this essay provides a catalyst that draws the argument back from the written text and the physical gestures of the performance text to the vocal and musical articulations of the corporeal and embodied performance text. Although there is debate about how 'the grain' is to be interpreted in practice, it serves here to highlight the importance of the embodied performance text and the vocal delivery of song in discussions of pleasure, bliss and, above all, entertainment in musical theatre.

Conclusion

Setting aside the role of marketing, there must be features in the construction of musical theatre performances that allow them to engage and possibly manipulate

[45] Jill Dolan, *Utopia in Performance: Finding Hope at the Theatre* (Ann Arbor, 2005), p. 5.

[46] Ibid., p. 5.

[47] Ibid., p. 7.

[48] Ibid., p. 8.

[49] Barthes, 'The Grain of the Voice'.

[50] Noted in Dominic Symonds, 'The Corporeality of Musical Expression: "The Grain of the Voice" and the Actor-Musician', *Studies in Musical Theatre*, 1/2 (2007): pp. 167–81, which also refers to Nicholas Till, 'Roland Barthes on the Voice in Modernity', which identifies a passage in Barthes' 'Lesson in Writing' as equally 'problematic'.

the emotional attachment of their audiences and so achieve their enormous popularity. What are the features of musical theatre that lead to its ability to stimulate emotional engagement, to move and to entertain? Some theories of entertainment have been referred to above, that provide a foundation from which to progress.

This study will draw on the existing canon of musical theatre works to provide examples that effectively exemplify and problematise integration, realism and entertainment. The majority of the works studied here have been performed in London or New York in the last 30 years. There are some unlikely inclusions; a Gilbert and Sullivan operetta is included since their works are still performed and are canonically argued to be influential in the development of musical theatre. This inclusion allows exploration of the consistency of practices in the relationship of music, lyrics and narrative from a number of works across the history of musical theatre. A Brecht/Weill opera is included to focus the discussion of debates about *gestus* and distance. Compilation and revue style shows such as *Mamma Mia* and *We Will Rock You* are analysed not from the perspective of economics and globalisation but in light of their production of audience identification and pleasure.

The exploration begins by identifying how signification works in musical theatre texts through the interaction of music with lyrics and narrative in the production of plot and character. Then the trope of integration is critiqued, which opens up a discourse about the diversity and complexity of narrative constructions in musical theatre texts. The focus moves then to the exploration of texts in performance to challenge the construction of realism and to explore reflexivity and distance in performances of musicals with and without linear narratives. Finally, musicals that sit outside the canon of integration are analysed to propose ways of theorising revue, biographical and compilation musicals in relation to musical identification and entertainment. Flowing through these arguments are references to discourses of the singing voice, first in its aesthetic signifying role, later as corporeal embodiment of emotion, and finally as producer of identification and cognitive empathy.

Given the diversity of types of musical or sub-genres outlined at the start of this chapter there can be no clear sense that any particular mode of construction is entirely responsible for the ability of musical theatre texts to reach out to and entertain all its audiences. However, there are cognitive and physiological responses to music and voice that might play a part in the representation or stimulation of emotional attachment or identification. Mirror neurons and vocal touch have an effect on empathy which may contribute to the text being read as 'realistic' by its audiences. At the same time, and conversely, disruption and excess might contribute to a Barthesian construction of jouissance. So 'realism' is a term to be challenged and deconstructed, even though entertainment may result partly from the empathy created through a linear narrative and a particular construction of realism. Alternatively, jouissance may be the partially glimpsed result of a deconstructed or alienated narrative.

The purpose of this study is to problematise assumptions about musical theatre performance as 'only entertainment'. It attempts to do this by focusing on a series of objectives: to clarify the ways musical theatre signifies its characters, its plots and its narratives; to explore the ways music and other media interact to alienate or engage audiences in an emotional and empathetic involvement and a perception of 'realism'; to suggest theoretical frameworks to account for musical theatre's ability to entertain. After all, my experience is that musical theatre is often emotional, comic and very enjoyable. The desire to understand why that is so is the starting point for what follows.

Chapter 1
Musical Characterisation in *HMS Pinafore* and *The Rocky Horror Show*

How is a musical theatre text understood? How can the combination of texts from the disciplines of music and drama contribute to the construction of meaning in ways that are particular to musical theatre? In his comedy show, recorded on video as *Unrepeatable* (1994), Eddie Izzard performs a sketch in which he describes a character in a film who cannot hear the background music that accompanies the scene. The character walks along in the park having a thoroughly good time, but the music gives the audience a premonition of impending disaster. The comedian plays on the different information available to character and audience for comic effect. The sketch also draws attention to the way music, character and narrative interact in film. The audience reads the performance signs; body language, text, scenery, lighting and so on, and understands the light-hearted emotion of the character. It also recognises the musical signs that suggest that something unpleasant will soon befall the character. Both of these systems rely on cultural recognition of previously established conventions and are apparent in film and musical theatre. Most interesting in this case is that the coded messages give different information so that one element disrupts the easy acceptance of the others. This results, as Izzard rightly points out, in the audience being in the position of having more, or different, information than is available to the character; it has narrative information that in this case is conveyed through music. The cultural knowledge required to process and read the signs, which seem entirely obvious in the example above, can be unpacked to reveal how the interaction of music with a dramatic performance adds to the total effect: it is more than the sum of its parts.

Nicholas Cook's *Analysing Musical Multimedia* proposes that each individual text mediates the other(s) to produce a meaning that is not musical or visual but arises from the interaction of the parts.[1] This idea is fundamental to writing on film music, such as *Unheard Melodies* by Claudia Gorbman.[2] In this she suggests that film music's interactions with visual images are extremely complex:

> Its nonverbal and nondenotative status allows it to cross all varieties of 'border': between levels of narration (diegetic/non-diegetic), between narrating agencies

[1] Nicholas Cook, *Analysing Musical Multimedia* (Oxford, 1998).
[2] Gorbman, *Unheard Melodies*.

(objective/subjective narrators), between viewing time and psychological time, between points in diegetic space and time (as narrative transition).[3]

It is clear that musical theatre texts are likely to be at least as complex and that music can have multiple functions simultaneously that are read in relation to other parts of the text. The combination of music and other texts that results from the performance of musical theatre can produce complex or multiple readings. These ideas will be developed over the following chapters, beginning here with an exploration of how musical theatre uses genre for character stereotyping and satire.

Signs exist in the words, the music, the structures and the genres of the text, all of which are read as mediating each other within a cultural context as the work is performed at a particular time and place. Musical styles or signs can point to location, historical epoch, mood, or race/class of the performers. So in *Show Boat*[4] Joe sings 'Ol' Man River', which is coded in the style of spiritual/gospel music, and frames him as black, god-fearing and working class. This is supported in the script and performance and points to the potential for a high degree of over-coding in musical theatre texts. Julie's performance of 'Fish Gotta Swim' differs from Magnolia's as required by their racial backgrounds, and begins the narrative of racial difference through vocal and musical signification. A more recent theatrical example can be found in *Jesus Christ Superstar*.[5] In this musical one can draw a comparison between Jesus singing 'Gethsemane' and drawing on the codes and signification of rock music, while 'King Herod's Song', in a music hall style, signifies Herod as a light-hearted entertainer. Thus, Jesus is portrayed through the musical genre as a rebellious defender of the people, while Herod is seen as a fool and a jester.

In this chapter I'm going to introduce W.S. Gilbert and Arthur Sullivan's opera of 1878, *HMS Pinafore*. The second half of the chapter contains an analysis of several songs from the opera to exemplify the ways in which understanding of character, location and historical period can be produced through the combination of music and lyrics in performance. The analysis will consider two issues of representation in this opera. These are the representation of seafarers in folk-song and in the opera, and the representation of comic and heroic characters through a combination of verbal presentation and musical language. The reading of the combination of musical and dramatic signs in this work, when considered in its social context, is discovered to contain the potential for ironic or satirical readings that might not be understood by a twenty-first-century audience.

[3] Ibid., p. 30.

[4] Music by Jerome Kern, Book and Lyrics by Oscar Hammerstein II and P.G. Wodehouse, based on the novel by Edna Ferber (1927).

[5] Music by Andrew Lloyd Webber, Book and Lyrics by Tim Rice (1971).

Finally, the signification of characters in a very different work, *The Rocky Horror Show*,[6] will be analysed briefly to demonstrate how character signification through musical genre has continued in the twentieth century. The overall aim is to identify how characters are created in various degrees of complexity through the combination of music and lyrics. Moreover, I will place the texts in their historical contexts to propose contemporaneous interpretations, even while remaining aware of the potential for multiple or divergent interpretations.

HMS Pinafore

To begin to explore the ways music can signify in a musical theatre text, I have chosen to analyse a selection of moments from *HMS Pinafore*. This work is still performed, so it must still be understood by, and appeal to, a contemporary audience, though the contemporary interpretation is doubtless substantially different. W.S. Gilbert (1836–1911) and Arthur Sullivan (1842–1900) wrote their comic operas over a period of 25 years from *Thespis* in 1871 to *The Grand Duke* in 1896.[7] The connection to the broader field of opera is implied in the subtitles used to describe these works; most are described as 'comic opera'. This terminology may have served several purposes. It associated these works in the public mind with grand opera, a respectable and high-class entertainment, while at the same time avoiding the term 'operetta' and seeking dissociation from risqué, 'foreign' entertainments. Certainly it was clear to audiences that while the entertainment was comic, they weren't going to be subject to the raciness of burlesque. The musical content was of a more sophisticated type than other such popular entertainments and audiences were alerted that they were going to hear some trained 'operatic' voices. Finally, the term was probably used for purposes of comic irony insofar as there is often a mock seriousness in W.S. Gilbert's libretti and operatic parody in Arthur Sullivan's music.[8] It is generally agreed that their works offer a representation of a changing national identity[9] or social commentary.[10] However, it is their influence on the

[6] Book, Music and Lyrics by Richard O'Brien (1974).

[7] Hayter calls them operas (Charles Hayter, *Gilbert and Sullivan* (Basingstoke and London, 1987), p. xi), Scott calls them comic operas (Derek Scott, 'English National Identity and the Comic Operas of Gilbert and Sullivan', in P. Horton and B. Zon (eds), *Nineteenth Century British Music Studies*, vol. 3 (Aldershot, 2003), pp. 137–52), Knapp calls them musical comedies (Knapp, *The American Musical*, p. 8).

[8] I am grateful to Michael Goron for these thoughts. He continues: *Trial by Jury* is described as a 'Cantata', which is deliberately ludicrous, but you have to know what a cantata is to appreciate the joke.

[9] See Scott, 'English National Identity'; and Knapp, *The American Musical*, p. 8.

[10] See Hayter, *Gilbert and Sullivan*, p. 3.

subsequent development of American musical theatre[11] that makes their work particularly suitable as a starting point for exploring the signification of texts in musical theatre.

Raymond Knapp, in *The American Musical and the Formation of National Identity*, highlighted the importance of Gilbert and Sullivan's *HMS Pinafore* in demonstrating 'the capacity of musical comedy to express a national identity' to an American nation beginning to find its own identity.[12] Knapp's analysis of *Pinafore* identifies a series of issues the opera raises as well as establishing a tradition of treating England and English characters as comical in American musical theatre that survived for many years, both 'celebrating and mocking English nationalist sentiments'.[13] The issues the work raises include English society's hierarchies, the satirical suggestion that naval abuses were a thing of the past, and the satire of personal freedoms. The portrayal of English seamanship was 'self-deprecating' despite it being the 'locus of both English patriotic pride and contentious American engagement in the nineteenth century'. Moreover, the English characters are represented as 'regimented, contented mannequins in sailor suits'.[14]

At the time Gilbert and Sullivan were collaborating there was a second wave of British imperialism stimulated by the recent establishment of Queen Victoria as Empress of India.[15] Within that context older myths of what it is to be English can be identified in, for example, *Yeomen of the Guard* and newer constructions in *Utopia Limited* – so the comic operas could represent a document of the multiple and changing facets of Englishness during the period. In late Victorian England there was uncertainty about whether an English identity was being diluted by imperial expansion or by socialist and republican ideas.

Jingoism was a feature of the overt patriotism of the period that was satirically attacked in the comic operas and in other popular songs.[16] Despite the satire, overt patriotism had also been common in songs and melodramas and 'abounded in the 1870s'.[17] However, Derek Scott also identifies what he calls Victorian notions of English qualities, which are generally those of the bourgeoisie and which he identifies in the comic operas. These are listed as 'character', 'duty', 'prudence' and 'composure'.[18] He speaks of the slow development of freedom through parliamentary democracy, the preference for pragmatism and practicality over the

[11] See for example Scott, 'English National Identity'; Knapp, *The American Musical*; Hayter, *Gilbert and Sullivan*; Lamb, *150 Years*.

[12] Knapp, *The American Musical*, p. 8.

[13] Ibid., p. 46.

[14] Ibid., p. 35.

[15] Scott, 'English National Identity'.

[16] Scott records that 'Jingoism' is a term derived from an 1877 Music Hall song 'War Song' written by G.W. Hunt and sung by the Great Macdermott.

[17] Ibid., p. 139.

[18] Ibid., p. 146.

intellectual, the 'dislike of excess, whether in emotion, manner or dress',[19] and mentions that respectability and decorum are prized, especially in women. Finally, however, there is another feature that appears in the comic operas; the quirky, topsy-turvy and often eccentric humour of Gilbert.

The musical language is also quintessentially of its time and place in its utilisation or even burlesquing of well-known genres within the contemporary culture, whether from the concert and opera traditions, or from the folk and popular traditions. Both Scott and Charles Hayter document a wide range of references to well-known musical styles within Sullivan's score that undermine or parody more obvious interpretations. These include folk-song, ballad, madrigal, glee, and the compositions of Handel and Mendelssohn. As Charles Hayter notes;

> The Savoy Operas are a hybridisation of pre-existing elements from British theatre. In his libretti, Gilbert combined the magic and whimsy of the extravaganza with the irreverence of the burlesque and the nonsense spirit of his German Reed entertainments. Sullivan's scores welded the ballad opera tradition to the vitality of Offenbach.[20]

While the comic operas are of their time and represent a Victorian sensibility that can appear somewhat dated, it is the use of parody and the presence of an ironic or self-deprecating humour that is most appealing in these operas. This relates to a construction of comic distance through parody or satire that appears to be a feature of a line of English musical comedy performance apparent in the Victorian tradition of burlesquing stage works, especially opera. [21]

In support of this suggestion, and before analysing *HMS Pinafore*, I want to clarify the potential sources for the continuity of practice between the opera burlesque tradition and these comic operas. Roberta Montemorra Marvin has analysed the features of four burlesques of Handel's *Acis and Galatea* between 1842 and 1869.[22] One of these was by Francis Burnand who later collaborated with Arthur Sullivan on *Cox and Box* (1866).[23] Gilbert had written a burlesque of *L'Elisir D'Amore* by Donizetti (*Dulcamara or The Little Duck and the Great*

[19] Ibid., p. 146.

[20] Hayter, *Gilbert and Sullivan*, pp. 42–3.

[21] Roberta Montemorra Marvin, in 'Verdian Opera Burlesqued: A Glimpse into Mid-Victorian Theatrical Culture' (*Cambridge Opera Journal*, 15/1 (2003): pp. 33–66), argues that there is confusion over the term 'burlesque' as it was applied inconsistently in the Victorian era, sometimes deliberately to circumvent the theatre licensing regulations (pp. 40–2). Burlesque turned high to low art and breached categories relying on intertextual references and topical allusions (p. 44).

[22] Roberta Montemorra Marvin, 'Handel's *Acis and Galatea*: A Victorian View' in R. Cowgill and J. Rushton (eds), *Europe, Empire, and Spectacle in Nineteenth-Century British Music* (Aldershot, 2006), pp. 249–64.

[23] Marvin, 'Verdian Opera Burlesqued'.

Quack, 1866) and Meyerbeer's *Robert le Diable* (*Robert the Devil or the Nun, the Dun or the son of a Gun*, 1868).[24] He had also written many other styles of dramatic works such as melodrama, pantomime, comedy and farce before turning to comic opera.[25] In fact *Thespis* (1871), the first collaboration between Gilbert and Sullivan, is identified as 'an entirely original grotesque opera' but in the tradition of Planché's burlesques of the 1830s and 1840s.[26]

According to Marvin, the practice of burlesquing opera began in the mid-1840s, and by the 1880s most popular foreign operas had been the source for burlesque. Burlesques contained a mix of acting, singing, dancing and comic routines and were performed through spoken dialogue in rhymed couplets with musical numbers that were drawn from a range of sources interspersed at high points in the action. The main characteristics Marvin identifies are the topical allusions, word play, transformation and travesty of characters and scenes, satirical comment on social issues and varied musical numbers ranging from popular songs to operatic melodies. Clearly there is a connection here with Victorian and contemporary British pantomime, but Marvin makes a connection with the operas of Gilbert and Sullivan, while suggesting that burlesque stands apart from other forms of theatre in the nature, extent and focus of the parody, the form of the language, and the topics of the plots.[27]

I'm not suggesting that the Gilbert and Sullivan operas derived directly from opera burlesque. There were clearly many other influences on Gilbert and Sullivan from the variety of theatre and music they experienced and the economic and social circumstances of the creative processes. I am suggesting that there are particular features in their works that may provide a key to a thread of continuity in the construction of complex and satirical musical theatre texts. It is the intertextual reference to musical styles alongside topical allusions and social satire that I want to address here. This will enable exploration of the construction of meaning at this early stage in the development of musical theatre.

The story of *HMS Pinafore* concerns the love of a lowly sailor for the Captain's daughter, though her father wants her to marry Sir Joseph Porter KCB, the 'ruler of the Queen's Navy', clearly a much more advantageous match. It is finally discovered that the young tar, Ralph, and the Captain were accidentally switched at birth by Buttercup – a baby farmer – reversing their social positions and status. Righting the wrong makes the match between Sir Joseph and Josephine impossible and that between Ralph and Josephine possible. Everyone else pairs up in the most unlikely marriages but within the same social classes. The plot explores and satirises the fixed social hierarchies of the time, though resolving the issues within the status quo by marriages within social class.

24 Hayter, *Gilbert and Sullivan*, p. 38.

25 Ibid., p. 9.

26 Ibid., p. 16.

27 Marvin, 'Handel's *Acis and Galatea*', p. 253.

Many people[28] have spoken of Sullivan's skill in parodying popular British music of the time, which included imported operettas, but chief among his sources were Handel, Mendelssohn, popular music hall songs and folk-songs. Derek Scott notes a comment by Sabine Baring-Gould that Arthur Sullivan used to frequent the British Library searching out folk-songs to use for ideas predominantly from eighteenth-century sources.[29] This is most clearly apparent in the music for the sailors in this opera, which draws on well known musical styles and lyrical references to the heroism of sailors in order to satirise the patriotic excess and jingoism of the period.

The first edition of the *New National Song Book* published in 1906 contains a number of songs about seafaring that had been collected and arranged by C.V. Stanford.[30] They demonstrate how sailors were represented in the period before *Pinafore*. 'You Gentlemen of England' is a seventeenth-century song in a stately 4/4 time that prefigures or inspires the anthem 'For he is an Englishman' in *HMS Pinafore*. It includes the lines 'A sailor must have courage, no danger he must shun, in every kind of weather his course he still must run'. The song concludes that when the danger is over 'We find a hearty welcome wherever we may go, Safe and sound on dry ground, When the stormy winds do blow'.[31]

The stormy winds are also evident in 'The Mermaid', which is a much more lively and energetic rhythmic song whose refrain is

> While the raging seas did roar, and the stormy winds did blow,
> And we, jolly sailor boys were up, up aloft
> And the landlubbers lying down below below below,
> And the landlubbers lying down below[32]

before the ship goes down. 'The Bay of Biscay' documents a ship that is almost lost in a storm in the Bay when a sail is sighted and one imagines the sailors are rescued.[33] The music for this song is in faster 2/4 time and contains leaps and scale patterns that are more in keeping with the hornpipe though not directly related.

'Ye Mariners of England' with music by Dr J.W. Callcott and poem by Campbell is again rather stately though marked 'not too slow', and also speaks of the stormy winds as well as the battle through which the mariners of England guard our native seas.[34] In this too are references to the field of fame, to Blake

[28] For example James Day, Derek Scott, Raymond Knapp, Charles Hayter.

[29] Scott, 'English National Identity', p. 150.

[30] C.V. Stanford (ed.), *The New National Song Book* (London, 1906).

[31] Ibid., p. 8.

[32] Ibid., p. 24.

[33] Ibid., p. 27.

[34] Ibid., p. 36.

and Nelson, and to manly hearts, who, as Nelson is reported as saying of his men, 'mind shot no more than peas'.[35] The men are reinforced since the

> spirits of their fathers shall start from every wave,
> for the deck it was their field of fame and ocean was their grave.

The third verse begins

> Britannia needs no bulwarks, No towers along the steep;
> Her march is o'er the mountain-waves, Her home is on the deep.

Even more stirring and vigorous is 'Heart of Oak' by Dr William Boyce and David Garrick.[36] It is equally patriotic, calling men to glory and honour 'for who are so free as the sons of the waves?' The chorus proclaims

> Heart of oak are our ships, Jolly tars are our men:
> We always are ready. Steady boys, steady,
> We'll fight and we'll conquer again and again.[37]

In 'We be Three Poor Mariners', from about 1609, the mariners speak of their support for the merchantmen 'who do our state maintain' but of their lack of care for the 'martial men who do our states disdain'.[38] 'Tom Bowling', a much more musically developed ballad by Charles Dibdin, speaks of the sailor, Tom, now dead, as 'the darling of our crew' with a form of 'manliest beauty, His heart was kind and soft'.[39] He always kept his word and had rare virtues, 'he'd sing so blithe and jolly' but his soul is now 'gone aloft'. So despite the frequent reference to the likelihood of death either through storm or battle, a life at sea is popularly referred to as one of freedom, adventure and fortune, and the heroic sailor is revered for his gentleness, manliness and beauty. These are the features satirised by their excessive portrayal in the representation of the sailors in *HMS Pinafore*. Musically, in the folk-songs there appear to be three broad types of music: anthemic patriotic chorales; rhythmic and energetic stirring music with dotted rhythms; and faster dance-type music with turns and scales in melody and accompaniment that suggest jigs and hornpipes. As will be demonstrated below, these three types are apparent in the representation of sailors in *HMS Pinafore*.

[35] Quoted in Scott, 'English National Identity', p. 143.

[36] Stanford, *The New National Song Book*, p. 41.

[37] There is a verbal reference to this song in *Utopia Limited*; 'Though we're no longer Hearts of oak, Yet we can steer and we can stoke' (quoted in Scott, 'English National Identity', p. 145).

[38] Ibid., p. 14.

[39] Ibid., p. 31.

These songs were all noticeably from an English tradition. I found a lack of songs of the sea from the other countries of the United Kingdom, except in relation to fishing and missing home. There are also numerous sea shanties or working songs such as 'What Shall We do with the Drunken Sailor'[40] and 'Blow the Man Down'[41] whose words deal with practical aspects of work, or love and absence from the sailor's perspective, rather than identifying how a sailor is signified. In all the folk-songs above there is a mythologising of the British Tar or the English Man, with 'British' tending to relate more to empire and battle, and 'English' to home and country. They contain a romanticised view of the freedom and valour of a life at sea defending the nation, sentiments that are satirised in *HMS Pinafore*.[42]

As times changed so, to some extent, did the representation of sailors. By the time Noel Coward was writing his revues two songs sum up the different perspectives. 'Has Anybody Seen Our Ship?'[43] represents the good-natured drunken exploits of sailors on shore leave, who blame the girls for leading 'our tars astray', in a music hall parody that contains the same hornpipe references heard throughout *Pinafore*. 'Sail Away'[44] retains the romantic sentiment and escapism of the seafarer. The verse contains the lines

Time and Tide will set him free from the grief inside him.
Sea and sky will ease his heart, regulate his troubled mind.

The chorus begins: 'When the storm clouds are riding through a winter sky, Sail Away', recapturing the escapism and idealisation of a life at sea.

'He is an Englishman',[45] from *HMS Pinafore*, relates in overall style to 'You Gentlemen of England'. It is sung in a steady monophony by the crew when Ralph and Josephine are discovered trying to escape. The patriotic anthem is undermined by the ridiculous lyric and the mock stereotyping of other races that is apparent in the D'Oyly Carte productions. It concludes 'But in spite of all temptations to belong to other nations, He remains an Englishman!' The portentous stateliness of the music, derived from the anthems of folk-song and developed as a pastiche of

[40] T.P. Ratcliff, *News Chronicle Song Book* (London, no date), p. 136.

[41] Ibid., p. 137.

[42] This was, in fact, a period of some anxiety over British naval supremacy, as discussed in David Cannadine, *Aspects of Aristocracy* (New Haven, 1994), and A.N. Wilson, *The Victorians* (London, 2002). Most battleships at the time were ironclad gunboats. Significantly, Pinafore is an old fashioned Man o'War, a sailing ship, clearly a nostalgic throwback to happier times, and to the type of nautical melodrama Gilbert was parodying (Michael Goron, Personal Communication).

[43] Noel Coward, *The Lyrics of Noel Coward* (London, 2002 [1965]), pp. 169–70. This song is from the sketch 'Red Peppers' in *Tonight at 8.30*, 1935–1936.

[44] Noel Coward, *The Essential Noel Coward Song Book* (London, 1980 [1953]), pp. 276–9. The song is from the musical *Ace of Clubs*, 1949.

[45] Gilbert and Sullivan, *HMS Pinafore*, p. 120.

the British choral tradition, over-dramatises the ridiculous lyric.[46] The extended melisma on the first syllable of the word 'English', which in the D'Oyly Carte productions was broken up as separate syllables, 'i-i-i-i', satirises the seriousness of the musical style.

This song is reprised at the end of the second act[47] so that the opera appears to finish with a patriotic anthem, but one whose musical seriousness is undermined. Derek Scott refers to Hesketh Pearson's comment about the 'satire on blatant patriotism' and Arthur Jacobs' 'absurd mock-patriotic context' of this song. In this case these commentators note how satire is created through the combination of portentous music with 'dramatic triviality'.[48]

The counterpart to this song is 'A British Tar is a Soaring Soul',[49] which also occurs on two occasions in the opera. It contains both chorale type music and a motivic reference to the hornpipe. It first appears as a trio supposedly written by Sir Joseph Porter and sight read by Ralph, the Boatswain's Mate and the Carpenter's Mate. It is arranged as a three-part glee in the madrigal tradition, another tradition popular in Britain at the time. The first section is in monophony, the second section in polyphony, followed by a hornpipe-type final line before the chorus reprises the polyphonic section as a choral refrain. Here, there is the incongruity of the sight reading of a complicated part song by the ordinary sailors, which draws attention to the class satire that is at the heart of the opera. There are the same adjectives as are found in the folk-song tradition that spoke of freedom and civility, 'A British Tar is a soaring soul; As free as a mountain bird'. The lyrics also speak of 'manliness' and describe an outrageous exaggeration of the physical representation of justified anger and violence; an exaggerated parody of that heard in 'Heart of Oak'.

> His nose should pant and his lip should curl,
> His cheeks should flame and his brow should furl
> His bosom should heave and his heart should glow
> And his fist be ever ready for a knock down blow.[50]

The intricacy of polyphonic writing distances the presentation of emotion from the individual singer and even from the singing group, counteracting the excessively exaggerated description of the aggressively virtuous sailor in the lyrics, making it seem incongruous. The song is reprised in an altered version by the ladies at the end of the act building up to a patriotic finale from the assembled crew and chorus.

[46] In fact Scott demonstrates a direct resemblance between this tune and 'Ward the Pirate', a Norfolk folk-song arranged for male voices by Vaughan Williams (after James Day, *Englishness in Music: From Elizabethan Times to Elgar, Tippett and Britten*, London: Thames Publishing, 1999).

[47] Gilbert and Sullivan, *HMS Pinafore*, pp. 149–50.

[48] Scott, 'English National Identity', p. 140.

[49] Gilbert and Sullivan, *HMS Pinafore*, p. 50.

[50] Ibid., p. 51.

The hornpipe choral reprise gives vigour, energy and comic lightness, in contrast to the polyphonic writing and lurid descriptions of the anticipated attitude of the naval man.

In 'He is an Englishman' a trivial lyric was juxtaposed with an anthemic musical setting. Here, the expectations of the lyric might suggest a setting to portray the 'noble beast' of the lyric, but again this is undermined, in this case by the delicacy and agility of the polyphonic setting and the accuracy required in singing. So the combination is different, but the juxtaposition of popular musical genres against the lyrical expectations works in the same way and suggests a performance style that provides comedy through a serious and truthful rendition of the juxtaposed materials.[51]

The scale patterns of the hornpipe which pervade the score belong to the third category of folk music representing seafaring, the jig.[52] Scale patterns similar to the hornpipe appear in the introduction to 'I am the Captain of the Pinafore'[53] for the first time in the opera, where it might suggest the shipboard location in a stereotypical fashion linked with the light-hearted spirit of a dance. The recitative contains the incongruity of the mundane greetings set against what might be regarded as a more high-flown – if outdated – operatic style; the recitative. The verses continue the use of mundane or workmanlike language in words and music that presage the discovery of the Captain's real social class. At the same time the musical setting explores the relationship between Captain, men and the social structures of the ship-board society as well as preparing for the contrasting representation of other characters. Raymond Knapp develops this idea exploring the relationship between chorus and soloist in the refrain 'What never, Well, hardly ever' to demonstrate the lack of authority of Captain over crew as signified in the choral relationships.[54] There is therefore a presentiment of the new relationship that will be in place by the end of the comic opera. In this way musical language and musical structure are being used not only to create a geographical and atmospheric context, but to prefigure plot developments and social relationships.

Even more interesting, and preceding this moment, is the entrance of Buttercup – also named Mrs Cripps in the score – who appears at the start of the show after the opening chorus of sailors.[55] She sings a short but grand and patriotic recitative of welcome to the 'men o' wars-men, safe guards of your nation', before, in the same musical style, establishing her commercial intentions; 'you've got your pay, spare

[51] There is also a section of nautical musical pastiche, similar in feel to that in *Pinafore* in 'A Wandering Minstrel' in *The Mikado*.

[52] Knapp identifies the hornpipe as developed from a nineteenth-century jig (published in 1855–9 in *Popular Music of the Olden Times* by W. Chappell), in *The American Musical*, p. 42.

[53] Gilbert and Sullivan, *HMS Pinafore*, p. 21.

[54] Knapp, *The American Musical*, p. 39.

[55] This part was played by a pantomime and burlesque actress, Harriet Everard. It is possible the popular feel of the aria was written for the actress's particular skills.

all you can afford'.[56] However, the grandeur and patriotism is then undermined as Buttercup introduces herself in a simple contralto waltz aria that wouldn't be out of place in the music hall or indeed in the nursery; 'I'm called little Buttercup'. This combination is puzzling.

The recitative certainly sets the precedent for other mock-operatic recitatives by other characters in the course of the opera,[57] but is ill-suited to what is revealed about Buttercup. Buttercup is a working woman who plies her trade in the harbour selling goods to the returning sailors. She has in the past been a 'baby farmer' and is referred to as a 'plump and pleasing person'. It is possible to speculate that the appearance here of the 'baby-farmer' Buttercup is a satirical reference to Queen Victoria's long period of absence in mourning and rearing her children at Osborne House.[58] The grandeur of the recitative style could be a patriotic reference to Britannia ruling the waves of the new empire since Victoria had been exalted to Empress of India in 1876. But her aria is clearly more in line with a popular, working-class tradition than the grand recitative with which she is introduced. The aria perhaps suggests the down-to-earth mother figure, or even quite a youthful representation. The combination suggests a satirical reading or at least a topical allusion to images of Victoria as Empress and baby farmer.

One might conclude therefore that the topsy-turvy fantasy world the authors are creating is not intended to be coherent or realistic, though there is enormous attention to realistic detail in the costume, actions and set. In place of realism, incongruity and unexpected juxtapositions are being used to challenge class-based hierarchies and stereotypical representations and to make topical allusions. If it weren't for the date one might almost call this combination of music and lyrics 'gestic'.[59]

The young lovers in *HMS Pinafore* are Josephine (soprano) and Ralph (tenor), and each sings an opening song: Josephine sings 'Sorry Her Lot' and Ralph sings 'A Maiden Fair to See', at their first entrances.[60] These songs use poetic language, chromatic melody, romantic harmony and ornamentation over strumming, slow, ¾ time accompaniments. Each is lovesick for the other, but feels the other is out of their class. For Ralph this is a musical and verbal language that would be beyond the range of a poor sailor, but of course he is eventually revealed to be a well-born lad, satirising the assumption that musical and poetic gifts or tastes are inbred in

[56] Gilbert and Sullivan, *HMS Pinafore*, p. 12.

[57] These mock-operatic recitatives were originally performed by actors who sang rather than by opera singers. This may have a bearing on how they were delivered in performance.

[58] Queen Victoria was not seen in public from 1861 until the mid-1880s, although she continued to carry out official engagements.

[59] This is a reference to the Brechtian use of the term which will be developed in Chapters 3 and 4.

[60] 'Sorry Her Lot' (Gilbert and Sullivan, *HMS Pinafore*, p. 28) and 'A Maiden Fair to See' (ibid., p. 18).

those of high birth. Josephine sings 'Sorry Her Lot' also referring musically to the romantic tradition. The similarity of their musical and poetic language creates a perspective of the two as singing/speaking in similar high-flown language and so suggests their musical and verbal suitability for each other, which is enacted in their betrothal later in the story.

Their duet later in the act begins with each singing solo; Josephine requests Ralph refrain from pressing his suit as he is lowly born. Ralph responds by characterising himself as 'the lowliest tar that sails the water' and she as an 'unfeeling beauty' and 'proud maiden'. However, at the end of the argument they sing their individual lyrics to homophonic music, simultaneously signifying their differences and their similarity. Ralph then decides to commit suicide, at which point Josephine admits her love and the trio follows with Cousin Hebe joining them to sing 'Oh Joy, Oh Rapture Unforeseen' before the lovers agree to run away together that very night. Dick Deadeye tries to stop the pair but the whole company agrees that a British tar is a worthy suitor. The fact that the heroine and hero sing in similar musical and poetic language, is clearly not a 'realistic' characterisation but one that allows a romantic reading of the characters as well-suited, and anticipates the eventual renegotiation of their relative status. This combination challenges issues of hierarchy and class structure through the popular musical language of Victorian Britain.

These patterns of representation using musical genre can be traced throughout the history of musical theatre and musical film. Jane Feuer identifies the oppositions of jazz and opera, or popular versus elite art as the narrative subject of many film musicals of the Hollywood era.[61] In these films the representational associations of musical genres are transferred to the characters that espouse them, and as the characters learn to sing or dance together their love grows. In *HMS Pinafore* the lovers are predestined by their musical similarity to be together even though they appear to be from different classes.

In Act Two Josephine has a second solo in which she reconsiders her decision. This is followed by a trio between Josephine, her father and Sir Joseph Porter – the man her father wants her to marry. This begins 'Never mind the why and wherefore, love can level ranks'. Sir Joseph's intention is to persuade her that his higher born state need be no obstacle to their marriage, but she draws solace from his words and determines to steal away with Ralph. Alongside the earlier material for the lovers this represents a structural strategy that would become a feature of later musical theatre and film in which the heroine's and hero's musical and dramatic trajectories are balanced; a strategy that Rick Altman refers to as the 'dual focus narrative'.[62] In this case the lovers each have an opening solo in which they identify the impossibility of their love, so that although they are enacted

[61] Jane Feuer, *The Hollywood Musical* (London, 1993), pp. 54–65.

[62] Rick Altman, 'The American Film Musical as Dual-Focus Narrative', in Steven Cohan (ed.), *Hollywood Musicals: The Film Reader* (London and New York, 2002), pp. 41–52.

one after the other, the understanding of the audience is that these two events are simultaneous. The love story is not told from one perspective or the other, but both characters are balanced in their love for each other, in the amount of stage-time or musical material they have, and in the importance of their journeys towards each other.

In this comic opera stereotypical characterisations are used in order to create satire through incongruous associations. Although characters change social position, their rank and status is prefigured through well-known musical associations. Music and language are used in conjunction here to suggest status and suitability as well as atmosphere and context. This reading of *HMS Pinafore* suggests that Gilbert and Sullivan were using the combination of music and lyrics to signify the social situation so that rank, status, context and atmosphere are indicated, while at the same time, the juxtaposition of music and other texts allows social realities to be challenged, made comic, and satirised.

The Rocky Horror Show[63]

HMS Pinafore is a very early example of these practices of musico-dramatic signification in musical theatre, though reference was made to *Show Boat* and *Jesus Christ Superstar* at the start of the chapter. A musical from the 1970s, *The Rocky Horror Show*, also draws on genre signification to establish characters. There are many other musicals that could have been used, but this seemed about as far removed in context and style as possible, and yet still demonstrates some common features.

In the decade from the mid-1960s to mid-1970s, rock music was a genre associated with the macho posturing of performers such as Mick Jagger and the Rolling Stones, and with counter-cultural youthful, left-wing communities and their search for 'authenticity'.[64] Keir Keightley suggests that the term 'rock' 'may mean rebellion in musical form, distorted guitars, aggressive drumming, and bad

[63] This section is derived from my own article 'Don't Dream it, be it: Exploring Signification, Empathy and Mimesis in Relation to *The Rocky Horror Show*', *Studies in Musical Theatre*, 1/1 (2007): pp. 57–71. I am grateful to the editors for permission to reproduce it here.

[64] Authenticity in rock music has been widely discussed. See for example Richard Middleton, 'Pop, Rock and Interpretation', in Simon Frith, Will Straw and John Street (eds), *The Cambridge Companion to Pop and Rock* (Cambridge, 2001), pp. 213–25, and more recently the exchange in *Musical Quarterly* between Mark Mazullo and Greil Marcus: Mark Mazullo, 'The Man whom the World Sold: Kurt Cobain, Rock's Progressive Aesthetic and the Challenges of Authenticity', *Musical Quarterly*, 84 (2000): pp. 713–49; Greil Marcus, 'Comment on Mark Mazullo "The Man whom the World Sold"', *Musical Quarterly*, 84 (2000): pp. 750–3; Mark Mazullo, 'Response to Greil Marcus', *Musical Quarterly*, 84 (2000): pp. 754–5.

attitude' and that 'the idea of rock involves a rejection of those aspects of mass-distributed music which are believed to be soft, safe or trivial'.[65] The result is that rock music was associated with ideas of youthful subversion and resistance, even as it existed in the mainstream.

Within rock, sub-genres emerged that included, in the early 1970s, glam rock. Glam rock at this time included artists such as David Bowie – in his Ziggy Stardust and Aladdin Sane periods – Marc Bolan and Annie Lennox. The music is regarded as having enormous sexual energy, with performers using alternative and androgynous identities and high levels of sensuality. Glam rock regards as 'authentic' music that focuses on experimentation, progress, technology and its elitist positioning of the artist.[66] Recent work on the development of the concept of 'authenticity', for example by Richard Middleton, recognises the importance of social positioning and the fluidity of subjectivity.[67] So, when analysing this text it is important to understand how glam rock was signified at the time and within what context, while allowing that its reception in contemporary performance is fluid.

Frank and the Transylvanians might be participants in a glam rock concert. Frank indulges in sexually provocative posturing while wearing women's underwear, and has bisexual romps with Janet and Rocky. This, alongside Magenta and Riff Raff's possibly incestuous relationship and their deliberately mysterious and grotesque presence, could be seen as an extension of the glam-rock personas of the early 1970s. Eddie, on the other hand, is a leather-jacketed, motorbike-riding character, originally played in the United States by Meatloaf, but often characterised as looking and sounding like Elvis. This characterisation relies on the folk or country blues associations of a nostalgic rock'n'roll sound in 'Whatever Happened to Saturday Night'. This is regarded as passé within glam rock and he is killed. Janet and Brad are associated with the lighter pop sound of 'Damn it Janet', which from a rock aesthetic might be regarded as superficial. Brad is made to appear insignificant and foolish, while Janet's musical language adapts as the plot develops. Rocky's 'The Sword of Damocles', draws on associations of sensuality through the use of rumba patterns and prefigures his overwhelming sexual activity.

The guitar rhythm of 'The Time Warp' introduces the aggressive and distorted sound world of the Frankenstein Place as the young couple arrive, making an association between the distorted guitars, the rock music and the strange, aggressively sexual and disturbing world at the castle. This sets up a relationship between the musical style, the location, and its inhabitants. The place has 'rock music' credibility. Frank, who enters to a much heavier, slower drum pulse, becomes the star performer of the rock concert. He introduces himself as 'not much of a man by the light of the day, but by night I am one hell of a lover'. This is followed by the refrain, 'I'm just a sweet transvestite from trans-sexual

[65] Keir Keightley, 'Reconsidering Rock', in Simon Frith, Will Straw and John Street (eds), *The Cambridge Companion* (Cambridge, 2001), p. 109.

[66] Ibid., pp. 131–9.

[67] Middleton, 'Pop, Rock and Interpretation', p. 215.

Transylvania'. Again, the glam rock performance with its connotations of youthful subversion and sexuality reinforce the character and his credibility with the culturally aware rock fan audience.

Different musical styles are being used to underpin characterisations, but the perspective from which they are read is that of a glam rock aesthetic, which looks for experimentation and progress. This is apparent in the transformation of Janet from a conformist virginal female 'just like Betty Munro', looking forward to marriage to Brad, into a sexually liberated woman. This is represented by her musical development from the pop sounds and clear soprano tones in the refrain of 'Damn it Janet' to her solo 'Touch-a Touch Me' with its rock-rumba rhythm, introduction of a lower vocal register, and a throatier, full-bodied vocal sound. The plot here draws on a perception that rock music can release the uptight from societal restrictions. There is a parallel journey played out in *Dirty Dancing* as the rock'n'roll music and latin influenced dance style liberates the heroine into sexual adulthood. Equally, in *Footloose* the young people escape the restrictions of the town to dance to rock'n'roll. These examples are predominantly from dance musicals, and use musical and dance styles as a reflexive feature of the narrative,[68] but one can also trace the characters in the stage version of *Cabaret* in relation to their music. There is the influence of Jewish and folk music on Herr Schultz, the reference to music hall and variety traditions in the stage music of Sally and the MC, and the more romantic musical theatre character of Cliff's song 'Why Should I Wake Up'.

Interestingly, the Janet that Brad imagines in the harmony line to his country rock number of love and loss, 'Once in a While', is back in the soprano mould. It is performed after he has seen Janet having sex with both Frank and Rocky and might represent a difficult transition back to the soprano range for the performer. However, Janet is not seen singing this song in all productions. Sometimes she appears only vocally and could be perceived as being Brad's imagination of the sound of his perfect woman. Whether the couple are reconciled is open to interpretation, though they survive and leave together. These brief examples demonstrate the way that *The Rocky Horror Show* employs particular types of music in relation to a glam rock aesthetic of the 1980s to signify character types and to underpin narrative and plot. The practices, though from a different historical context, are not dissimilar to those seen in *HMS Pinafore* when read in the context of the patriotism and parody of Victorian Britain.

Conclusion

There are several ideas that have been explored here. The ways in which a text signifies within its time and place, and the difficulties of reading it from a more distant context, are demonstrated by reading the material for the sailors and

[68] See Feuer, *The Hollywood Musical*, for a development of this argument.

Buttercup in *HMS Pinafore* in the context of contemporary folk and popular styles. The musical styles in *The Rocky Horror Show* are read from the perspective of glam rock. The use of structure and genre as well as localised signs produce character stereotypes as seen in the readings of Josephine and Ralph in *HMS Pinafore* and the differences between various characters in *The Rocky Horror Show*. The interaction of signs and disciplines in the creation of comedy or parody is seen in the reading of the patriotic anthems and the presentation of Buttercup in *HMS Pinafore*.

However, in the discussions of both these works there has also been mention of the vocal style or range of the singers: Josephine, the heroine of *Pinafore*, sings in a romantic style and in the soprano range. Buttercup sings contralto and her aria is in a popular music hall style. The sailors sing a three-part glee with incongruous lyrics, pitting vocal quality against lyrical or character stereotype. In *The Rocky Horror Show* Janet's vocal range and style changes as different parts of her character are explored. Frank 'N' Furter moves between the raucous glam rock of 'I'm a Sweet Transvestite' to the melodrama of a slow rock ballad in 'I'm Going Home'. Riff Raff uses a high tenor/falsetto range in the middle section of 'The Time Warp' for an eerie, other-worldly quality. But it is not only range that signifies; the tone quality, ornamentation and accuracy of pitch and rhythm also alter as required by these different styles. In responding to different aesthetics of genre and vocal production the voice signifies in its own right and contributes to the complexity of meaning and character representation. Musical style, pitch range and the use of technology have changed in the course of the century in different types of musical theatre work and have had an effect on vocal production and meaning. Before continuing the examination of the potential for multiple readings, distance and disruption in the musical theatre text, the next chapter will outline some developments in vocal signification.

Chapter 2

Encoding the Voice:
Show Boat, *Guys and Dolls*, and
Musical Theatre Post-1960

Whether the particular type of musical is comic, dramatic, jukebox or conceptual, musical theatre is a form in which a large part of the emotional material and some of the narrative information is communicated in song. When singing the pitch, dynamic and rhythmic range used by the voice can be expanded and extended beyond that used in speech, creating a different framework for vocal signification than would be present in speech. The performance of song communicates semantic, verbal information, but also contains many other areas of communication including vocal range, genre, style, intonation, accent, vocal register, and the choice of sound qualities – tone and timbre. These are subconsciously used in everyday communications, and through these subconscious attributes a voice is individual, identifiable and understandable. But vocal delivery also communicates the emotional state of the singing body and so links performer and character. As Jacob Smith says, 'the voice can function as an index of the body, a conveyor of language, a social bond, a musical instrument of sublime flexibility, a gauge of emotion, a central component of the art of acting, and a register of everyday identity'.[1] The somatic emotional communication that connects performers, characters and spectators will be returned to in a later chapter, but for now the signification of voice in song will be discussed.

Roman Jakobson recounts the story of an actor at Stanislavsky's Moscow Theatre who was asked by a famous director to make 40 different messages from the phrase 'This evening' 'by diversifying its expressive tint'. Jakobson asked the actor to repeat the test and to find 50 possible messages in the phrase. He concludes 'Most of the messages were correctly and circumstantially decoded by Muscovite listeners. May I add that all such emotive cues easily undergo linguistic analysis'.[2] Mladen Dolar, who records the story, concludes that 'all the shades of intonation which critically contribute to meaning, far from being an ineffable abyss, present no great problem to linguistic analysis'.[3]

[1]　Jacob Smith, *Vocal Tracks* (Berkeley, 2008), p. 3.

[2]　From Roman Jakobson, 'Closing Statement: Linguistics and Poetics', in Thomas A. Sebeok, *Style in Language* (Cambridge, 1960), pp. 350–77. Quoted in Dolar, *A Voice and Nothing More*, p. 21.

[3]　Ibid., p. 21.

The vocal music of musical theatre is predominantly comprised of lyrics whose performance is composed using defined pitch, rhythm and phrasing, with the implied harmonic structure completed by instruments. In this way composers and lyricists have a bearing on some aspects of vocal communication, perhaps limiting to some extent the freedom of expression available to singers over speakers. But performers are not completely circumscribed by the musical text in the meanings and emotions they communicate, as intonation, dynamic range and pitch are relative concepts that are stylistically interpreted. Tone and timbre are not defined in musical notation at all, though they are through understanding of genre and culture. Emphasis and enunciation are entirely open to the performer's determination of how best to express character and situation. So there is a space, a similar space to that identified by Jakobson above, in which the performer's interpretation interacts with the composed text in the creation of meaning.

Patterns of communication alter within culture and over time, so it is not surprising that the vocal patterns through which composers represent character and emotion, and through which performers interpret them for audiences have changed in the course of the twentieth century. A quasi-operatic delivery for lyrical singing and parlando delivery for comic singing has been replaced to reflect developments in technology and popular culture that influence the composition of musical theatre texts. Such changes reveal a new aesthetics that is related specifically to the vocal performances of musical theatre song. This can be equated with a democratising of vocal tone in some parts of musical theatre, away from aspirations to operatic sound and delivery and towards popular styles. The consequence of this in the second half of the twentieth century is a greater diversity of vocal styles to include *bel canto*'s beautiful tone alongside an increased focus on verbal communication with speech pitch and speech pattern rhythms in some songs. The influence of folk, rock, blues and other popular styles can be felt not only in the harmonic and melodic structures but in the tones and timbres of the voice that are less pure, more idiosyncratic, containing a greater degree of vocal 'fry', breath or other extended sounds. In many types of popular music there is room for ornamentation or even improvised additions to the melodic line, or alteration of pitch, attack and rhythm as the song is made personal to singer and character. These features perhaps provide a key to the development of new styles of emotional expressivity in the vocal delivery of musical theatre.

Eric Salzman and Thomas Desi have argued that composers of through-composed operas place the emotion in the musical construction, where the orchestral accompaniment is expected to drive 'all the action as well as the thoughts, intentions, emotions and interactions of the characters being portrayed'.[4] Given the demonstration by Jakobson recorded above, this is highly unlikely to be the responsibility of the music alone, but the musical accompaniment acts as both commentary and reinforcement of character delineation and stage action. With the alternation of music and number in both number operas and popular musical

[4] Eric Salzman and Thomas Desi, *The New Music Theater* (Oxford, 2008), p. 37.

theatre Salzman and Desi write that 'the orchestra's function is largely restricted to introductions, song-and-dance accompaniments, scene music, and some mood setting'.[5] Their argument is that in the through-composed opera 'the orchestra plays a much more involved role'. It has already been argued in Chapter 1 that the musical styles and genres in operetta and musical theatre have considerable complexity and many of the same functions that Salzman and Desi argue to be apparent only in through-composed texts, though perhaps created in different ways. But this is not the place for musicological analysis or debate about the differences between opera and musical theatre or between through-composed and number works. What I am suggesting is that in musical theatre, whether through-composed or not, the singer's vocal timbre and style of delivery, produced as a result of an interaction with the musical composition and understanding of genre, has developed a greater importance and variety in the production of character and the signification of emotion than might have been the case in nineteenth-century operetta singing.

Bruce Kirle argues that musical theatre texts are the result of collaborations between teams of people including the performers and the context.[6] Their interpretation remains 'open' because productions, contexts, but most importantly performers, change, and the performance is always a result of vocal delivery communicated through tone and articulation as well as musical accompaniment and other performance signs. I don't deny the ability of singers of opera and operetta to embody characters or to signify their emotions, but rather to suggest that musical theatre has developed a different aesthetic for accomplishing that embodiment and signification which relies on a closer relationship to popular forms whether vaudeville, music hall, African-American music and style, minstrelsy or cantorial singing. This represents a move towards increasing the importance of text, style and the expression of emotion through an extended range of vocal timbres. Arguably this might also equate to a class-based move from high art to popular culture. Clearly, though, these developments also establish new norms that are contained within the aesthetic of the 'musical theatre sound'.

This chapter will track the development of that sound from separate operatic and popular traditions, through the twentieth and into the twenty-first century as vocal style has been influenced by popular music and recording technology. Stephen Banfield talks about two shifts that occurred in musical theatre development during the twentieth century. The first occurred between the late nineteenth century and the 1920s, during which the female belt, the comic style, 'cantorial' singing and crooning all contributed to the development of musical theatre style and 'redefined distinctions between black and white, Jew and Gentile, American and British, folk and opera, south and north, comic and serious, ordinary and special'.[7] The second

5 Ibid., p. 36.

6 Kirle, *Unfinished Show Business* , pp. 1–2.

7 Stephen Banfield, 'Stage and Screen Entertainers in the Twentieth Century', in John Potter (ed.), *The Cambridge Companion to Singing* (Cambridge, 2000), pp. 63–82. This

shift arose from the introduction of microphones and the influence of pop and rock music in the mid-century. Banfield says that this second shift 'was about age and gender'. The result he surmises is that 'the acting singer became the singing actor'.[8]

The aim here is to begin to identify the range of vocal qualities required by different musical theatre scores and characterisations. This interacts with the styles of delivery by the performer and so contributes to the communication of character and meaning and the production of pleasure in musical theatre texts.

Developing the Nineteenth-Century Vocal Aesthetics in Operetta

Since there are no recordings it is impossible to identify the tone quality of singers before the twentieth century, though one can make suppositions based on the available texts and commentaries. Given that limitation, the following patterns can be surmised from a study of the literature. Opera singing began in small indoor spaces, the preserve of the rich and aristocratic, and, with no special vocal training, voices were perhaps similar to those of folk singers. However, over time, certain vocal qualities came to be prized in opera so that in the seventeenth and eighteenth centuries 'high voice singing' and virtuosity were required attributes as singers elaborated on their roles, especially in *da capo* arias.[9] Castrati and sopranos dominated, and basses and female altos played secondary roles. Salzman and Desi note that 'the vocal qualities that were most prized were focused tone, delivery of text, flexibility, expressivity and the ability to ornament and improvise – all qualities that have more in common with latter-day jazz vocalization than with either Greek theatre or what we traditionally think of as opera singing'.[10] Small orchestras were dominated by strings and continuo keyboard playing in relatively small theatres so singers could be heard. La Fenice, in Venice, designed to allow the voice to carry, had about 1,000 seats in a horseshoe shape with several levels of balconies allowing the audience close proximity to the stage, and was, in 1800, believed to be the largest in Europe.[11]

Gluck, in his later operas – from *Orfeo ed Euridice* in 1762 – attempted to find an alternative to the 'artifice and complexity' of Baroque opera[12] so that by the time Rossini was writing in the early nineteenth-century ornaments and cadenzas were often written out because the practice of improvisation had largely died out.[13] In a sense this represents a move from a theatre focused on the performer to a

reference p. 79.

[8] Ibid., p. 79.
[9] Salzman and Desi, *New Music Theater*, p. 16.
[10] Ibid., p. 15.
[11] Ibid., p. 16.
[12] John D. Drummond, *Opera in Perspective* (London, 1980), p. 166.
[13] Salzman and Desi, *New Music Theater*, p. 16.

theatre prescribed by the composer. Still, agility and flexibility were prized, and at this point distinctions between theatre singing and operatic singing could not have been great as performers moved between theatrical and operatic performance.[14] At the same time – from 1760 onwards – comic opera and *intermezzi* represented a revolt against serious opera, and often relied on a national musical idiom and contained speech between musical numbers. This form was developed from the 1780s by Mozart. Moreover, especially in Italy, comic opera began the exploitation of the bass voice either in comedy or in burlesque.[15]

In the nineteenth century, with the increasing popularity and professionalism of opera, population growth and the increasing wealth of the bourgeoisie, larger theatres were built that required bigger voices. Alongside this orchestras grew in size and sonority, requiring powerfully projected voices to be heard over them. A technique of supporting the voice developed and the use of vibrato became a common device for magnifying and projecting sound.[16] A new type of powerful voice, more suited to singing Wagner than Rossini, thrilled audiences and dominated opera for a century and a half.[17] Other styles of singing continued to exist, but lacked the prestige of opera singing. So it was that operatic high voice singing and *bel canto* sound became even more separated from the 'natural' voices of folk and popular performance and achieved a significantly different status. Most popular and regional folk styles were based on so-called 'natural voice singing' – singing in chest registers close to the speaking voice – and were used in social and religious events and popular theatres.[18]

Bel canto singing is difficult to define since it has been taught in many ways by different teachers, but in general the qualities it teaches are a perfect legato production through the whole range, use of a light tone in the higher registers and agile and flexible delivery. James Stark connects *bel canto*'s origins to the virtuoso singing of the sixteenth and seventeenth centuries, and describes the *chiaroscuro* or 'well-rounded' tone of the voice as containing both a 'bright edge as well as a dark or round quality in a complex texture of vocal resonances'.[19] A significant development in the understanding of vocal technique was the invention of the laryngoscope by Manuel Garcia II in 1854, which enabled the first view of the vocal mechanics and altered the understanding of vocal production.[20]

By the mid-nineteenth century in Paris comic operas were extremely popular, as well as dance halls and *cafés-concerts* where audiences enjoyed catchy and accessible songs 'delivered by performers expert in putting such material

[14] Ibid., p. 17.

[15] Donald Jay Grout, *A History of Western Music* (London, 1973 [1960]), p. 470.

[16] Salzman and Desi, *New Music Theater*, p. 18.

[17] Ibid., p. 19.

[18] Ibid., p. 21.

[19] Smith, *Vocal Tracks*, p. 121 quoting James Stark, *Bel Canto: A History of Vocal Pedagogy* (Toronto, 1999).

[20] Ibid., pp. 124–5.

across'.[21] This remark demonstrates the importance of performance in the delivery of these songs. From 1848 Hervé – the alias of Florimond Ronger – was writing works in a variety of styles that contained comic songs and buffoonery, and gradually the genre of operetta was established through his work and that of his compatriot, Jacques Offenbach.[22] In Germany a tradition of comic opera continued in the work of Franz von Suppé, but at the same time most of Europe was influenced by Offenbach, whose operettas toured the continent, being especially influential in Vienna and London.[23] In Vienna the operetta was developed from 1871 by Johann Strauss. In London there was a greater interest in burlesque opera and other popular forms which, combined with the awareness of Offenbach's operettas, influenced Gilbert and Sullivan.[24]

Operetta singing was derived partly from the high voice and *bel canto* technique of opera and to some extent and in some places shared its higher status, but it was also, always, more commercial, popular and, often, comic. There was also a significant influence from theatre singers and actors and popular musical genres as well as a range of vocal styles of production. Early musical theatre singing derived from operetta singing as a simplified version of operatic high voice singing, modified to permit clear articulation of the words, especially in high registers. Sopranos and tenors dominated, using high voices that appeared youthful, but could also soar above the orchestra and be heard.[25] Even baritones playing less romantic characters were often placed in the upper part of their range, but comic characters and altos were also present as a result of the popular theatre influence. Stephen Banfield, in 'Stage and Screen Entertainers of the Twentieth Century', argues that there was in fact a much greater range of influences as will be discussed below.

However, some parts of operatic signification did transfer through to musical theatre. Catherine Clément records that sopranos in opera were often 'persecuted victims'; tenors represented 'Courage and Rebellion', baritones represented 'Organized Opposition'; mezzo-sopranos represented 'Resistance, Witchcraft, and Treason' and the bass and contralto represented 'voices from beyond the human world'.[26] Mary Ann Smart comments that '[t]he traditional images of helpless soprano, vulnerable romantic tenor, baritones law-giver, etc., are so deeply entrenched that even when individual works depart from the pattern the

[21] Lamb, *150 Years*, p. 5.

[22] Ibid., pp. 5–14.

[23] For more detail see ibid., Chapters 1, 3 and 6.

[24] As was established above, the work of Gilbert and Sullivan is not only influenced by operetta, but by popular song, art song, burlesque and the Gallery of Illustration.

[25] Salzman and Desi, *New Musical Theatre*, p. 22.

[26] Catherine Clément, 'Through Voices, History', in Mary Ann Smart (ed.), *Siren Songs* (Princeton, 2000), pp. 17–28. This reference pp. 22–4.

archetypes remain'.[27] She argues that it is in this space between archetype and the specific that meaning can emerge.

To return to consideration of *HMS Pinafore*, the lovers sing in the tone and style of light opera, a higher art, to signify their lofty moral characters. Other comic characters sing in a range of styles. Sir Joseph Porter is represented in patter song at the pace and pitch of speech, a type of song developed from the music hall tradition,[28] and Buttercup, the mezzo role, is represented in mock-operatic recitative and simple waltz melody. What this demonstrates is the awareness of the operatic archetypes, alongside an awareness of the different aesthetics of voice placement and delivery in different types of theatrical performance. As early musical theatre began developing out of operetta and other popular forms, there remained an elitist privileging of the higher trained voices for lovers over lower-pitched popular styles for comic characters that would gradually be undermined by the influence of popular song and its widespread delivery in recorded form.

The Influence of Jazz, Blues and Ragtime

The comic operas and operettas of Gilbert and Sullivan and others[29] as well as musical comedies crossed the Atlantic in both directions, but there was a significant new influence transferring from the United States to Europe in the latter part of the nineteenth and early twentieth century, and that was the influence of African-American music and vocal timbre.

Some parts of vocal communication, like the words, melody and rhythm, are consciously learned and produced. Other parts are perhaps less consciously produced or read, especially in popular music, perhaps being assumed to be 'natural', such as intonation, tone and timbre. These features may be mimetically learned and reproduced as an attribute of culture and genre. As Jonathan Rée says, 'distinctive vocal styles can identify people as sharply as their bodies or their

[27] Mary Ann Smart (ed.), *Siren Songs* (Princeton, 2000), p. 12.

[28] Stephen Banfield notes that male comics were either charming dandies or uncoordinated eccentrics who sang predominantly parlando, between baritone and tenor in range, 'with flattened tone, no sostenuto and very little vibrato'. Banfield, 'Stage and Screen Entertainers', p. 67.

[29] Other musical theatre teams of the period were Edward German and Basil Hood, Ivan Caryll and Lionel Monckton. Works produced by George Edwardes at the Gaiety Theatre included *The Gaiety Girl* (1893), *The Shop Girl* (1894) and *A Runaway Girl* (1898). Several shows at Daly's theatre, also produced by Edwardes, had scores by Sidney Jones. Other composers of the period were Paul A. Rubens, Leslie Stuart, Howard Talbot and in the early twentieth century Oscar Asche. For more information see Lamb, *150 Years.*

faces',[30] and Cornelia Fales identifies the dimension of timbre as carrying the most information about a source and its location.[31]

In music the dimension of timbre has been more studied and has greater importance in the composition and signification of works outside the European classical tradition, which tends to focus on pitch and intonation. While writing about African vocal performance of 'traditional declamatory styles' in the Belgian Congo, Fales suggests that

> With the exception of a better or worse ability to remember texts to many songs, there seem no real criteria for a good or less good performance. The sole characteristic that seems to distinguish one performance from another is the quality of *ubuguruguru*, a term difficult to translate, but meaning something like 'noise', 'agitation', or 'turbulence'.[32]

This noise can be created by accompanying instruments, but in both African and African-American vocal practices it was often created within the timbre of the voice as a result of loose glottal closure, a raised larynx and less resonance in the cavities of the head, which results in a throaty or raspy sound. This type of timbre lacks the resonance of *bel canto*, and within a western tradition accustomed to regarding *bel canto* singing as 'good', a raspy timbre was initially regarded as reflecting a lack of training or sophistication.[33]

Jacob Smith documents some of the recordings of the early part of the twentieth century that reveal the vocal 'rasp' that took on a heightened meaning as an index of blackness, in contrast with the culturally dominant – white – *bel canto* timbre.[34] In America this timbre was associated with work songs, field hollers, gospel and country blues and therefore contributed to a cultural stereotyping of black voices which had negative racial connotations at the turn of the twentieth century.[35] However, the recording of 'black' voices, although the subject matter of

[30] Jonathan Rée, *I See a Voice* (London, 1999), p. 2.

[31] Cornelia Fales, 'The Paradox of Timbre', *Ethnomusicology*, 46/1 (2002): p. 57.

[32] Ibid., p. 83.

[33] Smith, *Vocal Tracks*, p. 134.

[34] Ibid., p. 115.

[35] Ibid., pp. 134–5.

the recording might be constrained according to stereotypes such as those seen in minstrel shows,[36] allowed a democratisation of these musical timbres and genres.[37]

At first jazz and blues music was associated with performances in churches and at funerals, but also in the popular domain in honky tonks, juke joints and whorehouses,[38] and so some styles of singing carried sexual and racial connotations of 'otherness', sensuality, and certainly a lower status. However, recordings and radio as it developed brought these new vocal sounds to a wider public, and the songs proved to be enormously popular, and even to some extent produced a popular reaction against high trained voices.[39] An example of 'the negro voice' is given by Stephen Banfield who describes the vaudeville comedian Bert Williams' performance as '90 per cent parlando', but with a modern sense of rubato phrasing, casual breathing and general timing, and when he sang it was at the higher end of his range with no vibrato and imitative glissandi.[40] These new timbres and styles were combined with an existing theatre tradition that also used 'natural' timbres, including the 'belt' – a high extension of chest register related to a cry or a sustained shout. Banfield records examples of the introduction of the female belt in musical theatre performed by Celeste Holm in *Oklahoma!* and Ethel Merman in *Annie Get Your Gun,* and a differently produced film belt – which relied on a microphone – used by Judy Garland as early as 1936.[41] It is likely that the belt was used rather earlier in popular theatre performances.

The other significant influence Banfield notes is cantorial singing, epitomised by recordings of Eddie Cantor, Irving Berlin and Al Jolson. The characteristics of this style include a pitch between baritone and tenor,

> highly flexible in register and rhetoric, but unifying these by maintaining an intimate lyrical intensity over a concentrated tessitura rather than by long-line phrasing and disguising of breaks. Legato is achieved in short spans but all trace

[36] The two principal stereotypes that came from these shows were, first, the Jim Dandy or Zip Coon character, representing the northern urban black man who, according to L. Erenberg, was 'a creature of impulse, who got drunk, danced about wildly, got into scrapes and put on airs … He was racially incapable of self-control'. L. Erenberg, *Stepping Out: New York Nightlife and the Transformation of American Culture 1890–1930* (Chicago, 1984), p. 27. The second stereotype was the Jim Crow figure who represented the 'southern lackadaisical rural plantation figure'. David Walsh and Len Platt, *Musical Theater and American Culture* (Westport, 2003), p. 28.

[37] Walsh and Platt argue that the minstrel show was not simply a racist parody, but was also, for its time, educational, attempting to bring black and indigenous subcultures to a wider public. Ibid., p. 27.

[38] Salzman and Desi, *New Musical Theatre,* p. 21.

[39] Ibid., p. 24.

[40] Banfield, 'Stage and Screen Entertainers', p. 69.

[41] Ibid., pp. 65–6.

of Italianate articulation has gone. Parlando is still frequently resorted to but as a wise-cracking respite from singing.[42]

These performers also liberated body language and overt emotionalism in theatre singing.[43] In musical theatre this extended the possibility of character representation through popular genres as well as the incorporation of new popular singing styles. But for this type of sound, and the newer crooning, to be heard in larger halls, amplification was needed.

The Effects of Technology

The development of amplification and microphone technology transformed the potential range and size of the audience for singers from the 1930s onwards. Timbres, ornamentation and musical genres from African-American and Jewish singing had begun to influence mainstream popular tastes as a result of phonograph recordings and live touring by performers, but microphones and amplified recordings also made it possible that softer, lower voices and a more intimate delivery could be recorded. Steven Connor suggests that the crooning style[44] was discovered by singers working with sound engineers when it was realised that microphones could not cope with the extreme dynamic ranges of singers accustomed to singing acoustically in large halls.[45] But there were advantages that came as a result of the quieter delivery and close microphone. As Simon Frith says,

> The microphone made it possible for singers to make musical sounds – soft sounds, close sounds – that had not really been heard before in terms of public performance ... The microphone allowed us to hear people in ways that normally implied intimacy – the whisper, the caress, the murmur.[46]

The effect of crooning is to make it appear that the singer is very close to the listener singing in a breathy tone, and the possibilities of amplification highlighted tiny subtleties of delivery so that voices could be produced with a more individual and idiosyncratic sound.

[42] Ibid., p. 70.

[43] Ibid., p. 72.

[44] For more on the history of crooning see Allison McCracken, 'Real Men don't Sing Ballads: The Radio Crooner in Hollywood, 1929–1933', in Pamela Wojcik and Arthur Knight (eds), *Soundtrack Available: Essays on Film and Popular Music* (Durham, 2001), pp. 105–33.

[45] Steven Connor, *Dumbstruck: A Cultural History of Ventriloquism* (Oxford, 2000), p. 38.

[46] Simon Frith, *Performing Rites* (Oxford, 2002), p. 187.

> The crooning voice is full of what Roland Barthes has called the grain of the voice, its individuating accidents of intonation and timbre. The microphone makes audible and expressive a whole range of organic vocal sounds which are edited out in ordinary listening; the liquidity of the saliva, the hissings and tiny shudders of the breath, the clicking of the tongue and teeth, and popping of the lips.[47]

Low voices, the throaty sounds of blues and folk, and the breathy, intimate croon were hugely popular in recorded music. Still, in live performance singers had to stand by a microphone to achieve the effect of crooning, or, in musical theatre, use a microphone with a cable, sing high, or belt until the development of effective wireless radio microphones that became widespread in musical theatre performance as recently as the 1970s and 1980s.[48]

At last performers could stray from the presentation of songs facing towards the audience and still be heard, and could incorporate a greater range of popular music styles from the recording industry. In recent years the advantage of this technology is that singers have the opportunity to move freely and to produce a full range of vocal sounds. The complaint levelled against the use of technology is that the sound of musical theatre has become increasingly reliant on sound engineers and sound designers who attempt to reproduce the effect and balance of recorded sound, divorcing the production of the sound from the body of the singer and the acoustics of the space. These ideas will be developed in a later chapter; for now the consequences of these developments on the characters, musical styles and vocal techniques of musical theatre performers need to be established.

A Developing Vocal Aesthetic for Musical Theatre

The importance of the incorporation of popular styles into the musical is in the effect it has had on vocal production, and the loosening of the association of soprano and tenor vocal ranges and *bel canto* technique with the leading characters; the lovers. The styles of singing in popular music are more earthy and less controlled, more overtly emotional and perceived as more 'authentic' or 'natural'. In the course of the twentieth century popular singing styles have influenced vocal production and detached some of the previously common associations, though in many cases musicals use common associations in order to suggest character or location, or in order to subvert these associations. The incorporation of popular music has also led to the opportunity for much greater ornamentation and variation of style and

[47] Connor, *Dumbstruck*, p. 38.

[48] There are many claimants to the title of inventor of wireless microphone technology, but the technology was not sufficiently available, cheap or reliable for use in many theatres until the late 1970s, and not widespread until the 1980s.

technique in musicals that incorporate contemporary musical cultures and their vocal timbres and patterning.

In early musical comedy, following the pattern established in operetta, the heroine and hero explored their feelings in love songs; in the very early days of musical theatre and operetta often in waltz time. Steve Swayne recounts the history of the waltz in his article 'Remembering and Re-membering: Sondheim, the Waltz, and *A Little Night Music*'.[49] He concludes that although the dance had been inaugurated in the eighteenth century with scandalous overtones and a sense of universality, by the time it reached Broadway it had lost these associations, though retaining the ability to signify romance and passion. He continues:

> Rodgers and Hart's waltz 'Lover' (from the 1932 film musical, *Love Me Tonight*) captures in one word the intensity and the naughtiness that Wolf and Werther experienced. Romberg's 'The Desert Song' from the 1926 musical of the same name contains the lyrical sweep and swoop one has come to associate with a great, Valentino-esque romance. Even the famous waltzes that open *Oklahoma!* and *Carousel* project a romance, respectively for a day and the promise it holds … and for a community and the life lived within it.[50]

While the lovers communicated in poetic language, comedy characters communicated in more direct speech using earthier comic language, shorter phrases, faster 4/4 time and the idioms of vaudeville. These patterns varied as musical theatre began to incorporate many styles of popular music and, later, rock and gospel music, developing and adapting to changing cultural contexts. The result of this was a changing vocal aesthetic from a 'classical' sound similar to that used in operettas like *Rose Marie* and *The Desert Song* to what is now known as a 'musical theatre sound' including the 'glottal onset' and the 'belt' alongside increased ornamentation and 'extended voice'.

Show Boat[51]

In *Show Boat* there is a blend of styles from operetta and from popular music that results partly from 'the attempt to represent the two sides of the racial divide'.[52] In this musical music is used as an index of race through song styles and a performance aesthetic that signifies blackness in relation to the cultural stereotypes established in recordings of popular music. Todd Decker identifies

[49] Steve Swayne, 'Remembering and Re-membering: Sondheim, the Waltz, and *A Little Night Music*', *Studies in Musical Theatre*, 1/3 (2007): pp. 259–73. In this article Swayne argues that Sondheim reinterpreted the waltz.

[50] Ibid., p. 262.

[51] Music Jerome Kern, Book and Lyrics Oscar Hammerstein II and P.G. Wodehouse, 1927.

[52] Knapp, *The American Musical*, p. 186.

the following: a pseudo-spiritual, 'Ol' Man River'; a blues built on a 12-bar blues progression, 'Can't Help Lovin' Dat Man'; a lengthy dramatic choral spiritual, 'Mis'ry's Comin' Aroun''; a levee dance, 'Queenie's Ballyhoo'; 'an ironically self-aware jungle number' combining primitive chanting with jazzy syncopated energy, 'In Dahomey'; and 'a hot Twenties hey-hey rouser in the 11 o'clock spot', 'Hey Feller',[53] though not all these songs made it past the try-outs. These songs exist alongside the 'white' operetta of Magnolia and Ravenal, the blues style of Julie, the African-American timbre of Queenie and the vaudeville inflected performance of Ellie. Here, the incorporation of popular song styles from African-American heritage and from white vaudeville performance exists alongside white *bel canto* singing, and the use of these styles indexes time, place, race and status according to existing social norms.

It is perhaps difficult to identify Magnolia as a heroine as the narrative explores the differences between Magnolia – young, white, soprano, and Julie – slightly older, mixed race, mezzo-soprano, though Magnolia is clearly the love interest. These two could be respectively heroine and anti-heroine since Julie is left alone and unemployed at the end, though she is the character who behaves heroically. The other female characters are Queenie – black, mother figure, contralto, and Ellie – white, comedy song and dance performer, mezzo-soprano. The songs these characters sing, however, help to suggest a reading. Magnolia and Ravenal sing love duets for soprano and tenor, meeting in the song 'Only Make Believe', which prefigures the 'if only' songs 'If I Loved You' from *Carousel* and 'People will Say We're in Love' from *Oklahoma!* by Rodgers and Hammerstein in mid-century. There is a brief phrase in waltz time at the end of this song that prefigures their waltz 'You are Love', first in the Cotton Blossom performance and later reprising it at their reunion. This material conforms in pitch and genre to the stereotypes for lovers outlined above, though the first performance of 'You are Love' is framed within a historical story being performed on the Cotton Blossom, which is, itself, set in and after 1880. So there is an element of archaism in using the genre in this way. Nonetheless the waltz time love song signifies their passion for each other onstage and off, and is reprised by Ravenal when they are reunited.

Raymond Knapp notes that the waltz appears as an underlay only twice in the score and always in association with Ravenal and almost always with Magnolia's idealising view of him.[54] He concludes that 'the waltz style itself takes on the function of a quasi-leitmotive, connecting the relationship between Magnolia and Ravenal as well to the larger issue of fantasy vs. reality'.[55] The important point in this argument, though, is that the lovers are represented in western European *bel canto* singing and the style of operetta.

[53] Todd Decker, '"Do You Want to Hear a Mammy Song?": A Historiography of *Show Boat*', *Contemporary Theatre Review*, 19/1, (2009): pp. 8–21, p. 8. This article identifies the problem of analysing *Show Boat* because of its many versions.

[54] Knapp, *The American Musical*, p. 187.

[55] Ibid., p. 187.

Julie is introduced in 'Can't Help Lovin' Dat Man' which has a much more 'bluesy' feel as a result of the strumming bass line and the flattened third in the melody on the word 'lovin''.[56] More importantly, as a result of awareness of genre implied in the harmony and melody, the song is sung with a different 'feel' from Magnolia's *bel canto* delivery. This includes leaning into notes, sliding across rising intervals, 'swinging' the rhythm in melody and accompaniment, and allowing the singer rhythmic freedom in the delivery of the words. It is the singing of this song that allows the African-American characters to realise that Julie has a similar heritage to theirs, so clearly it requires a vocal timbre more in keeping with black vocal performance. This means a 'natural' tone that potentially incorporates breath sounds, huskiness and an idiomatic delivery connoting a 'black' timbre. Magnolia reprises the song when trying to get a job at the Trocadero towards the end of the show, singing to her own guitar accompaniment – possibly a reference to the banjo accompaniment implied in the strumming accompaniment to the bridge section and an instrumental reference to the roots of blues performance. Her performance is less coded as blues because of the 'white' vocal timbre, though the performer may incorporate the rhythm and intonation of blues. Magnolia is then asked to sing the song in ragtime in a further appropriation of the song. These versions of the song demonstrate the impact of pace, timbre and intonation on the delivery of certain genres, and especially of the reading of *bel canto* as white, heroic and higher status. But Queenie also sings, and the older woman is represented in a lower range that contains the timbre of an African-American character, but also, the rounder tones and lower range associated with age. This is comparable with the Reverend Mother 30 years later in *The Sound of Music*[57] whose age and wisdom are represented in the lower range and heavier sound of the contralto.

There is another couple in the show: Ellie and Frank are a pair of vaudeville performers doing song and dance routines in the Cotton Blossom show. They are introduced in a dance routine as the Cotton Blossom arrives, and subsequently although they are introduced as a duo, Frank only dances. Ellie sings 'Life upon the Wicked Stage' with a chorus of girls in the onstage show. This is typical vaudeville with comic lines that require a particular form of over-the-top vaudeville characterisation, a melody in the mid to low range of the female voice and delivered at almost the rhythm of speech. The melody has dotted rhythms to give energy and bounce and the accompaniment supports the melody with little ornamentation until the dance break.

Ellie, Julie and Magnolia perhaps represent the three female voices that began to be incorporated into musical theatre: the *bel canto* soprano, love interest; the jazz inflected, earthy or sexual blues singer, with a huskier or noisier timbre; the

[56] There are other figures in the melody (such as the major/minor ambiguity in bar 30) and harmony that signify a blues style. In addition the verse is a 12-bar blues. For more analysis see ibid., pp. 191–2.

[57] Music and Lyrics by Richard Rodgers and Oscar Hammerstein, Book by Howard Lindsay and Russel Crouse (1959).

vaudeville influenced comedy character whose delivery focuses on articulation of comic lyrics and sometimes uses a 'belt' sound. This mix of styles reflects developments in the popular music industry in which, as Allison McCracken records, Tin Pan Alley's second generation of songwriters were influenced by vaudeville so that middle class ballads gave way to the 'more permissive tone and lyrics of vaudeville novelty songs, creating a new genre of popular song that celebrated the glamour and excitement of big city life, including its romantic and erotic possibilities'.[58]

Guys and Dolls[59]

Two decades later, in *Guys and Dolls*, the heroine, Sarah, retains the soprano timbre and style – though perhaps with a lower tessitura even than in operetta – but the hero, Sky, is pitched below the tenor range as a baritone. This may be a response to the lower-voiced crooners who combined 'the intense romanticism of the high-class ballad, the amorality of the vaudeville novelty song, the emotionalism of minstrelsy and the sensuality and accessibility of jazz',[60] but may also incorporate the influence of the Jewish cantorial voice. Sarah, the 'mission doll', sings 'I'll Know' as a duet with Sky. The song begins with a *colla voce*, recitative-like opening section followed by the aria/duet containing the romantic sweeps and flamboyant *tenuto* moments of operetta, especially in the writing for Sarah. An example is the *tenuto* on G2 at the summit of the phrase 'I'll be strong' that allows an appreciation of the beautiful voice as well as demonstrating the strength of her determination.[61]

Sarah and Sky's duet is 'I've Never Been in Love Before' which is also quite rhapsodic, using tonal harmony and conforming to the expected range and intonation of young lovers in musical theatre. But Sky's prologue 'My Time of Day' contains a jazz influenced melody and accompaniment in a free fantasy. Interestingly, Allison McCracken suggests that for a few decades from the 1930s crooners were perceived as arrested adolescents or 'idealist, innocent young men … who would presumably someday grow up and out of their childish crooning phase'.[62] So 'My Time of Day' represents Sky as more adventurous, more sensual, or more of an idealistic, naive innocent, but the freedom or excess of the jazz influence and crooning style disappears in the harmonically restrained duet with Sarah. Sky appears to sacrifice his wild and youthfully unpredictable ways to

[58] McCracken, 'Real Men don't Sing Ballads', p. 109.

[59] Music and Lyrics by Frank Loesser, Book by Jo Swerling and Abe Burrows (1950). Based on Damon Runyon's *The Idylls of Sarah Brown*.

[60] McCracken, 'Real Men don't Sing Ballads', p. 112.

[61] Frank Loesser, *Guys and Dolls* (New York, 1950), p. 29 – seven bars before letter C.

[62] McCracken, 'Real Men don't Sing Ballads', p. 125. She continues: 'This portrayal of the crooner as adolescent suggests how culturally ingrained the association between emotion, pitch, and masculinity was by the mid-1930s.'

conform to Sarah's musical language, and they must sing together if audiences are to believe they will live happily ever after. This section ultimately suggests that they are not quite as well suited as the happy-ever-after ending of many musicals. This is also prefigured by Adelaide and Sarah's duet in a vaudeville style, 'Marry the Man Today', which continues 'And change his ways tomorrow'. This change in musical style indicates that Sarah has moved from a *bel canto* timbre to vaudeville performance to get her man, while his music – and therefore his representation – has moved from the unpredictable, free floating jazz to the emotional delivery and simpler harmonies of musical theatre. The lyrics also suggest that the girls are gambling on the success of their marriages.[63]

It was still quite common in musicals that there should be a second couple to carry the comedy in vaudeville style songs; Adelaide, already mentioned above, and Nathan Detroit. Here, as in *Show Boat*, the second female is a performer, so her act allows presentation of vaudeville style material. She is represented as more overtly sexual in the diegetic performance and sexually active in the narrative – she has been engaged to Nathan for 14 years, waiting for him to marry her. Her vocal range in 'Take Back Your Mink' with the show girls covers only an octave from middle C, a comfortable range to belt the end of the song. Interestingly, it is a waltz sung by the supposed innocent who has been importuned by her lover. In the foxtrot reprise the singers take off the clothes the lover has given them – an excuse for a partial striptease that challenges the innocence the singer, in a flirtatious or ironic fashion, purports to have, and characterises the type of presentation at The Hot Box where Adelaide works.

Adelaide's solo within the narrative 'Adelaide's Lament', reprised later as 'Adelaide's Second Lament', covers the same vocal range at a much freer pace with a recitative-like melody as whole phrases are declaimed on a single note, though, as Knapp points out, it has an accompaniment containing the 'bump-and-grind' that conventionally accompanies striptease.[64] This lower vocal range is also a feature of the older female performer – as sung by Queenie in *Show Boat* – appropriate for the aging showgirl, engaged for 14 years. Since Adelaide has a permanent cold psychosomatically brought on by 'living in sin', she is usually characterised by a nasal or throaty delivery and an unusual degree of raucousness and over-the-top characterisation that complements the exaggerated speech of the comic hoods and gangsters retained from Damon Runyon's stories. The vocal characterisation comes from vaudeville and is rough and 'noisy'. The melodramatic timbre, the coughs and sneezes all relate to what Erving Goffman describes as 'flooding out',[65] a form of breaking the frame – in this case breaking

[63] Raymond Knapp interestingly suggests that the religious characters' songs each contain elements of the gamblers' styles and vice versa, with Sarah using syncopation and sexual double entendre in 'If I were a Bell' and Sky 'prays' in 'Luck be a Lady'. For a development of this argument see Knapp, *The American Musical*, pp. 142–3.

[64] Ibid., p. 141.

[65] Erving Goffman, *Frame Analysis* (New York, 1974), p. 350.

the frame of song with a wealth of living sounds and a vocal timbre that is far removed from the normalising or desirable frame of *bel canto*.

Nathan Detroit, Adelaide's fiancé of 14 years only sings a single duet with Adelaide, 'Sue Me'. This song doesn't conform to the stereotypes that have been set up within musical theatre either, but draws on the crooning technique for Nathan's lines that are marked 'Slowly and Plaintively' in the score, in contrast to Adelaide's angry verses. It is interesting, then, that the part was sung in the film version by Frank Sinatra.[66] Other songs include 'Guys and Dolls', 'Luck be a Lady' and the mock spiritual 'Sit Down You're Rocking the Boat', all for the male principals and male chorus. These songs are all in popular idioms that both contain and contrast the religious music of the Salvation Army officers.[67] In the same way that Mary Ann Smart argued that the space between vocal archetypes and specific characterisations allowed the articulation of meaning in opera,[68] here musical theatre archetypes have formed that are strong enough to be used or subverted in the signification of character and meaning.

While one musical can hardly be taken as representative, the influence of popular music and technology can be seen in *Guys and Dolls*. There is a range of genres from 'high' and 'low' musical forms, the use of jazz harmonies and the crooning style for Nathan and Sky. Alongside this, vaudeville styles, overt emotionalism and female belt have developed that allow the presentation of a greater range of characterisation and the representation of overt sexuality for Adelaide. The soprano timbre is also adapted through its interaction with other musical techniques for Sarah in 'If I were a Bell' and more completely in 'Marry the Man'. This constitutes a developing musical theatre aesthetic. Vocalists are still split between comedy characters predominantly performing songs developed from a vaudeville aesthetic but increasingly incorporating emotional characterisation, while the lovers perform in highbrow styles and tones but incorporating popular genres.

Post-1960

From about 1960 the range of musical styles found in musical theatre expanded again to incorporate the developing pop and rock music, then later gospel and other commercial styles using electronic instruments and radio microphones. At the same time elements of the *bel canto* technique, vaudeville and African-American

[66] McCracken, in 'Real Men don't Sing Ballads', suggests that early crooning represented an anxious masculinity. Bing Crosby's films and others that followed developed a strategy to reduce this anxiety by linking the crooner to other masculine stereotypes – in this case, gambling and the all-male environment.

[67] This is a continuation of Knapp's argument cited above that each group's music incorporates the music of the other, the two musical types being Tin Pan Alley and Hymn-like. Knapp, *The American Musical*, p. 142.

[68] Smart, *Siren Songs*, p. 12.

influenced genres that can be seen in *Show Boat* and *Guys and Dolls* were retained. For example, *Phantom of the Opera*,[69] set in Paris in 1861, uses a combination of genres drawn from nineteenth-century opera and twentieth-century musical theatre to represent characters and to provide comedy. The opera singers Carlotta and Piangi require big, melodramatic operatic voices, while the part of Christine requires a *bel canto* tone and intonation – or what Jessica Sternfeld describes as a lighter lyric soprano. Raoul is what Sternfeld describes as a 'strapping Broadway tenor, not operatic but not pop-style either'.[70] This is clearly a development from the overtly emotional cantorial singing Banfield has identified. The Phantom, with his high tessitura, can use a timbre produced through a rock falsetto technique though there is no pop or rock in the writing or delivery. Sternfeld continues: 'the rest of the voices resemble Raoul's in style: theatre voices, big and flexible, with occasional tips toward operatic and a complete absence of pop elements.'[71]

This is in contrast with Andrew Lloyd Webber and Tim Rice's earlier musical *Jesus Christ Superstar* that was first released as a rock album and contains pastiches of many styles. The vocal styles include a combination of high rock for Jesus and Judas, low folk rock for Mary Magdalene, and vaudeville for King Herod. The significant feature here is that in this and other rock musicals women's voices are in their chest or 'natural' registers incorporating the musical theatre belt, while heroic male voices are in the high rock tenor range incorporating falsetto and the extended voice range and 'flooding out' of the scream. This is especially true for Jesus in 'Gethsemane' and Judas in 'Damned for all Time'. This confusion of gender in sound is referred to as a characteristic of the second shift by Banfield.[72] He also refers to C. Osborne's article to identify the features of the female range as either a soprano block on top of a belt sound, or the alternating use of 'legit' sounds and belt sounds in the same range.[73] Whether from this musical or from the popular forms on which they draw, these features influenced subsequent rock and pop musicals that incorporated these vocal ranges and voice types.

Specific vocal qualities developed for rock musicals that were characterised by a lower vocal range for women, and often a higher vocal range for men. Both require a full-throated belt that is rougher and has a less controlled sound than that used in the musicals discussed so far. Equally, there is also greater use of a quiet breathy quality, especially for intimate or tender emotional moments, and the opportunity to use catches and sobs or broken sounds to represent deep emotion. The performers and the musicians in rock musicals are allowed, or even encouraged, to take much greater liberties in adding ornamentation to the written

[69] Music by Andrew Lloyd Webber, Lyrics by Richard Stilgoe and Charles Hart (1986).

[70] Jessica Sternfeld, *The Megamusical* (Bloomington, 2006), pp. 239–40.

[71] Ibid., p. 240.

[72] Banfield, 'Stage and Screen Entertainers in the Twentieth Century', p. 79.

[73] Here Banfield is referring to C. Osborne, 'The Broadway Voice: Just Singin' in the Pain', *High Fidelity* (January and February 1979): pp. 57–65 and 53–6.

line. There is a desire for a certain roughness or noisiness of timbre and production to represent the rock sound of urban rebellion and a working class aesthetic that is characterised by a vocal technique that sounds rougher, less controlled, and less practised.

In 1972, just after *Jesus Christ Superstar* had opened, *Grease* opened.[74] The music is nostalgic reflecting the 1950s setting and the idealised innocent fun of a youth culture enjoying rock'n'roll. This musical retains the two pairs of lovers, the innocent girl and more experienced boy, Sandy and Danny, and the raunchy sexually active pair, Kenickie and Rizzo. Although this casting and the structure of the musical is typical of earlier musical theatre, the musical language derives from pop and rock'n'roll. All the female parts are pitched in the chest register, though Sandy is introduced in a bright waltz 'Look at me I'm Sandra Dee', while Rizzo's big solo is the slow rock number 'There are Worse Things I Could Do'. Danny has the pop-rock numbers with the men, 'Greased Lightnin'' and 'Sandy', before the lovers are united in style and song in the disco-pop 'You're the One that I Want'. All these songs require a pop-rock sound and the ability to belt.[75]

At the same time as musicals using contemporary pop and rock music were being introduced, other musicals continued to use what might be regarded as the vocal conventions of 'golden age' musical theatre which also continued to develop. Here, too, there is an enormous range of music that requires different approaches to singing. Stephen Sondheim is perhaps the most important single composer of musical theatre in the second half of the century.[76] His songs are immensely complicated musical and textual compositions that require a strong technique, a large vocal range, and exceptional articulation and clarity of rhythm. They are also immensely detailed character studies that draw on a range of musical theatre styles and form an important part of the contemporary repertoire.

Older characters tend to sing in lower ranges and younger ones in higher ranges, with the older women's ranges being similar to the higher range of the tenors; as Stephen Banfield notes, 'to a certain extent this is a practical matter where singing actors are concerned, for the male and female ranges are not very different from one another in many popular singing traditions'.[77] So, in *Follies*,[78] 'Broadway Baby' and 'I'm Still Here' are songs set in a chest register for older women characters requiring a throaty or husky timbre, while 'In Buddy's Eyes', a memory by the older woman of her younger self, is a much more sustained mezzo-soprano ballad. Here is a development of the vocal ranges of characters from *Show Boat* representing a continuation of the vocal patterning of musical theatre. It is

[74] By Jim Jacobs and Warren Casey.

[75] A recent article by Julie A. Noonan, 'Popular Voices: Amplification, Rock Music and Vocal Quality in *Grease*', *Studies in Musical Theatre*, 3/2 (2009): pp. 185–200, analyses the vocal performances in *Grease* at much greater depth.

[76] One of his works will be discussed in more detail in the next chapter.

[77] Banfield, *Sondheim's Broadway Musicals*, p. 183.

[78] Stephen Sondheim and James Goldman (1971).

also a pragmatic situation in which younger performers are using a fuller and higher range when their voices have innocence and flexibility and signify youth and a carefree agility, while the older characters have a more idiosyncratic husky or throaty vocal timbre and a more limited, lower range.

Vocal Cry and the 'Money Note'[79]

Michel Poizat discusses the moments in opera when the soaring voice drives all other thoughts away and moves the listener to a thrill or shiver of musical ecstasy.[80] He charts the development of the operatic voice through its history from 'verbal expressions of emotion to such wordless outbursts as Lulu's final scream at the end of Alban Berg's opera',[81] a trajectory in which 'singing grows more and more detached from speech and tends more and more toward the high notes; and culminates in the pure cry'.[82] This is a response to the visceral expression of climax, whether of life or death, in the vocal and emotional excess of the singer's voice at moments of musical and dramatic climax. Poizat argues that the extremity of emotion occurs at moments when the singer and the listener are both removed to the extent that the voice appears to be pure voice, pure sound, and both singer and listener disappear, becoming pure ecstatic voice.[83] Like the infant's cry the singing voice manipulates itself into an object, a symbol of suffering, need and frustrated desire.[84] This dissociated voice is always closer to the condition of a cry than of an articulate communication because the cry is pure utterance. It has the force of speech in excess of its recognisable and regularising forms. So the cry is argued to be excessive of semantic content and instead is regarded as the pure voice. For Poizat the force of the cry becomes embodied in the voice of the soprano as a soaring, inhuman power, the subject of boundless longing and the object of fetishised desire. These excessive, high moments in musical theatre are sometimes referred to in the commercial jargon as the 'money notes'.

In Poizat's argument there is not a rift, but a tension between pleasure and jouissance; pleasure results from a mastery of the pursuit of gratification, while jouissance results from the impossible quest, beyond the limits of absolute

[79] The money note is a colloquial term for the high, climactic notes in a song that stir the audience to rapturous applause and send shivers down the spine. It could be argued that these are the moments that encourage the audience to spend its money on seeing the show or buying the recordings.

[80] Michel Poizat, *The Angel's Cry* (Ithaca and London, 1992), pp. 3–4.

[81] Ibid., Cover note.

[82] Ibid., p. 40.

[83] This argument is based on the premise that the operatic voice becomes disembodied as a voice-object at these extreme moments, an argument that will be debated in a subsequent chapter.

[84] Connor, *Dumbstruck*, p. 33.

transgression.[85] He relates this to the sound of the Beatles; 'you will be struck by those voices of the Beatles, very high voices, almost head voices, a genuine call for the cry, a call that is heard and resoundingly answered by the thousands of cries and piercing screams of teenage girls'.[86] In musical theatre this moment of 'cry' or the 'money note' occurs to some extent in the climactic high moments of songs by sopranos and tenors in the operetta tradition, and can be understood, for example, in the wordless vocalise of hero and heroine in *The Light in the Piazza*.[87] It is also heard in the high rock tenor falsetto or full voiced screams for example by both Jesus and Judas in *Jesus Christ Superstar*,[88] or by Buddy in 'Buddy's Blues'[89] and in the high belt notes of the lower female voices throughout the musical theatre canon. So the focus on verbal communication through 'natural' or speech pitched delivery disappears again in the signification of emotional excess and the pleasure or bliss in its audition.

Finally, though, Cavarero describes how the voice reveals the sex of the singer, but that one of the essential pleasures of opera is the confusion and confounding of gender in melodrama and the staging of drag.[90] Here the parallel with developments in musical theatre is impossible to resist, so that even though this chapter charts the movement from the acting singer to the singing actor and the increased focus on words and emotion, the high tenor cry and the soaring female soprano or the mezzo-soprano belt notes overlap in those moments of ecstasy and jouissance, removing gender and meaning and leaving only pure sound.

Conclusion

By the end of the twentieth century and into the twenty-first century musical theatre has moved away from the stereotypes of operetta. It has incorporated an enormous variety of popular styles, and consequently a variety of vocal timbres. However, there does appear to be an aesthetic that is sometimes called a 'musical theatre style' of singing. There are a number of requirements of the vocal technique the principal of which appear to be an understanding of a range of popular styles and the intonation and ornamentation they require. This is accompanied by the ability to communicate language clearly but not at the expense of musical effect, and the ability to use vocal timbre and accent to create exciting and inventive characterisations. The most important innovation, though, is the ability to communicate a range of emotions from plaintiveness and vulnerability to anger,

[85] Poizat, *The Angel's Cry*, p. 7.

[86] Ibid., p. 208.

[87] Music and Lyrics by Adam Guettel, Book by Craig Lucas (2005).

[88] Music by Andrew Lloyd Webber, Book and Lyrics by Tim Rice (1971).

[89] From *Follies* (1971). Music and Lyrics by Stephen Sondheim and Book by James Goldman.

[90] Adriana Cavarero, *For More than One Voice* (Stanford, 2005), pp. 126–30.

excitement and joy through vocal timbre and intonation, which includes moving beyond the limits of a *bel canto* style and incorporating sobs, sneezes, screams, laughter, belt and cry, and all the excesses and flooding out of vocal communication.

Developments in genre have had an enormous effect on the cultural understanding of timbre, intonation and pitch. These are all read through awareness of the wide range of music available to listeners, and each musical style has aesthetic and cultural associations. Musical theatre exists within this cultural framework, and singing styles or vocal representation reflects that, even while retaining a distinctive approach that relies on communication of character and meaning through popular forms, alongside the excesses of pure utterance that allow access to pleasure and jouissance.

Chapter 3

Integration and Distance in Musical Theatre: The Case of *Sweeney Todd*[1]

The first two chapters have explored how musical theatre texts and performances have signified from the late nineteenth century to the present, and in the first chapter there was the implication that the many signs in a musical theatre text might jointly signify a complex, parodic or satirical reading through the combination of signs. This is not the canonic version of the development of the musical theatre text, which argues that the musical has become increasingly 'integrated' in the course of its development. The term 'integration' and the concept of 'the integrated musical' are generally taken to imply that songs, dances and narrative work in parallel towards the same dramatic end. This might imply that the various parts of the performance text work together to produce a single, clearly discernible reading of a coherent narrative, in which music, dance and book over-code each other. However, since each medium signifies in a different way – neither music nor dance signifies through language, and the voice signifies as much through its other signifiers as through its semantic content – this could be considered problematic.

On the other hand, and as has been argued above, it is also possible that different parts of a multimedia sign can be disjunctive, presenting different aspects of a character, atmosphere or situation such that a more complex reading of a single situation is presented. This disjunction might include the use of flashback and narration, the use of dissonance, pastiche or word painting. The result is that the performance is read as a linear narrative peopled by psychologically coherent characters but the characters and situations can be more nuanced in their presentation and less stereotypical in their interpretation. This chapter and the next will challenge the idea of integration in musical theatre by exploring its meanings and analysing examples of practice.

This chapter will, first of all, review approaches to the idea of 'integration' that are current within the literature, and which are variously argued to stem from the structures apparent in *HMS Pinafore*, *Show Boat* or *Oklahoma!* There will be an initial exploration of the concept of 'distance'.[2] The focus will then turn to

[1] This chapter was originally published in *Contemporary Theatre Review*, 19/1 (2009): pp. 74–86. I am grateful to the editors for permission to develop the article here.

[2] Derived from Brechtian *Verfremdung;* literally 'making strange'. The Brechtian terms 'Verfremdung', 'Epic' and 'Gestus' will be outlined more fully in the next chapter.

several moments from *Sweeney Todd*[3] in order to explore the tensions between 'integration' and 'distance'. It is argued here that musicals that are regarded as 'integrated' present a coherent narrative, but that the narrative may be signified through individually disjunctive or alienating elements rather than a fusion or integration of elements. Therefore there is an open question as to the usefulness or accuracy of the term 'integration' in relation to this strand of musical theatre development.

Integration

Many writers of musical theatre history identify the development of the 'integrated musical' as a distinct strand in the development of the musical. For example John Bush Jones acknowledges Gerald Bordman, who he suggests rightly observes that 'American theatregoers were exposed to a rare, but not new, kind of musical theatre in which book, lyrics and music combined to form an integral whole'.[4] Interestingly he says this in reference to *HMS Pinafore* which he and Bordman regard as a significant influence on the development of the Princess Theatre shows of the second decade of the twentieth century in New York, and which has been argued above to contain satire created through the interaction of genres and expectations. In this history, *Show Boat* was the successor, as he suggests the influence appears to have been otherwise largely ignored in America at that time. Later, Jones states that *Show Boat* was the first large scale integrated musical 'in which song and dialogue work together to reveal the characters and tell their story',[5] and certainly my arguments in the previous chapters outline how music is conveying some parts of the narrative in its coding of musical genre and vocal type.

Peter H. Riddle points to the integration of the score and story in the Princess Theatre shows of Jerome Kern, Guy Bolton and P.G. Wodehouse. 'They established a format that was more tightly knit than the variety-show amalgam of the revue, and more approachable than the opulent, artificial old-world ambience of operetta.'[6] Riddle speaks of *Show Boat* following in that tradition in which the 'songs were a fundamental and essential element in the plot development'.[7] He clarifies what this means as follows: '*Show Boat* carried the concept of plot/music fusion to a new level. Each of its musical numbers flows naturally out of the preceding dialog and action. Not only do they convey and drive the tale, they

[3] Music and Lyrics by Stephen Sondheim and Book by Hugh Wheeler, *Sweeney Todd*, 1979.

[4] Jones, *Our Musicals, Ourselves*, p. 10.

[5] Ibid., p. 76.

[6] Peter H. Riddle, *The American Musical: History and Development* (Ontario, 2003), p. 40.

[7] Ibid., pp. 48–9.

provide the audience with insight into the characters' lives and thoughts.'[8] This is an interesting idea; musical numbers are responsible for driving the story, which implies an energetic movement through time, and also for giving insight into characters' lives and thoughts, which necessarily implies a slower pace of time passing, or even a hiatus while that moment halts the story's progress. While all this is certainly possible, it raises a question about the word 'natural' to describe the moment when a character breaks into song, and the word 'fusion' to describe a combination of media that signify in ways that are clearly quite complicated in their relationship to each other and to interpretation.

Andrew Lamb describes how *Show Boat* 'brilliantly integrated vernacular song and dance, as well as anticipating film techniques in its use of underscoring of dialogue'[9] though there is no example given of the application of this. There is, however, a dissenting voice. John Graziano allows that many people point to *Show Boat* as the first musical to integrate songs and book, but he refers to Kern's music for the show as a 'pastiche', and the structure of the show as 'an epic', in which music represents time periods and characters.[10] Clearly this is a different understanding of a musical score that supports moments in the story, but in which numbers might individually be quite diverse, and is certainly more in line with the arguments about vocal style, range and character presented in Chapter 2 above. So a more complex understanding of the situation might be that the score could be composed of diverse individual moments but that each part is related to the linear development of a single plot and the coherent representation of character. I will return to this thought later.

Jones then traces this strand of the musical through *Pal Joey* and *Lady in the Dark* to *Oklahoma!*[11] in which he suggests songs, dances and even orchestrations move the action along and develop the characters.[12] For Lamb, *Oklahoma!* is regarded as a development of the pioneering *Show Boat*, with 'credible everyday characters living ordinary lives and speaking everyday language'[13] despite the fact that they express themselves in song and dance. Jones describes the choreographic innovation of Agnes de Mille, 'who used the all-American language of the square dance to express the characters' feelings' so that this musical 'firmly established the integrated musical on the American stage'. He summarises the importance of this achievement as follows: 'What Kern and Gershwin had experimented with as far back as the 1920s – a piece that was not just a collection of catchy numbers, but

[8] Ibid., p. 49.

[9] Lamb, *150 Years*, p. 171.

[10] John Graziano, 'Images of African Americans: African-American Musical Theatre, *Show Boat* and *Porgy and Bess*', in William A. Everett and Paul R. Laird (eds), *The Cambridge Companion to the Musical* (Cambridge, 2002), pp. 63–76. This reference p. 75.

[11] Jones, *Our Musicals, Ourselves*, p. 140.

[12] Ibid., pp. 142–3.

[13] Lamb, *150 Years*, p. 257.

a fusion of drama, song, and dance – became a reality in 1943.'[14] It is apparent in all these discussions that the idea of fusion within what is regarded as an integrated musical has taken hold and become the accepted understanding of the development of musical theatre represented in the literature.

Jones continues the theme by exploring how geographic place and time contributed to the integration of all the elements giving a sense of 'authenticity' in *Fiorello* and later *Fiddler on the Roof*.[15] He also continues to trace the development of integration into the work of Stephen Sondheim when he suggests that *Sunday in the Park with George* is 'arguably the twentieth century's apotheosis of Richard Wagner's vision and goal of the *Gesamtkunstwerk*, the theatrical work in which nothing exists purely for itself without connection to the whole'.[16] He explains that Seurat forced viewers to collaborate with the painting in order to fully appreciate it. Similarly, Sondheim and Lapine wrote a musical in which the audience 'had to collaborate – to meet the show halfway', making the audience 'the ultimate collaborator'.[17] This understanding of the idea of integration is rather different from earlier ones in allowing that multiple voices create a whole that is actively interpreted rather than that all elements are fused in telling the story through realistic characters and situations, and implying a passive readership.

I don't dispute the direction that these histories document, or the drive for some sense of coherence and continuity between the elements of the musical in the presentation of a narrative and in the development of characters. What I want to explore is what might be meant by 'integration' and whether that understanding of integration is consistent with what occurs in performance.

In the arguments above there are already a number of different views within the historical development of the idea of integration, but the consensus appears to be that all the elements of the musical, which at various stages might be argued to include music, book, lyrics, orchestration, dance, underscore, and finally even the audience's understanding of the performance, are linked in a common endeavour to present a coherent development of plot and character. One could either argue that this is a heavily over-coded form, or that each of the constituent elements of music, dance, lyrics, plot, performance and so on, offers a different perspective adding up to a single understanding of the combination of all the parts. It is in this sense that I return to John Graziano's reading of the score of *Show Boat* as a pastiche and the form as epic, because there is no reason that these two ideas are incompatible if one understands integration as a combination of materials that jointly signify through their different media and genres. It is this proposal that has been developed in recent writing about integration in musical theatre.

The two main elements Jones points to are that musical numbers can compress time in moving a scene forward more quickly than dialogue can; and that the

[14] Jones, *Our Musicals, Ourselves*, p. 258.

[15] Ibid., p. 198.

[16] Ibid., p. 295.

[17] Ibid., p. 296.

dramatic and emotional power of a reprise links two moments in the story, a device that can be used for chilling irony.[18] Ann Sears contributes to this understanding in identifying the importance of the song reprises of 'Surrey with the Fringe on Top' and 'People will Say We're in Love' in *Oklahoma!*[19] These ideas will be further developed in the next chapters, but they suggest that the different media, different constructions of time and the potential for intratextual reference contribute to musical theatre's ability to communicate complex ideas, and to be read in multiple ways, though they mitigate against the idea of linearity.

In the cover note to *The Musical as Drama*, Scott McMillin suggests that 'until recently the musical has been considered as either an "integrated" form of theatre or an inferior sibling of opera'.[20] His argument is that neither of these views is accurate and that the musical has maintained a connection to the 'disjunctive and irreverent forms of popular entertainment from which it arose a century ago'.[21] He argues that the musical requires the suspension of the plot for the song. This necessitates an alteration in time structuring during songs that opens the possibility that each medium – dance, song, music and dialogue – explores different aspects of the action and the characters.

In the introduction I referred to D.A. Miller's view that the through-composed musical destroyed the structural opposition between narrative and number that provided one of the pleasures of musical theatre.[22] I would argue that the through-composed musical is also composed of individually disjunctive elements; even though *Sweeney Todd* is not through-composed, the examples I draw on below can be found in through-composed musicals. However, here again there is an understanding that musical theatre signifies through disjunction and juxtaposition as much as through continuity and over-coding.

The most developed analysis of the failure of integration in a golden age musical is offered by Dan Rebellato in relation to *Kiss Me, Kate* in which he argues that '*all* musicals, integrated or otherwise, may be involved in a psychical libidinal battle between restraint and order and there can be no prior determination that the libidinal energy of the songs can be integrated neatly into the narrative'.[23] He argues that in the end it is irrelevant to worry about the theatrical frames and the anachronistic references in *Kiss Me, Kate* because 'they only become problems if one insists that the show is an integrated musical because then it has to obey rules that it blatantly is not obeying'.[24] Instead he suggests that by opening a space for the vulgar, the double-meaning, the libidinal semiotic, 'the musical

[18] Ibid., p. 76.

[19] In Everett and Laird, *The Cambridge Companion*, p. 125.

[20] McMillin, *The Musical as Drama*, front flap.

[21] Ibid., front flap.

[22] Miller, *Place for Us*, p. 57.

[23] Dan Rebellato, '"No Theatre Guild Attraction are We": *Kiss Me, Kate* and the Politics of the Integrated Musical', *Contemporary Theatre Review*, 19/1 (2009): pp. 61–73.

[24] Ibid., p. 72.

offers pleasures that are fundamentally independent of its narrative'.[25] This idea of the musical as joyously excessive and voluptuous has already been established in the discussion above of the excesses and flooding out of vocal sounds and will be developed further in subsequent chapters.

Raymond Knapp also suggests a potential double reading, separating the acted character and the musical emotion, which allows the audience to be aware of both performer and character simultaneously.[26] This is similar to the operation of distancing that Brecht discussed in relation to his epic theatre, in which the audience was expected to be aware of the performer demonstrating the role and telling the story, rather than believing that the actor *was* the character. 'The peculiarity of the artist watching himself, which is an artistic and ingenious act of self-alienation, prevents the total identification of the spectator ... and brings forth a wonderful distance from the events.'[27]

Alienation

In the notes to *Mahagonny*[28] Brecht listed the distinguishing features of the dramatic form – which, he argued, sought an emotional response to the drama – and the epic form – which sought a rational response. The epic theatre is designed to distance the spectator so that s/he is forced to consider the actions of the event and learn from them. In these notes Brecht called for a radical separation of the elements so that each commented on the others. Although Brecht developed these ideas with a political and educative function in mind, the ideas themselves were not new, and nor are they only used with political intent.

Marvin Carlson identifies an early source of the idea of making strange (*Verfremdung*) in Aristotle's *Poetics*[29] in which the poet was obliged to make familiar language unfamiliar by the use of metaphor, ornament, and strange or rare words. Francis Bacon is reported to have advised the use of 'estrangement' and the German Romantics and Russian formalists speak of the importance of making a subject strange, or making the familiar strange.[30] There is a similar situation with the separation of the elements in 1920s Russia; *The Oberiu Manifesto* contained the suggestion that 'there should be no attempt to subordinate individual elements;

[25] Ibid., p. 72.

[26] Knapp, *The American Musical*, p. 12.

[27] Brecht quoted in Erika Fischer-Lichte, *The Show and the Gaze of Theatre* (Iowa City, 1997), p. 36.

[28] In *Bertolt Brecht Collected Plays*, ed. John Willett and Ralph Manheim (London, 1979), vol. 2, pp. 87–90.

[29] Carlson is referring to Chapter 22 of the *Poetics* in *Theories of the Theatre* (Ithaca and London, 1993), p. 385.

[30] Ibid., pp. 385–6.

they best advance the scenic plot if they remain autonomous and of equal value. Their conflicts and interrelationships are the basis of theatre'.[31]

Brecht used the separation of the elements and *Verfremdung* to maintain within the audience a conscious intellectual engagement, but the devices of distancing can be used in other ways and without political intent, and, as Knapp and others have identified, the use of song in musical theatre allows the audience to be simultaneously aware of the musical atmosphere and emotion, and of the performer singing. This argument, that separates song from scene so that each allows different aspects of plot or character to be revealed, highlights the artificiality of musical theatre. The musical simultaneously signifies itself as 'authentic' or 'realistic' and is written in ways that promote the idea of integration and the suspension of disbelief, while in fact being disjunctive and diverse. Knapp develops this idea in relation to the concept of 'camp', arguing that

> audiences not only relish the heightened dramatic effect that song can create, but also seem to need the comforting artificiality that comes with it … The inherent exaggeration of interpolated song allows audiences to experience more deeply the dramatic situation and characters on stage because music, singing, and often dancing decisively remove that situation from anything even remotely like the real world.[32]

His conclusion is that artificiality provides 'protection from the dangerous, potentially destructive effect of emotions felt too deeply'.[33] This disjunction is read by some as authentic emotion but by others as high camp: the vocal cry of, for example, Jesus in 'Gethsemane' could be heard as the overwhelming 'flooding out' of the emotional reality of the moment, the authentic re-creation of rock performance, or the excessive and enjoyable camp produced by the musical and vocal expression of the song's climax. This combination allows audiences to perceive the performance and empathise with the character while retaining individual levels of separation and enjoying the pure sound of the cry.

Music also offers the opportunity for the composer to explore alienation caused by the disruption of expectations within tonal harmony or by setting up certain expectations that are not then followed through. Certain genres have associated structures, timbres and harmonic frameworks, certain chords require resolution and repetitive musical patterns set up expectations of similarity and difference. In tonal harmony, whether or not one is able to describe the event in words, there are grammatical structures, just like those in language, that are aurally recognised by most people that imply certain consequents. L.B. Meyer argues that while we don't fully anticipate the conclusion of a phrase, if the expected pattern is

[31] Ibid., p. 361.

[32] Knapp, *The American Musical*, p. 14.

[33] Ibid., p. 14.

not forthcoming there is an emotional and an intellectual response.[34] Just as an unfinished phrase or a word that is out of context leaves the reader perplexed, the same is true for the listener to music. I have argued elsewhere that Eisler and Weill made full use of the possibilities of upsetting musical genre and continuation to confound expectations and disrupt identification and therefore create a complex reading.[35] But does a complex and multi-layered reading necessarily mean that the elements are not integrated? Rather, might integration in musical theatre be more complex than is suggested by the notion that the elements of the musical support a single reading?

Stephen Sondheim's Works

Non-linear narrative structures can have a distancing effect, disrupting identification with plot and character and creating an emotional distance between performance and audience. Sondheim's work is littered with examples of the disruption of linear time, as in *Merrily we Roll Along*, with the plot unfolding backwards,[36] *Follies* in which the characters appear alongside their former selves, and *Assassins* in which a group of assassins drawn from 1865 to 1981 come together. Or there is the jump in historical period in *Sunday in the Park with George* from the 1880s to the contemporary world of 1984. Expectations of narrative structure are also explored in *Into the Woods*, though in this case it is the audience expectations of the plot that are challenged, again causing a disruption and a distancing effect. Other works, such as *Pacific Overtures*, *Sweeney Todd* and *A Funny Thing Happened on the Way to the Forum* are set outside the contemporary world, drawing on the potential for audiences to romanticise and exoticise other worlds and times. This encourages empathy with romantic characters and situations in an 'integrated' world, but creates distance from a sense of identification with everyday heroes. The result of these devices is that audiences are challenged to become aware of the themes of these works, and, following Knapp's argument, are also able to experience the situations more fully.

Narration, which occurs in many of Sondheim's works such as *A Funny Thing ...*, *Into the Woods*, *Assassins*, *The Frogs* and *Sweeney Todd*, distances the audience from identification with the story by placing a frame around the story, and instead creating a point of contact between audience and narrator. It is clearly present in *A Funny Thing...*, which offers Pseudolus the opportunity to comment on the story and join with the audience in a complicit relationship; pointing to the experience of audience involvement with performer rather than the empathetic identification with character. In *Into the Woods* the place of the narrator becomes

[34] Leonard B. Meyer, *Emotion and Meaning in Music* (Chicago, 1956), pp. 25 and 46.

[35] Millie Taylor, 'Collaboration or Conflict: Music and Lyrics by Brecht, Weill and Eisler', *Studies in Theatre and Performance*, 23 (2003): pp. 117–24.

[36] There will be more analysis of this device in the next chapter.

increasingly complicated as the characters turn on him and move outside the frame he has created. This is an astonishing and complex moment of transition in which the separation of the world of the performers from that of the audience is challenged, and the distance created by the narrator is anarchically overrun. The audience, which had been engaged in an interaction with the narrator in watching the story, is suddenly left bereft of the explanatory and distancing voice. Shocking events happen, to which the audience is brought terrifyingly close, before the final company chorus of 'Into the Woods' replaces the 'story-telling' frame and allows the audience to return to its distanced position.

While *Into the Woods* has a solo character as narrator, others have a chorus as narrator. This is true of *Assassins* and *The Frogs* as well as *Sweeney Todd*. In these cases it is not only the commentary that creates distance, but also the use of direct address that changes the mode of delivery and alters the relationship between audience and performance. There are also musical considerations in the use of a chorus, which at the very least increases the dynamic range and allows for spectacular climaxes and a greater variety of musical textures. The choral commentary not only provides a distanced view and separation from the story but an experience of either a massed monophonic sound or a polyphonic texture.

In all of these cases, the end result is a complex understanding of the characters, situations and events of the story, and often a perspective on them suggested by the framing lens of music and performance. That is not to say the elements are not 'integrated' in creating a coherent performance world, but that the interaction of the elements of the musical and dramatic worlds is more complex than the general use of the term – with its connotations of over-coding or fusion – might imply. The book musical is likely to include disjunction and disruption between the elements in the creation of its narrative, therefore manipulating its audience's reading between emotional involvement with characters and situations, and distanced awareness of wider issues and events or reflexive reference to other materials.

This distanced awareness of reflexivity may, in fact, be one of the sources of musical theatre's popular success: because of its in-built capacity for disjunction and disruption the musical has the potential to be anything from high camp and escapist entertainment to a biting commentary on contemporary events and morality. And both these extreme types of musical theatre could be argued to be 'integrated' if the plot and characters are coherently presented, and an understanding of a perspective for reading the performance as a whole is generated. So perhaps the term has been so widely and vaguely used as to render it meaningless or at least imprecise, and, since music, words, actions and voices all signify in different ways, perhaps the unique potential of the musical is to suggest complex ideas through disjunction and disruption as well as through concord and unity. Both of these might be considered unified in their narrative aims or themes.

Sweeney Todd

The version of the story of *Sweeney Todd* used by Stephen Sondheim and Hugh Wheeler was developed from Christopher Bond's play. It contains elements that might be considered as signifying 'integration', and others that might be regarded as alienating. The tension or interaction between these two possibilities produces a coherent narrative that is simultaneously engaging and emotionally involving, while remaining comic, melodramatic and grotesque.

In *Sweeney Todd* there is a mix of features that might be regarded as either the techniques of integration or distancing devices. One might loosely regard the use of underscore, the use of leitmotif, the use of genre pastiche, mickey-mousing[37] and sound painting, as the tools of integration, though on occasions all can be argued to create distance. The use of verse structures and repetition are clearly more reflexive, though both can contribute to the development of character and narrative. More clearly distancing are the framing of the story with narration, the use of dissonance and disruption of themes, the overwhelming coincidences of the melodramatic story and the grotesque characterisations. I will give examples of these features below, but the problem remains that the presence of integrative features only creates moments of continuity for the character and moments of identification or empathy for the audience, which are constantly disrupted by other features.

The use of underscore helps to mitigate the transition from unaccompanied speech to accompanied song. The performer still takes a leap from speech to song, but the speech is already heightened because of the presence of musical accompaniment, and the musical continuity maintains a sound level and sense of unity between speech and song. This can be seen/heard in the opening scene of Act One. Anthony looks around London and sings of his pleasure at being 'home again' as there's 'no place like London'.[38] Todd responds and his position suggests a more cynical outlook, and then they continue their conversation in speech with underscore maintaining the mood and the musical themes. The Beggar Woman interrupts with her dissonant and coarse ditty, before Todd chases her off, still with musical accompaniment which is almost filmic in its depiction of mood and action. Again Todd and Anthony converse and the London theme returns. Even during Todd's soliloquy 'There's a Hole in the World like a Great Black Pit' which leads into 'There was a Barber and His Wife' and then returns to 'There's a Hole in the World ...', there are interjections from Anthony and short sections of dialogue. This easy movement between speech and song is made possible by the musical

[37] This is a term used in film music and is derived from the cartoon character whose name it assumes. It is used to describe the type of music that aurally depicts the physical actions of a character. Pantomime examples include the use of a staccato rising figure in time with the actor's steps to depict creeping or the use of percussion effects to render painless slapstick blows. This device is used less overtly in many film scores.

[38] *Sweeney Todd* No 2 and 2A Bars 201–62, Vocal Score pp. 25–31.

continuation and use of motif that suggests mood, atmosphere, location and character. It suggests continuity between speech and song that is extended by the use of speech pattern rhythms and speech pitch melodies for quite large sections of the sung music. Moreover, it sets the parameters for the musical so that audiences read the characters as 'natural' whether using speech or song.

However, there are exceptions to the experience of continuity that are clearly signified in the music and text. The Beggar Woman's interjections consist of a high-pitched, plaintive and dissonant plea for alms followed by a low-pitched jig, reminiscent of children's nursery rhymes but with a dissonant accompaniment and suggestive lyrics. Given their dissonance and disruptiveness as well as the coarseness of the verbal text, and the extreme vocal ranges, these interruptions are clearly intended to be shocking and alienating both for the characters and in breaking the mood of the scene so far. The extreme variations in language and vocal range could also be read as signifying madness. The disruption contributes to the narrative because it provides a catalyst for Todd to tell his story, and to suggest the seamier side of the narrative to be presented. Nonetheless it is disruptive to the atmosphere of the moment and contains within it disruptions of musical continuity and genre expectation.

Todd's solo song is less clearly disruptive, but the extended pitch range, the length of the solo song, the use of repetition pointing to an arch-like song structure, and the rise to a dramatic climax all separate it from the conversational scene. However, it also allows a longer and clearer opportunity to begin to understand Todd's background and state of mind. This is less obviously distancing, since the song grows gradually out of the situation and musical themes, and contributes to the understanding of situation and character, but the presence of repeated words and lines, especially the word 'beautiful', the structure of the song with repeated sections and an overall arch shape are all reflexive reminders of the theatrical illusion, and the artifice of musical performance. Carolyn Abbate has argued that the use of diegetic or phenomenal song is always a reflexive reminder of the act of performance and the theatricality of the musical theatre event itself, causing a disruption in identification with the narrative.[39] So, although the song grows out of the scene and uses many techniques of integration, like underscore, continuity of atmosphere and mood, gradual increase of pitch range and movement beyond the rhythm of speech, and a textual exposition of the character within a plot situation, the nature and structure of the song still retains a sense of formality and distance. This is, of course, a useful feature, since Todd becomes distanced from Anthony and the audience in his memory of the experience, isolating himself in a move to a remembered world. So a musical device that might be considered reflexive and therefore a distancing feature is used here to contribute to the way the story can be told, by separating important moments from the rest of the fabric of the text.

Other operatic and filmic devices are used in the score that contribute to the sense of a complete world of performance; these are leitmotif, sound painting

[39] Abbate, *Unsung Voices*.

and mickey-mousing. The use of leitmotif occurs throughout the score and is profoundly important in interpreting this work since themes are closely related to characters and audibly transform from one song to another. The use of leitmotif has been documented by Stephen Banfield in *Sondheim's Broadway Musicals*.[40] Suffice it to say here that leitmotif guides the listener through the performance, providing atmospheric associations with characters, and reminding the audience of earlier moments in the story.

Sound painting is the use of a musical phrase that sounds like the object it imitates. Three obvious examples are: the mimicry of the bells of London in the accompaniment to 'No Place like London',[41] which acts as a leitmotif for the difference between Anthony and Todd; the factory whistle that occurs at the climax of the narrated Prologue as the word 'Sweeney' is repeated in rising and increasingly dissonant and high pitched chords,[42] and which links the whistle to this almost screamed sound in the narration at the point of Sweeney's acts of homicide; and the birds that Johanna sings about and that appear to accompany 'Greenfinch and Linnet Bird'.[43] In each case these are atmospheric features and contribute to the sense of place at the same time that they provide a mood for the character and action. But they are not sound effects; they are musical devices that are read as signifying these things. As an audience we are accustomed to reading them and so they appear to create an integrated world, but, of course, like the reflexivity that arises from the structures of song, the world that is created by a reproduced bell sound on orchestral instruments is subtly different from one that is created by hearing a bell chiming in an exterior location. Some of the bird sounds are reproduced electronically and then fade,[44] but others are the product of ornamented figures on the woodwind that fit rhythmically into the tempo and pitch of the song. There is a bird seller on the street, so the sounds are integrated into the narrative and are symbolic of Johanna's situation, but the reproduction of the sounds instrumentally simultaneously creates the integrated world of the performance, provides an atmospheric accompaniment to the song, and offers a reflexive reminder of the illusory and artificial nature of the performance.

The clearest examples of mickey-mousing, though there are many in the score, occur in Mrs Lovett's song 'The Worst Pies in London' in which each action has a

[40] Banfield, *Sondheim's Broadway Musicals*, pp. 292–307.

[41] For example in Todd's melody and the accompaniment at No 2 & 2A Bars 7–8 and 13–14, p. 20, and repeated in the melody at Bars 212–13, p. 27. The motif appears in the accompaniment in the first four bars of the section (p. 19). It could be argued to relate to other motifs that appear throughout the score in melody and accompaniment.

[42] The climax/scream is at No 1. Bar 130–5, pp. 14–15. The rising chord sequence begins at Bar 114, p. 12 and continues to the climax.

[43] As, for example, in the introduction to No 6 Bars A–E, p. 62 and again in the flute figures at Bars 4–5 and 15, pp. 62–3.

[44] Stephen Sondheim and Hugh Wheeler, *Sweeney Todd*, Vocal Score (New York, 1981), p. 62.

musical correlate interrupting the flow of the song. These actions include sticking the knife in the counter, pushing Todd onto a stool, grunting, spitting, smacking and flicking, and, in the second verse, pounding and rolling the dough to make a pie. These are tightly choreographed actions that require detailed rehearsal, and which the audience applauds as a technical feat, but which are simultaneously read as contributing to the representation of Mrs Lovett's world and to the black comedy. Both mickey-mousing and sound painting, therefore, contribute to the sense of an integrated world in which music contributes to the creation of atmosphere, even while they are clearly seen and heard to be moments of technical artistry and artifice which the audience simultaneously reads, passively enjoys and enthusiastically applauds.

Much more clearly distancing is the use of a story that is already known; the story of *Sweeney Todd* is based on a true story about Benjamin Barker that became an urban myth. The story of *The String of Pearls* appeared as a nineteenth-century serial that introduced Sweeney Todd in print[45] and may later have provided source material for many literary and dramatic representations. It may have influenced Christopher Bond's version that provided the source for Stephen Sondheim and Hugh Wheeler. There is always, therefore, a sense of re-presentation in the telling of this story which contributes to the creation of distance from involvement. Moreover, the framing of the story with narration as prologue, epilogue and interruption to events maintains awareness of the performance frame and distance from emotional involvement. A significant example here is the interruption by the members of the chorus which alters the time frame and creates distance immediately after the Beadle has announced his intention of coming to Todd's parlour to be shaved. This interrupts the pace and tension that has just been created, and comments on the situation, reminding the audience of the prologue and the theatrical illusion. The next interruption by the narrators occurs after Todd has killed for the first time, and again interrupts and comments on the events, slowing the progression and disrupting involvement. The narration occurs again in the wigmaker sequence, which ultimately leads to Todd killing his own daughter. Again the effect is to interrupt identification and involvement and maintain distance and the awareness of black comedy, melodrama and the horror of the story.

Equally disruptive is the sequence of numbers that ends Act One, with 'Epiphany', Todd's soliloquy of vengeance, followed by 'A Little Priest', Todd and Mrs Lovett's comic waltz. The extreme difference in style of these two songs promotes a dramatic disruption of mood. The tension between Todd's desire for vengeance, the black comedy of the plans for its fulfilment and his ultimate tragedy is most clearly presented in this combination. At the same time there is incongruity between music and lyrics in 'A Little Priest'. As Steve Swayne remarked in

[45] I am grateful to an anonymous reader of the earlier version of this chapter for this information. The text of *The String of Pearls* was published in book form by Wordsworth in 2005. Anon., *Sweeney Todd or the String of Pearls: The Original Tale of Sweeney Todd*, Wordsworth Mystery and Supernatural (London, 2005).

'Remembering and Re-membering: Sondheim, the Waltz, and *A Little Night Music*', by the time it got to Broadway, the waltz had lost its scandalous overtones and had become a signifier of love.[46] This is in marked contrast to the lyrics in 'A Little Priest' which comically explore the potential of various professional people to be the most appetising pie-filling in Todd and Lovett's murderous project. This creates a genre contrast, as the waltz is used at the inception of a murderous collaboration – though Mrs Lovett also has other collaborations in mind. Both the contrast between the soliloquy and the waltz and the contrast within the waltz between genre expectation and lyrical content contribute to the disruptive effect, with the waltz undercutting the passion and rage of the soliloquy with a grotesquely comic song of shared purpose.[47]

Such contrasts permeate the score, and are characterised by the tension between involving the audience in Todd's emotions, and distancing it to appreciate the black comedy so that the ultimate tragedy is more clearly felt and understood. This tension can also be appreciated in the use of beautiful melodies at tense moments, such as 'These are My Friends' and 'Pretty Women', both of which are slow waltzes, and both of which occur as Todd plans and attempts to carry out his revenge. The former links Todd with the tools of his trade, to which he sings this love song. These were the tools used in the past to support his happy life and which therefore provide a contrast with his current use of the same tools for revenge. The latter links the Judge and Todd in singing overtly about pretty women in general, but drawing attention to the story of their love/lust for the same woman, Johanna's mother Lucy, and subsequently for Johanna herself and the murderous consequences of that passion. This contributes to the awareness of complexity in the story because it allows the audience to appreciate the melodies and be drawn empathetically to Todd even as the most heinous acts are being enacted.

The vocal ranges and styles can be read as signifiers of archetypal characteristics. Todd's vocal range and timbre is notably heroic in the high baritone range of the older hero, with many opportunities for lyricism in 'My Friends' and 'Pretty Women'. However, he also has black comedy in 'A Little Priest'. Both lyricism and comedy can contribute to the empathy that is generated and therefore to the tragedy of the work. 'Epiphany' allows the performer to communicate across a greater range of timbres and extended sounds than the heroic ideal. There is anger in the recitative-like sections during which he berates the audience: 'Come on! Sweeney's waiting! I want you bleeders! You sir! Anybody! Gentlemen, now don't be shy!' There are moments of tormented lament as he speaks of his need for vengeance in what Banfield and Hirsch describe as the 'Kyrie' motif of

[46] Swayne, 'Remembering and Re-membering', p. 262.

[47] 'Pretty Women' and 'A Little Priest' are discussed at greater length in Paul M. Puccio and Scott F. Stoddart's chapter 'It Takes Two: A Duet on Duets in *Follies* and *Sweeney Todd*' in Goodhart, *Reading Stephen Sondheim*. *Sweeney Todd* is discussed from pp. 123–6, though the whole chapter is interesting.

supplication,[48] before the final climax 'I'm Alive at Last, And I'm Full of Joy!' with its dissonant accompaniment and noisy violence. These moments move beyond signification to pure sound that offer a different type of libidinal excess to that identified by Rebellato in *Kiss Me, Kate* but still one that challenges the limits of signification through which the integrated narrative might be communicated. This final section of 'Epiphany' offers Todd his moment of excessive flooding out as the sound of the voice moves from meaning to intense rapture and ecstasy, and control is surrendered.

Johanna and Anthony sing in the accepted voices of melodramatic or operetta young love: soprano and tenor. Johanna's song 'Green Finch and Linnet Bird' is described by Stephen Banfield as 'operatic in its overladen verbal language … its touch of coloratura to imitate the birds and its classical accompaniment figure'.[49] Banfield also describes the discursive modulations as 'uncharacteristic' of Sondheim. In an operetta or melodramatic context, then, Johanna is vocally marked as the heroine in a song with a short cadenza and sustained climactic phrases, frequent changes of tempo or rubato sections and extensive modulation that suggest a romantic rhapsody. In contrast the words of the song describe Johanna's situation through her comparison of herself with the singing birds outside her window. She wonders how the birds can sing 'sitting in cages, Never taking wing?', and 'maddened by the stars'. In the middle section she wonders whether the birds are actually screaming. She does this in a vocal timbre that could move beyond the beautiful to the excessive vocal cry, before describing her own cage and the need she feels to adapt to her imprisonment by singing instead of having the freedom to fly. Here, as in Todd's apocalyptic soliloquy, is the expression of pure sound, beyond words, that can be read as song, cry, excessive emotion or madness, and perhaps prefigures the unlikeliness of a happy ending.

Anthony begins as the heroic sailor with all the connotations of a sailor's freedom and adventure that were discussed in Chapter 1 above, and singing in the tenor range of the hero. There is heroism in his opening exchanges with Todd who saved his life, and their vocal mirroring of the phrase 'no place like London' draws attention to their different moods and different vocal colours, though the phrase is sung at the same pitch. Anthony is the youthful heroic figure, and in his duet with Johanna, 'Ah, Miss', their voices come into monophony at the final phrase 'Look at Me' and 'Let me sing' when their eyes also meet. But their joy – and our reading of their loving union – is interrupted first by the Beggar Woman and then during Anthony's song 'Johanna' by the return of the Judge, her guardian. The return of the Judge links the Beggar Woman, Johanna and the Judge in a triangle of love, lust, rape and abuse.[50] The Beggar Woman, Johanna's mother, leaps dramatically

[48] Banfield, *Sondheim's Broadway Musicals*, p. 296 refers to Foster Hirsch, *Harold Prince and the American Musical Theatre* (Cambridge, 1989), p. 123.

[49] Ibid., p. 292.

[50] Whether you read the Beggar Woman's madness as illness or consequence of her rape and casting out by the Judge, the discovery that Johanna, her daughter, is potentially

between begging for alms in a soprano range – perhaps the vestiges of her former voice – and the coarse ditties she sings to attract trade at a much lower pitch and using a coarser, noisier timbre.

Anthony's aria that follows is also rhapsodic, sustained and lyrical – the tenor solo of the young lover, but it contains verbal references to stealing her, to the dark, and to being buried, albeit in her yellow hair. His vocal style and pitch fall into the accepted categories of operetta but are subverted by the lyrics and the melodramatic passion of the climax, and undermined by the interruptions of the Beggar with her grotesque and coarse language. There is a narrative reason for the interruptions, but they also undermine the view of the sailor as heroic, since they are a reminder of the reality of the sailor's life and the availability of prostitutes, the prevalence of danger and violence and so on.

Mrs Lovett is a comic figure and a manipulator for whom sympathy is much less desirable since it will be discovered that she contributed to the downfall of Todd's wife and daughter. However, the complexity is increased by making audiences understand and enjoy her outrageous comic excess. She is therefore created in music, lyrics and dialogue in a much more grotesque, but comically approachable, fashion. Her vocal range is mezzo-soprano, with many opportunities for her to use a parlando style or sing raucously, as in the squawks of the seagull in 'By the Sea'. This is typical of the vaudeville inspired, sexually active, older woman. Her opening number, 'The Worst Pies in London', institutes the idea of her as a comic figure; in it she bemoans the state of her life in short, broken phrases. The lyrics are in colloquial parlance, in which she intimates that cats would make good pie filling if she could only catch them. This pattern is continued in 'A Little Priest' the duet with Todd in which she suggests putting people into pies 'Seems an awful waste. I mean, with the price of meat what it is, When you get it, If you get it … Good you got it'. With the comic persona, the gritty language and the overt sexuality – revealed more clearly in 'By the Sea' – Mrs Lovett becomes a latter day and much more grotesque comic figure developed from the same mould as Adelaide in *Guys and Dolls*.

Later, it seems her maternal feelings for Toby become paramount during the more lyrical lullaby 'Nothing's Gonna Harm You' in which the longer flowing phrases of the melody allow Mrs Lovett to appear much more sympathetic. But this is undermined when it becomes clear that she was lulling him into a false sense of security so that she could lock him in the bakehouse and arrange his murder. In these ways she appears as a comic grotesque of the Victorian ideal of femininity and motherhood exemplified in this story by the idealised vision/ memory of Todd's wife and child.

The vocal ranges and styles of these characters contribute to the complexity of their presentation, but Todd has the music and the detailed character exposure that allows the audience to be drawn to him even while being alienated by the grotesque crimes and melodramatic situations. Yet again, this complexity contributes to the

subject to the same fate adds weight to a reading of Johanna as on the edge of madness.

understanding and involvement in the narrative, even as distance and comedy are simultaneously created.

Conclusion

But is *Sweeney Todd* an example of an integrated musical? Given the current use of the term I would suggest that it is, since all the elements support an understanding of a narrative, even if its being followed requires an active readership. However, what does become problematic is the correlation of integration with audience involvement since the story is clearly told using disruption as well as techniques of emotional engagement. It is the combination of, and movement between, distance and empathy that contributes to this musical's success. The plot/music fusion that Peter Riddle and John Bush Jones speak of is clearly not always present in this musical, though the narrative that results can be considered unified.

What this does suggest, though, is a narrative construction that is comprised of disruptions, discontinuities and gaps, and whose musical language uses and distorts genre stereotypes and vocal archetypes. The use of flashback, dissonance, pastiche and word painting, as well as sophisticated understanding of vocal genres and timbres, has contributed to a disjunctive and complex text. To return to consideration of Roland Barthes' pleasure and bliss, it is possible to speculate that reading and interpreting this sort of text may produce particular types of enjoyment in the reader based on their approach to the material, and may account for its lack of commercial success in its initial production. Pleasure is bound up with the consistently readable text, and since *Sweeney Todd* derives its style from melodramatic popular fiction there is a sense in which this text can be considered as satisfying and comfortable, espousing a morality where the killers are punished for their misdeeds. However, what I have tried to show in my analysis is that the text is more complex and that it can also discomfort and unsettle. There is the presentation of Todd as both victim and villain, of the Judge as righteous and god-fearing but evil, of Mrs Lovett as lovably comic, maternal and murderous, Johanna as heroine but caged and possibly on the edge of madness, and Antony as hero and kidnapper. All these characterisations, which are created through combinations of music, action, words and voices, open up gaps, cuts, losses and disruptions which have the potential to challenge the experience of narrative certainty. The reader is then free to explore and interpret such gaps that might impressionistically offer a reflection of a dystopian world, opening up themes of power and corruption, love and vengeance.

Alongside such thematic and character-based disruptions, the vocal cry, the musical flamboyance and the comic grotesquery contribute to the experience of overwhelming excess that might be conceived of as camp or bliss, but which is activated in moments within and between plot and characters, narrative and song. Thus is instigated the opportunity to explore what is made possible by acknowledging the disjunctive and alienating form of the musical that nevertheless

remains not only narrative, but also engaging and popular. In the next chapter these ideas will be further developed by analysing works that upset narrative continuity or create ironic comparisons within their texts.

Chapter 4

Layers of Representation and the Creation of Irony: *Aufstieg und Fall der Stadt Mahagonny*, *Merrily We Roll Along* and *The Last 5 Years*[1]

In Chapter 3 the questioning of the terms 'integration' and 'alienation' led to an understanding of how a linear narrative might be created through the use of individually disjunctive elements in the work, and how this might be read as pleasurable or blissful, excessive or camp. This chapter goes further in looking at how unstable signification or the juxtaposition of conflicting signs in the text as well as in performance can contribute to the creation of unstable characters and a potential for dialectical reading. The majority of this chapter will analyse *Aufstieg und Fall der Stadt Mahagonny* by Bertolt Brecht and Kurt Weill. At the end of the chapter, consideration will be made of two more recent works, *Merrily We Roll Along* and *The Last 5 Years* to identify some of the non-chronological structural strategies that are present in contemporary musical theatre and to explore how these structures might contribute to distanced and ironic readings.

As established above, multimedia texts are understood by interpretation of the various parts of the text as each is mediated by other(s). This suggests that analysis of a multimedia text must include reference to all its constituent parts and that there is the potential for non-congruence between the parts. Non-congruency can occur between simultaneously presented signs resulting in a vertical or synchronous non-congruence in a particular moment, or at different points within the work, leading to a horizontal or diachronous non-congruence. In addition, the use of musical or verbal leitmotifs can act as a reminder of earlier situations or actions, contributing to the potential complexity of representation.

There are particular difficulties inherent in the analysis of multimedia works in performance. There are two reasons for this; firstly, as seen in the previous chapters, there are signs acting simultaneously in more than one medium, each affecting the interpretation of the other(s), and secondly, in any performance text there is the potential for alteration or interpretation of signs as new information is offered during the course of the performance. Marvin Carlson raises the issue in 'Psychic

[1] A substantial part of this chapter was published in Gad Kayner and Linda Ben Zvi (eds), *Bertolt Brecht: Performance and Philosophy* (Tel Aviv, 2005), pp. 159–76. I am grateful to the editors for permission to develop this work here.

Polyphony'[2] that in any performance text there is the simultaneous presentation of signs in different media, and that those signs are present in the performance over different periods of time. Some signs remain present as props, in the costumes or as part of the scenic design while the state of the characters changes according to the literary text. The interpretation of individual signs varies as other signs with which they are juxtaposed alter. This presents the possibility that implied meaning at one point in time is disrupted by the introduction of another contradictory sign at a different time. Carlson compares the time frame of the *mise-en-scène* with the literary text, but, as has been seen above, even without including the *mise-en-scène* there are complexities in written texts where more than one medium is used and where the text is destined for performance. A character may be seen in one context, inspiring a supposition about the character that is called into question by later information.

In performance both synchronous and diachronous information is being interpreted by the reader simultaneously, and so a third dimension is created which incorporates both media across the time frame of the work to produce a complex reading based on the juxtaposition of signs both simultaneously and sequentially in both media within and without the text. There is an example in *Miss Saigon* where the beautiful singing of the girls at the wedding ceremony is overlaid by the firing of guns. This juxtaposition of love and war in the moment of the wedding – the vertical dimension – creates tension in the interpretation of that moment. However, the moment also prefigures the separation of the lovers which is already anticipated by an audience who knows the story – from *Madame Butterfly* – and heightens the dramatic impact of the moment through the reading of the combined text with the previous knowledge of the story.

Intertextuality, intratextuality and reflexivity all have an effect on the interpretation of the performance text. Intertextuality involves the incorporation of 'other' texts within the one being presented and has an impact on the reading of the text. Within performance this may include quotation, reference to other works, imagery or the presence of star performers, but it also includes genre awareness and understanding.[3] These ideas are developed in relation to the theatre by Marvin Carlson in another work, *The Haunted Stage*, in which he argues that 'every play is a memory play' because the relationships between theatre and cultural memory are so deep.[4] Intertextuality has also been the principle underpinning the arguments about genre, signification and archetypal patterns in previous chapters, since understanding of signs occurs as a result of repetition of structures and patterns from one work to another, one historical epoch to another, and one genre to another.

[2] Marvin Carlson, *Theatre Semiotics: Signs of Life* (Bloomington, 1990).

[3] For more information see Graham Allen, *Intertextuality* (London and New York, 2000), in which Chapter 5 relates most clearly to performance texts.

[4] Marvin Carlson, *The Haunted Stage* (Ann Arbor, 2001), p. 2. This aspect of reception will be returned to in later chapters.

Intratextuality is the reference to moments within the performance text, such as the reprise of musical motifs or recognisable sections of songs. This was referred to above in relation to the work of John Bush Jones and Ann Sears who suggest that the power of reprises is that they link moments in a story, an effect that can be used for dramatic irony.[5] As a structural device repetition can provide a sense of unity and completion, but it can also highlight the difference between one moment and another. In musical theatre, since repetition and reprises are a frequent part of the structure, this feature is particularly important.

Reflexivity has been referred to in Chapter 3 above, and refers to the moments where consciousness is raised of the act of performance.[6] In musical theatre, any mention of the fact of singing or speaking, or operatic or song structures, can draw attention away from the content and onto the performance and so disrupt the theatrical frame, the suspension of disbelief, and therefore the empathetic reading of the performance. It is not only mention of these devices, but the use of verse structures, musical styles or operatic gestures that are outside the expectations of the genre – and rely on cultural memory – that can draw attention to the performance rather than the content and act reflexively. Here there is an overlap between intratextual reference and one of its consequences, reflexivity. As was evident in *Sweeney Todd* above, the result of such devices can be complex or multiple readings of a text.

In order to explore the interaction of signs in different media in some detail I have chosen to begin by analysing an episodic work where I would expect to find some complexity in the presentation of material; *Aufstieg und Fall der Stadt Mahagonny* by Bertolt Brecht and Kurt Weill. In the notes to the work Brecht articulated some of the methods of epic theatre, the first result of which is 'a radical separation of the elements'.[7] Weill commented that the scenes are self-contained musical forms in which '[t]he music … no longer furthers the plot but only starts up once a situation has been arrived at'.[8] More importantly for the purpose of this discussion, '[t]his music is never in the least illustrative. It sets out to realise human attitudes in the various circumstances leading to the city's rise and fall'.[9]

To narrow the focus still further so that detailed analysis is possible this chapter will explore the representation of just one character, Jenny. There are other examples of complex interactions between media in the opera that challenge interpretation of the literary text but the characterisation of Jenny is particularly interesting since she is a principal protagonist who is presented as a survivor and

[5] In Chapter 3 reference was made to Jones, *Our Musicals, Ourselves,* p. 76, and Sears in Everett and Laird, *The Cambridge Companion,* p. 125.

[6] See Abbate, *Unsung Voices,* in which the use of reflexivity to create disruption in operatic texts is explored in depth.

[7] Bertolt Brecht, *The Rise and Fall of the City of Mahagonny and The Seven Deadly Sins,* trans. W.H. Auden and Chester Kallman (London, 1979), p. 89.

[8] Ibid., p. 92.

[9] Ibid., p. 94.

a victim of society. She is also a complex character using a greater variety of musical styles than any other character in the opera. The score referred to here was published in 1969, edited by David Drew.[10] The production referred to is the Salzburg Festival production of 1998 which is available on DVD.[11]

Creating Distance

Brecht disliked what he termed 'culinary art'; that is art that allows the audience to be emotionally involved or to identify with characters. Rather he wanted the audience to be critically aware during the performance in order that the works could inspire political comment and social change. To achieve this he proposed a dialectical drama, later replaced by the title 'epic' theatre, which encompassed the techniques of *Verfremdungseffekt*, the distancing of the audience, and *gestus*.[12] Distancing was to be achieved by turning familiar objects into something peculiar, striking or strange. As Brooker says, 'the function of the *Verfremdungseffekt* is to puncture the complacent acceptance of character, motive, narrative, incident or resolution, as "fixed" and "unchanging" or "obvious" and "inevitable"'.[13] Thus it can be seen as integral to the more general concept of 'epic' theatre and related to *gestus*.[14]

Not only did Brecht encourage the audience to remain distant from the work through the techniques of epic theatre in writing the text, but he further encouraged critical engagement with the performance by creating tension between the action that is shown and the reality of a situation, *gestus*. The example Brecht gives is from Section Thirteen of *Mahagonny*, where the glutton eats himself to death, the effect of which was provocative at a time when people were starving. Here it is the juxtaposition of the event in the play with reality that causes the effect. In another example from the same opera, Jimmy is condemned to death for owing money for two rounds of drinks and a broken bar rail, while a murderer is seen to buy his freedom. Here two events within the play are juxtaposed to inspire comparison

[10] Kurt Weill, *Aufstieg und Fall der Stadt Mahagonny*, ed. David Drew (Wien, 1969). Jenny's part had been transposed and adapted for the 1931 Berlin production to be played by Lotte Lenya. Since the adaptations for Lenya are not integrated with what precedes or follows it, Drew has maintained the operatic version with the adaptations written for Lenya as an appendix.

[11] Video VLRM 030, RM associates/ORF, (1998). This is a problematic production since there is a lack of clarity between attempts at 'realistic' acting while singing and the functioning of the epic work, but it was useful in the opportunity it provided to observe the work in performance.

[12] Peter Brooker, *Bertolt Brecht: Dialectics, Poetry, Politics* (London, 1988), pp. 42–3.

[13] Ibid., p. 63.

[14] Ibid., p. 62.

with the social conditions outside the theatre. In both these cases a dialectical tension is created.[15]

Kurt Weill was concerned to some extent with the practical aspects of how the composer could help the performer to understand what was required in terms of performance and delivery. He suggested that the composer can create a basic *gestus* or *Grundgestus* by the rhythmic fixing of the text, but 'the specific creative work of the composer occurs when he utilizes the remaining means of musical expression to establish contact between the text and what it is trying to express'.[16] Weill wanted to move away from music that simply reinforced the dramatic situation or manufactured atmosphere and cultural setting. He believed that although music could not present psychological aspects of the character, it could elucidate events on stage by fixing a *gestus* so that a false representation of the action was not possible. The overriding concern of Epic Theatre and *gestic* Music is to create a dialectical relationship between elements to inspire critical thought, which, aside from the political purpose, has already been seen in action in the creation of satire in *HMS Pinafore* and complex characterisations in *Sweeney Todd*.

Aufstieg und Fall Der Stadt Mahagonny

Mahagonny consists of three acts divided into 20 scenes, presented as 'tableaux' juxtaposed to form a narrative sequence.[17] The plot concerns the creation, development and ultimately the fall of the city. The end of the city is sparked by the execution of Jimmy because he has no money, followed by demonstrations against rises in the cost of living. Jenny is a prostitute who arrives in the city in Scene 2 and works in the hotel/bar, Die Hier-darfst-du-Schenke – the As You Like It.[18] Jimmy buys her services in Scene 5 and thereafter they are often seen together.

[15] Meg Mumford, *Showing the Gestus: A Study of Acting in Brecht's Theatre* (Unpublished Diss., Bristol University, 1997) draws attention to the contradictions in the use of the term by Brecht during his career, in his work with actors, and by his collaborators, and to the conceptual, linguistic and translation difficulties that have affected study of the concept.

[16] Kim H. Kowalke, *Kurt Weill in Europe* (Ann Arbor, 1994), p. 493.

[17] Weill talks of 'twenty-one self-contained musical forms, each being a self-contained scene', Brecht, *Mahagonny*, p. 92. This includes the 'Benares-Song' that was omitted from the Berlin production and from Brecht's *Versuche*. David Drew suggests that it is musically of great importance, and that, while it may not merit a complete scene, it is justifiable as a coda to the trial scene. Kurt Weill, *Aufstieg und Fall der Stadt Mahagonny*, preface.

[18] It is suggested that the Americanism of the character names had become hackneyed; they were consequently replaced, though this was too late to affect publication of the piano score which retains the American names. John Willett in Brecht, *Mahagonny*, p. xii. However, the name of the bar was changed before the first production (Leipzig, 1930) and so appears in the piano score as the Hotel zum Reichen Manne (Drew in Weill, *Mahagonny*, preface).

Scene 2 begins with a projection 'Rasch wuchs in den nächsten Wochen eine Stadt auf, und die ersten 'Haifische' siedelten sich in ihr an' – 'Within a few weeks a city had arisen and the first sharks and harpies were making themselves at home'.[19] The stage directions say that Jenny and six girls appear carrying large suitcases, which they sit on to sing the 'Alabama Song'. The song is in English. It constitutes the entire scene, and is a set piece consisting of three verses and choruses.

The repetitive patterns, simple lyrics and obvious rhymes are all characteristic of popular cabaret song. However, the unusual word setting that stresses unimportant words disrupts the easy acceptance. The reference to the moon, a featured word at the start of the refrain of this song – as well as the American vernacular – is reminiscent of American popular song where love and romance take place beneath the moon. Among numerous examples are: 'When I Leave the World Behind',[20] which contains the lyric 'I'll leave the moon above to those in love'. Later examples include: 'Goodbye, Little Dream, Goodbye',[21] where at the end of a love affair 'the stars have fled from the heavens, the moon's deserted the hill', 'In the Still of the Night',[22] which contains the line 'Or will this love of mine fade out of sight, like the moon growing dim'.[23] Thus there is a dialectical relationship between the romance of the words and their use here, where the girls are looking for a new bar to sell 'love'.[24]

Alongside the reference to popular culture in the lyrics, the music also contains popular or cabaret idioms disrupted by ambiguous or unexpected harmony. The word setting of the verse is straightforward, with one syllable to one note, a small range and circular melodic patterns. The range is slightly above the pitch of speech but not particularly high. The accompaniment is in march time and has minim chords at the bar and half-bar in the bass and the off-beats in the treble. This

[19] Translation here is by W.H. Auden and Chester Kallman from Brecht, *Collected Plays*, 1979. Translations of songs are by Stern (no date) from the notes to the recording. These have been used because they do not attempt to fit the music and are therefore more faithful translations of the language. Weill, *Mahagonny*, p. 17.

[20] Irving Berlin, 1915.

[21] Cole Porter, 1936.

[22] Cole Porter, 1937.

[23] Song titles include: 'Blue Moon, Moonlight Serenade' (Glen Miller, 1939), 'Moonlight Becomes You' (Burke and Van Heusen, 1942), 'Old Devil Moon' (Harburg and Lane, 1946), 'Moon River' (Mercer and Mancini, 1961).

[24] Shuhei Hosokawa cites links between this song and 'Jungfernkranz' in *Der Freischütz* (Weber) that contain the relations of legal and congratulated marriage in *Der Freischütz* against illegal and condemned prostitution in *Mahagonny*. See Shuhei Hosokawa, 'Distance, Gestus, Quotation: "Aufstieg und Fall der Stadt Mahagonny" of Brecht and Weill', *International Review of the Aesthetics and Sociology of Music*, 16/2 (1985): pp. 181–99. This reference, p. 188.

pattern is a particularly common feature of cabaret songs of the period.[25] However, the harmony is disruptive of this identification. The bass oscillates between two chords, a tritone apart. The tritone is the most dissonant interval and particularly unexpected in popular music and so upsets the popular feel that the rhythm and the chordal patterns of the accompaniment set up. There is a pattern of soloist singing followed by a chorus echo that is a feature of musical theatre and popular music of the period. Here that expectation is disturbed by the introduction of dissonance in the chorus harmonies and in the accompaniment.

Already the opera/musical theatre question has been posed in several ways. The introduction to the song introduces the genre of popular song which acts reflexively as a reminder of performance, and as a metatextual irritant, since popular song is out of place in opera. Intertextual associations to popular songs are inspired both by the musical style and the language of the lyrics. Immediately, however, the popular song form is unsettled by the disruptive dissonance of the harmony.

The refrain has a melodic line characterised by wide leaps that flows up and down in question and answer patterns. This is a more romantic melody than the speech-based patterns of the verse, and follows the example of popular music in which the musical interest and the principal motif appear at the start – or occasionally the end – of the refrain. The pace of the melodic and harmonic movement is slow but is underpinned by an insistent rhythm that has associations with ragtime.[26] The whole refrain is accompanied by oscillating rhythms over a pedal chord, which could maintain its place in the popular repertoire, but is upset by the rest of the harmony that is often dissonant. The orchestration of the song uses instruments characteristic of a cabaret band: banjo – for the rhythm, especially noticeable on the off-beats – woodwind – particularly clarinet which has solo figures – and percussion. The vocal range is soprano, but the soprano of popular music rather than the high soprano of opera.

The effect of the popular music and American idiom, reminiscent of cabaret performances of the period, is to obscure whether Jenny and the girls are performing in a cabaret within the action – diegetic performance – or talking about themselves to the audience.[27] The presence of the large suitcase might

[25] For example, listen to 'Alles Schwindel' by Mischa Spoliansky (Berlin Cabaret Songs, Decca 452 601–2).

[26] Ragtime became popular in the early part of the twentieth century, beginning in America and spreading to Europe, and developing from African American music. It is characterised by four equal beats in the bass played in a 'stride' pattern which offsets the syncopated melody. The quavers or eighth notes in ragtime are each of equal length with two per beat, in contrast with blues which introduces a swing 'triplet feel' by splitting the beat into three.

[27] The term 'diegetic' is applied to singing or other performance that occurs in a musical theatre work by a character who can be heard performing a song by other characters onstage, in opera the term used is 'phenomenal' performance. McMillin, *The Musical*

suggest the arrival of the girls in Mahagonny, but even that could easily be read as part of a diegetic performance in the bar, and the Salzburg production maintains this uncertainty. Moreover, the soloist plus chorus of singers is a common line-up for cabaret. The beginning and end of the song is separated from the rest of the opera, and the musical genre also suggests a vocal timbre and singing style removed from the operatic world. This duality between diegetic performance and involvement in the narrative is a constant feature of Jenny's character and a reflexive reminder of the theatrical fiction. The dissonance in the harmony and the disruption of the popular form could also be read into Jenny's character, bringing awareness of the dissonance and instability in the character's life and work, even as it introduces Jenny as a theatrical performer and a new character with all the associations of being a performer of popular music in a world characterised by an elitist musical form.

Jenny's next entrance is in Scene 5, when she is introduced to the four lumberjacks and offered for sale. The reliability of Jenny is deliberately brought into question. When trying to raise her sale price to Jake from 30 dollars she says: 'Ich bin aus Havana, Meine Mutter war eine Weisse'.[28] But when, later in the same scene, she is asked her name by Jim she identifies herself as 'Jenny Hill aus Oklahoma'.[29] The contradiction within speeches is a device identified by Peter Brooker as an example of the working of 'epic' theatre. The actor is required to avoid the spectator identifying with individual sentences to show that the character is not a single, unchangeable entity.[30] The result of this is that Jenny's background is never fixed, but more importantly, everything she subsequently says is questionable. This becomes more apparent in Scene 6, where, to a sinuous saxophone and guitar accompaniment – both, incidentally, instruments of popular music – Jenny asks Jim how he wants her to dress and behave; 'Ich habe gelernt, wenn ich einen Mann kennen lerne, ihn zu fragen, was er gewohnt ist.'[31] She asks

as Drama, Note 1, p. 104 gives a full explanation of the development of the term from Plato and Aristotle to its use in musical theatre studies where diegetic elements are those perceived as performance by the characters onstage. The diegetic conventions in musical theatre are discussed by Banfield, *Sondheim's Broadway Musicals*, pp. 184–7, and are interpreted as performances that arise as part of the fiction rather than musical events apparently spontaneously sung by impassioned characters. Abbate, *Unsung Voices*, p. 29, defines 'phenomenal' performance as a musical or vocal performance that is heard as singing by the auditors onstage.

[28] Weill, *Mahagonny*, pp. 59–60. 'I come from Havana, My mother was a white woman.' Translation Stern, *Mahagonny*, p. 47.

[29] Weill, *Mahagonny*, p. 51.

[30] Peter Brooker, *Bertolt Brecht*, p. 46.

[31] Weill, *Mahagonny*, pp. 61–3. 'I have learned whenever I meet a man, to ask him what he is used to. Therefore tell me how you would like me to be.' Translation Stern, *Mahagonny*, p. 51.

how he would like her hair and her underwear, but when he asks about her wishes she defers, saying 'Es ist vielleicht zu früh, davon zu redden'.[32]

The immediate implication of this song, particularly the final lines, is that Jimmy has bought Jenny and she will now carry out his wishes or desires, but here again, there are two levels of presentation. Jenny the prostitute is doing what is required to earn her living by playing a part, but noteworthy here is her reversion to the formal 'Sie' to address Jim in the final lines of the song, maintaining the professional distance and not giving him what he desires. She is lulling him with the sinuous gentle song to believe that he can have all that he wants while maintaining her distance.

Musically, the gentle plucked strings, simple harmonic direction and sustained vocal line at speech pitch might be reminiscent of a lullaby, while the sinuous saxophone melody gives a sexual or seductive content. The saxophone melody is distinctive enough to make the ternary form[33] of the song easily recognisable, while the saxophone timbre has cultural associations with sexuality and 'low' music. There is a very high degree of motivic unity in the work which makes the song appear both structurally self-contained and unified, and simple and memorable. The motif is repeated either directly, in slightly altered form or at a different pitch within the first and third sections of the song and in melodically altered form in the middle section. The rhythm is maintained throughout. Altogether the simple but distinctive orchestration, the clear presentation of the saxophone melody, the consistent rhythm and the use of repetition make the song distinct from the more operatic singing from other characters and memorable. So its function as diegetic or not remains questionable. This becomes more important later in the opera when the theme recurs causing a further intratextual slippage between this moment and that.

Alongside the lyrics, a reading would suggest that Jenny is lulling her man and the audience with both comfort and sex. At the same time, according to Abbate's suggestion, the ABA1 structure and repetitive melodic patterns act reflexively to remind the audience of the performer playing a part in the theatre, lulling and seducing the audience.[34] The theatrical frame is reflexively present in Jenny's 'performance'.

Jenny appears at other times in the course of the opera, but the next section of relevance to this argument is the spoken section towards the end of Act Two. Jimmy cannot pay the bar bill and needs someone to lend him some money. In the longest unaccompanied scene of the opera – 11 speeches – the landlady and

[32] 'It is perhaps too soon to talk of them.' Translation Stern, *Mahagonny*, p. 51.

[33] In ternary form the song is divided into three sections according to the structure ABA or ABA[1]. Here the repeated section is an altered version with a different melody, A[1]. This form was a feature of operas of the late seventeenth and early eighteenth centuries, known as the *da capo* aria where the repeated section was a highly ornamented version of the first section.

[34] The use of a *da capo* structure is interesting because it adds an archaic element to the popular reference.

madam, Ladybird Begbick, first asks Jimmy's friend Bill for money, he walks away. She then asks Jenny to help as follows:

> Begbick: Und du Jenny?
> Jenny: Ich?
> Begbick: Ja warum denn nicht?
> Jenny: Lächerlich!
> Was wir Mädchen alles sollen!
> Begbick: Das kommt also nicht in Frage für dich?
> Jenny: Nein, wenn Sie es wissen wollen.[35]

Through the intervening stages of the operatic narrative, where Jenny and Jim are always together, it could be imagined that some sort of affectionate relationship has developed between them. However, here it is made clear that she is a working girl trying to make a living, a view supported by the duet in Scene 6 where it was established that she was paid to show affection. Thus, it is suggested that Jenny has been 'acting' her affection for Jimmy or that her motives and character are changeable, and the reflexive awareness of theatricality returns. Furthermore, the absence of musical accompaniment at this moment draws attention to the moment. Since Jenny – and everyone else – has sung throughout the work, with Jenny sometimes using popular song forms, there is a different theatrical 'realism' attached to speech that adds weight and focus to her denial of Jimmy. One might also draw an intertextual biblical reference out of this exchange, relating it to Peter's denial of Jesus.[36] This moment also acts as a reflexive reminder of the suspension of disbelief that has been invoked elsewhere in the work.

Immediately after Jenny's refusal to help, as Jimmy is put into irons and taken to prison, Jenny sings the song: 'Meine Herren, meine Mutter prägte'[37] to which I will return, but the final meeting between Jenny and Jim is in Scene 19, just before Jim's execution. The music accompanying the spoken scene is a reprise of the music of Scene 6. Jim begins the exchange; 'Hast du nicht sogar ein weisses Kleid an wie eine Witwe?' to which Jenny replies: 'Ja, ich bin deine Witwe und nie werde ich dich vergessen, wenn ich jetzt zurückkehre zu den Mädchen.' When

[35] Weill, *Mahagonny*, p. 226.
> Begbick: And you, Jenny?
> Jenny: Me?
> Begbick: Yes, why not?
> Jenny: Ridiculous, all the things we girls are supposed to do!
> Begbick: So you wouldn't consider it?
> Jenny: No, if you're interested in a precise answer.

[36] There are other biblical references throughout the work that make this possibility more likely than may appear from this one scene.

[37] Weill, *Mahagonny*, p. 226.

Jim implores her to 'Denke an mich!' she replies 'Sicherlich, Jimmy!' He asks her not to hold a grudge against him, and she says 'Warum denn?'[38]

On the surface this seems to be a touching farewell scene but it is undermined by several facts. Jenny was economical with the truth when she first introduced herself, and later, in the spoken scene, she refused to help Jimmy. It is also undermined by the fact that Jenny has been seen in 'Alabama Song', in the Scene 6 exchange and in 'Meine Herren meine Mutter prägte', as a performer who says and does what she must to earn a living. Her presentation uses popular styles that are themselves disrupted in direction and harmony, and some of her performance is arguably diegetic, casting doubt on when she is performing. The ambivalent and colloquial 'Sicherlich, Jimmy', might imply its opposite, while the response 'warum denn' might imply a world-weariness, a 'whatever' in contemporary slang, from someone continually let down, as well as reassurance for the listener.

The music that accompanies the scene also presents an ironic view; the same music and orchestration is used here as was used in Scene 6 when Jenny asked how she should dress and behave for Jimmy. Here there is a time distortion produced by the intratextual musical reference to the earlier scene, which acts as a reminder of Jenny's earlier performance. Is Jenny still performing? Is she still acting out her role as the girl he paid for? An optimistic response would be that the use of the familiar 'du' in this scene gives the lie to such speculation, but the musical reminder of the earlier scene certainly casts doubt on the character Jenny's credibility. Moreover, this is a spoken scene with musical underscore, reminding the listener of the other spoken scene of the work where Jenny denounced Jimmy. Aside from these two very important intratextual associations, the short section of speech acts as a reflexive reminder of the theatrical presentation and so might distance the audience and make it question further the layers of representation it sees and hears.

'Meine Herren, meine Mutter prägte' occurs just after Jenny has been asked to pay Jimmy's debt and save his life. As noted above, she refuses in a scene which contains biblical overtones. Like 'Alabama Song', this song could be read as a

[38] Ibid., p. 289. The translation of the complete verse from Stern, *Mahagonny*, p. 129 is:

> Jimmy: You are even wearing a white dress just like a widow, aren't you?
> Jenny: Yes, I am your widow, and never shall I forget you, when I return now to

the girls.

> Jimmy: Kiss me, Jenny!
> Jenny: Kiss me, Jimmy!
> Jimmy: Think of me!
> Jenny: Sure, Jimmy!
> Jimmy: Don't hold a grudge against me.
> Jenny: Why should I?
> Jimmy: Kiss me, Jenny!
> Jenny: Kiss me, Jimmy!

soliloquy or as a set piece diegetic performance, but importantly here, it draws together the devices that have been discussed in this chapter.

The performance is signified as diegetic performance partly because it is musically unlike the rest of Scene 16 and Act Two – almost all of Act Two is derived from a single motif – and because the lyrics contain specific references that support such a reading. For example, the first phrase of each verse, 'Meine Herren', indicates that the song is addressed to a group of people: in the plot Jenny no longer has a protector and so may be performing to catch another man, diegetic performance, or it could be a performance directly addressed to the operatic audience. The verse/chorus structure, noticeable through the use of repetition, also implies a song structure. At the same time, the song lyrics explain why Jenny does not help Jim, she needs to look out for herself and she will not be a victim, implying that the song could be a soliloquy. The same instability between diegetic performance and conversation/explanation can be seen here as in 'Alabama Song'.

The verse is marked 'Blues', but the vocal range is too high for blues, the melody too full of intervals and the harmony too dissonant, but the marking suggests a swing feel and possibly a mood for the song. The refrain is in the sexual/sensual rhythm of the tango with a warmer, less dissonant accompaniment. The upshot is that the song can be read on many levels, giving insight into Jenny's approach to life and sex, as an explanation of her refusal to help, as a performance to attract a new protector and as a reflexive reminder of the act of performance.

The style of music is popular song with unexpected dissonance and abrupt changes of harmonic direction as in 'Alabama Song', although here the juxtaposition of different popular styles in the verse and refrain – swing feel and tango – adds to the genre disruption as the juxtaposition of the two is quite jarring. The use of popular song acts reflexively as a reminder of the artifice of performance and, at the same time, it provides a reading of Jenny as a performer within a tradition of 'low' song separated from the 'operatic' singing in the rest of the work. But Jenny, the singer of popular music and a prostitute, is the character with whom the audience is expected to identify most closely, since she is the most fully drawn and complex character in the work and her music is the most repetitive and approachable – a similar position to the presentation of Sweeney Todd in the previous chapter.

The refrain is a direct repetition of a section of the Act One Finale, working in the same way as the intratextual link between Scene 6 and Scene 19 so that the later reading of the text is overlaid on the earlier. The refrain makes a link between the optimism as the storm veers around the city and the present low ebb of the city. The downfall of the city is therefore linked with the philosophy of looking after oneself espoused in this refrain. This casts foreboding on Jenny's future if she sticks to this philosophy and suggests a moral reading of the work to the audience.

Much more could be said about this song, and especially about the ambiguous sentence 'Ein Mensch ist kein Tier',[39] which might be regarded as the central line

[39] 'A Human Being is not an Animal.'

musically and lyrically of the song, but to do so would not clarify further the issues discussed above.

The question raised throughout this analysis is when is the character Jenny performing? Is there a 'truth' to the character? The unstable representation that occurs through the juxtaposition of music and lyrics, popular and operatic music, unexpected dissonance or the upset of genre expectations, diegetic and non-diegetic performance, reflexivity, intra- and intertextual reference, unsettles the reading of the character. These same devices are a frequent reminder that the performance is a theatrical fiction. They provide a constant mobility in the identification between audience and performance, performer and character, allowing the potential for multiple readings of the performance text.

This reading of the characterisation of Jenny opens the theatrical frame to question accepted representations of love and prostitution, and challenge 'truth' and 'fiction' in the representation. The argument presented here is that the instability in the characterisation, caused by reflexivity and genre disruption, encourages a different perspective on what is presented that leaves interpretation open.

Merrily We Roll Along

A related strategy is used in the text of *Merrily We Roll Along* to create complexity and dramatic irony, and to draw attention to the destructiveness of commercial success.[40] The musical begins on graduation night and contains the story of three friends, Frank, Charley and Mary, two men who write songs and musicals together as lyricist and composer, and a woman who loves one of them unrequitedly. The story focuses predominantly on the relationship of the two men, between whom Mary sometimes acts as a link, and whose lives are linked partly by their music. It documents their initial optimism, early success and then the gradual decline of their relationship as their different political and world views encourage them in different directions. Frank compromises his ideals for commercial success, while Charley tries to hold on to his integrity and credibility. The narrative is episodic with causal relationships appearing between scenes but the story is ordered in reverse chronology so that it appears as a gradually receding flashback instigated by Frank, but encapsulating a series of moments of interaction in the lives of the three main characters.[41] The reverse chronology changes the story from one of the

[40] *Merrily We Roll Along* (1981). Music and Lyrics by Stephen Sondheim, Book by George Furth, based on a play by George Kaufman and Moss Hart (1934) and originally directed by Harold Prince. The musical was reworked for a 1985 revival creating a new version of the book and score. This analysis is drawn from the 1985 version. For a comparison of the changes see Stoddart, 'Visions and Re-visions', in Goodhart, *Reading Stephen Sondheim*, pp. 191–2.

[41] Stephen Banfield identifies this strategy in other works including opera, novel writing, play writing and science fiction film in *Sondheim's Broadway Musicals*, pp. 321–2.

downfall of a relationship to one where the irony of idealism and the American Dream are exposed.[42] It emphasises the irony of a nostalgic desire for a return to the past, and as S.F. Stoddart remarks, 'This correlation of one's social experience with the historical moment underscores the cynicism and sadness the audience feels as the curtain comes down on the "happy ending"'.[43]

The libretto of the 1985 production contains instructions to begin the performance with a series of slides drawn from the biographies of the three characters that will reappear during the transitions between scenes, 'matching and illustrating each appropriate time and event'.[44] The Prologue simultaneously introduces the musical and lyrical material, the song 'Merrily We Roll Along' that will recur in the transitions moving the episodic structure chronologically back to the previous causal event. The lyrics identify the need to look back with questions such as 'How can you get so far off the track?' 'How does it happen?' and 'How did you get to be here?'[45] This material creates an outer frame for the enacted scenes, distancing the audience from empathy and maintaining a reflexive awareness of theatricality.

Two of the characters, Frank and Mary, appear in Scene 1 in 1976 aged 40. During the scene there is reference to the friendship shared between Mary, Charley and Frank until a 'famous television interview'.[46] When that scene is over the first transition tracks back to 1973, introduces Charley and re-enacts the television interview. The series of scenes moves backwards gradually and episodically to 1957 when the three have high hopes for their future successes aged 20 and at the start of their friendship.

The musical transitions link the episodes in a causal relationship that recreate 'Frank's moments of expediency'.[47] This strategy allows understanding of events but maintains emotional distance. For example, the final performance of 'Our Time', Part 3, the last song in the show, contains the three friends singing 'Years from now, we'll remember and we'll come back, buy the rooftop and hang a plaque. This is where it began – being what we can ... Our dream coming true, Me and you, pal, me and you'.[48] In the opening scene at the chronological end, Frank's words in the fragments of this song are slightly different 'It's our time coming through, All our dreams coming true, Working hard, Getting rich, Being happy – There's a switch',[49] even as the chaotic scene demonstrates that the dreams have foundered and there is very little happiness to be found. These small differences

[42] S.F. Stoddart develops this thesis at much greater length in his analysis of the plot. 'Visions and Re-visions', pp. 187–98.

[43] Ibid. p. 189.

[44] *Merrily We Roll Along*, p. 2.

[45] Ibid., pp. 2–5.

[46] Ibid., p. 20.

[47] Banfield, *Sondheim's Broadway Musicals*, p. 313.

[48] *Merrily We Roll Along*, pp. 120–1.

[49] Ibid., pp. 10–11.

become huge and iconic as representative of the destruction of hope and creativity. The audience is forced to maintain an emotional distance from the optimism of the young people at the end of the show by their awareness of the cynicism they have already been exposed to earlier in the show and the reflexivity of the structure.

Sondheim states in the liner notes to the 1982 Broadway recording that the musical is about friendship and that therefore the songs of Mary, Frank and Charley are connected through 'chunks of melody, rhythm and accompaniment'.[50] These musical and verbal motifs are modified over the course of the years, so a release might become a refrain in a later song, or a melody might become an accompaniment, a chorus become an interlude and so on. Repetition of musical sequences has the result of highlighting similarity and difference between moments or scenes and creating irony, as in the 'Old Friends' vamp sung by a drunken Mary at the party and later by a naive young Frank. Stoddart notes that these vamps 'create a symbolic matrix with the structure of the play … Distancing the plot from realism, encouraging the plot to be read moralistically, and somewhat more universally'.[51] Having heard the irony of Mary's mature version first in the show it is impossible to believe in Frank's version at the end of the show as a naive 20 year old in quite the same way. Banfield notes several examples of repeated songs in the score, but particularly identifies 'Good Thing Going' as being appreciated on 'several different levels that shift back and forth between an intensely private role for the song and a markedly public one'.[52] He continues:

> Its first level is as a diegetic depiction of a naïve but deserving hit, a love song written by two young men. On the second level it acts as a microcosm of their friendship and its fate, and thus of the show's overall plot, which they do not recognize but we do. Its third level is that of a potent expression of what all song must ultimately be about, our own self-knowledge, the unspoken or hidden thoughts, desires, and motivations that can never be wholly satisfied … In a paradoxical way, reading this kind of personal or subliminal application into it universalizes the song and reminds us that there is also a fourth level to be posited, that of a hit for Sondheim outside the show (the diegetic use of its Frank Sinatra recording over the air in the television studio scene has added a nice depth of reverberation … in productions since 1988).[53]

What becomes important is the role of the audience as interpreters both of the work and of the performance in its many productions and re-productions. Thus the work begins to take on new *gestic* meanings beyond those initially inscribed in the text.

[50] Composer's note referred to in Stoddart, 'Visions and Re-visions', note 9, p. 198 and Banfield, *Sondheim's Broadway Musicals*, p. 327.

[51] Stoddart, 'Visions and Re-visions', p. 194.

[52] Banfield, *Sondheim's Broadway Musicals*, p. 340.

[53] Ibid., pp. 340–1.

Attention is drawn to the repetition and difference between these moments by the repeated use of materials that refine the awareness of the perceived passage of time and the changes in the characters' lives and personalities. This is a similar effect to that in *Mahagonny* where different moments in time are linked by similar musical material that has the effect of sharpening awareness of the small differences that are to be perceived in characters and situations, and making ironic commentary apparent between them. In *Mahagonny* attention focused on the slippage between diegetic and non-diegetic performance, love and prostitution in the representation of Jenny and the effects of commerce on social relationships. In *Merrily* the story recapitulates the process in the characters' lives from cynical, drunken and, for Frank, commercial success, back to the idealism with which their story began. The consequence of this presentation is that the naive optimism of the chronologically early scenes is filtered through the awareness of the self-destruction that, though chronologically last, has been presented first.

So here, in a very different chronological, but equally episodic construction from that of Brecht and Weill, is a similar reference to the subliminal, thoughts, desires and dreams of characters and the multiple layers of meaning and interpretation for audiences. The episodic construction allows audiences to put together a narrative from the moments presented and the repetitions and gaps between the presented moments.

The Last 5 Years

The Last 5 Years was written and composed by Jason Robert Brown and is effectively a song cycle with no unaccompanied spoken scenes between the songs. It follows an even more complex chronology than *Merrily We Roll Along* with the male protagonist, Jamie, moving forward in time alongside his soon-to-be ex-wife, Cathy, who tracks back from the end of their relationship to the start. As with *Merrily We Roll Along* the result of the strategy is an episodic structure, but this time, because of the different chronologies of the characters, it only allows the performers to sing together in Scene 8 'The Next Ten Minutes'[54] – the mid-point – and to say goodbye from different perspectives in Scene 14 'Goodbye Until Tomorrow/I Could Never Rescue You'.[55] Other scenes contain both characters in different situations with one speaking and the other singing, as in Scene 3 'See I'm Smiling' in which 'Catherine is sitting at the end of a pier by the river in Ohio – Jamie has come, somewhat unexpectedly, for a visit' while Jamie appears 'Five years earlier, just after their first date'.[56] In Scene 10 Catherine is nervously singing at an audition, a scene that is countered by Jamie phoning her from his editor's office and later doing a reading in a bookstore. Both parts of this scene

[54] Jason Robert Brown, *The Last Five Years* (Libretto), p. 17.

[55] Ibid., p. 33.

[56] Ibid., p. 5.

highlight the differences in their demeanour as Cathy, the less successful actress, is unsure and nervous, while Jamie, the successful writer, is confident and relaxed.

The consequence of the episodic chronologically varied strategy is to highlight the differences between the characters throughout the story as well as at the different chronological positions in their lives through a varied version of flashback. The effect is of a continuing disjuncture throughout their marriage that perhaps predicts their separation. It also allows a series of varied representations of innocence and experience, hope and cynicism to be presented as the relations between the characters are subtly altered throughout the performance. Thus the difficulties of human relationships and the uncertainties of meaning and interpretation are reflexively explored in this work. Also important here is that there is no framing story, no particular perspective from which the story is told, though the sequence of events is clarified in performance by the continuity of the performer/characters playing each part. What it creates for the audience is an unstable evocation of difference between the characters and a sense of dramatic irony and altered sympathy as explanations and situations are gradually revealed. The audience is required to put together the pieces and construct a narrative, or it could read the text simply as a song cycle. In either case, the structure contributes to the distance from empathy with the characters, but increases the awareness of the sadness and tragic waste in the audience's omniscient and isolated understanding.

Conclusion

The texts in this and the previous two chapter demonstrate some of the ways authors and composers can create gaps and discontinuities that rely on audience interpretation and encourage the potential for thematic, *gestic* or personal readings alongside a simple reading of the narrative. They also draw attention to the act of performance and reveal the theatricality of particular moments to encourage awareness of wider themes in relation to the world beyond the theatre. Audiences respond differently to such texts; some audiences prefer the intellectual stimulation of the dialectical text, others prefer a simpler over-coded text, or read a potentially dialectical text as a simple linear narrative. It may be that the initial lack of success of some of Sondheim's work may result from the irony and distance that his works created for an audience expecting to be able to read them as escapist and entertaining.

Bertolt Brecht believed that music is one of the sources of unreality in operatic works, and the greater the unreality of the work, the greater the pleasure offered to the audience through the 'sordid intoxication' it induces.[57] The music, and particularly the singing, makes the real situations embodied in opera unclear and irrational, which creates pleasure for the audience members, and consequently they become less awake and less aware. 'The process of fusion extends to the spectator,

[57] Joy Calico, *Brecht at the Opera* (Berkeley, 2008), p. 37.

who gets thrown into the melting pot too and becomes a passive (suffering) part of the total work of art.'[58] It is interesting here that the word 'fusion' used throughout the debates about 'integration' in musical theatre should also appear, applied to the work that creates the passive, but intoxicated, audience member, and that in Brecht's theory the integrated work cannot represent or critique the real state of an alienated world, but can offer only escapist pleasure.

So the question is raised whether the urge towards integration in musical theatre has been a journey towards escapism, or whether, in fact, integration is a fiction that allows audiences to read complex texts as simple and entertaining narratives. Yet many of these texts also contain the potential for more complex interpretations, and awareness of these nuanced or dialectical readings opens the potential for a different type of pleasure. Audiences choose which of these readings they want to focus on, and in the next chapter some of the work of cognitive neuroscience will be introduced that has begun to provide answers to questions about how audiences might respond to complex theatrical texts.

[58] Brecht, 'Notes to the Opera', in Brecht, *The Rise and Fall of the City of Mahagonny*, p. 89, quoted in Calico, *Brecht at the Opera*, p. 37.

Chapter 5

Alternatives to Linearity: *Cabaret,*
Kiss of the Spider Woman and *Assassins*

The ability of audiences to negotiate different realities has been explained recently
in neuroscience as 'conceptual blending'. Gilles Fauconnier and Mark Turner
demonstrate that all learning and thinking consist of blends of metaphors based on
bodily experiences, which are continually blended together into an increasingly
rich structure.[1] Bruce McConachie applies this work to theatre when he argues that
'actors engage in conceptual blending to play a role' and that actors and audiences
'together create a fourth "mental space," which is distinct from the perception of
themselves in real time-space'.[2] Within this fourth space information from the
inputs of the actors and spectators along with generic and remembered information
are 'blended together to create perceptions that are distinct from all the inputs'.[3]
Most importantly, audiences select the blend of information they choose to
construct into meaning, which will include different balances between awareness
of narratives and meta-narratives, genre expectations, vocal stereotypes, other
audience members, characters and performers, and many other performances.

According to McConachie and Hart this blending 'also complicates the usual
distinctions dividing realistic from overtly theatrical productions and "passive"
from "active" spectators'.[4] They argue that all performances invite spectators
to move between various blends, but that framing of performances and generic
expectations encourage particular types of blending, 'but these are differences
of degree, not of kind'. This argument negates to some extent the idea of the
'alienation effect' but suggests that all performances involve active cognition, and
that all stage performances involve spectator recognition of theatrical framing.

So a cognitive approach suggests that when presented with a network of
spaces or images the audience processes the images maintaining a blend so that
interpretation and response is playful and continually in flux.[5] Amy Cook refers

[1] Gilles Fauconnier and Mark Turner, *The Way We Think* (New York, 2002), cover
note.

[2] Bruce McConachie and F. Elizabeth Hart (eds), *Performance and Cognition*
(London and New York, 2006), p. 19.

[3] Ibid., p. 19.

[4] Ibid., p. 20.

[5] I draw on Amy Cook's article 'Interplay: The Method and Potential of a Cognitive
Scientific Approach to Theatre', *Theatre Journal*, 59 (2007): pp. 579–94 as an inspiration
for the textual analysis in this chapter.

to Gilles Fauconnier to suggest that 'while any particular blend might vary from individual to individual, the network of spaces prompted in a given situation is more powerful as a process in flux, a series of variables, than simply a final blend'.[6] This might be interpreted in relation to musical theatre performance to suggest that in the course of a performance the blend of musical and dramatic materials presented to the audience at any one moment will continually alter the potential meanings of previously presented images, as has been argued in relation to *Mahagonny* above. At the same time, the individual will continue to respond to the full range of images and materials, performances and atmospheres, blending them according to personal choice within context. However, one can posit a series of variables from which the audience is likely to interpret the work, and undertaking a mapping of the likely connections can produce insights into the work as text and in performance.

Furthermore, what blending theory suggests is that extraordinarily complex information is assimilated using more of the brain but no more time. In fact Cook postulates the view that 'perhaps research on language, story, and performance could encourage those who wish to argue for fewer plays that have the ease of sitcoms, and more plays with the complexity of Shakespeare'.[7] It is possible that some people might find that the more textured performance, activating more parts of the brain and increasing the intensity of the brain activity, could also produce a different type of pleasure.

A recent study undertaken by Corinne Jola, Marie-Hélène Grosbras and Frank Pollick investigated the brain activity when dance was performed with and without music. Particular brain areas were activated in areas that correlated with auditory activity when music was heard alone[8] and in visual areas when watching dance alone.[9] When the dance and music were watched together multisensory areas were activated.[10] This means that the team found increased synchronisation across spectators in areas of the brain that process audiovisual stimuli. They concluded that – at least as far as the study went – audience responses to an audiovisual stimulation were more likely to be similar than to either stimulus alone. In light of this, Corinne Jola speculated that there might be more brain activity overall as a result of the combination of stimuli produced by attendance at a musical theatre performance, especially in the areas that integrate audiovisual stimuli. She also suggested, following her study, that there was likely to be greater synchronicity, or similarity in reading, among audiences of a multidisciplinary text that contained

[6] Ibid., p. 584.

[7] Cook, 'Interplay', p. 587.

[8] Left superior temporal gyrus.

[9] Right and left inferior temporal gyrus, right middle occipital gyrus and left cuneus.

[10] Right middle occipital gyrus and transverse temporal gyrus, left superior temporal gyrus, lingual gyrus and cuneus. Corinne Jola, Marie-Hélène Grosbras and Frank Pollick, 'Dance with or without Music: Does the Brain Care?' Poster presentation, *Kinaesthetic Empathy: Concepts and Contexts*, Manchester University, 22–23 April 2010.

music.[11] It is possible that this synchronicity might also generate a greater degree of emotional contagion, especially since it has been proved that entrainment can produce a bonding experience.[12]

This finding is particularly interesting in light of Brecht's suspicions of the 'culinary' effects of music and operatic texts, and the theorising of the reading of the structures of the musical theatre text and its performance as stereophonic and plural. It may be that individual intellectual responses can be varied, even as emotional responses and communal interpretation is synchronous, and that audiences understand multiple meanings even while they choose to partake of the communal experience and the culturally determined reading.

Long before the recent discoveries in neuroscience, Roland Barthes theorised in relation to language that '[t]he logic regulating a text is not comprehensive ... but metonymic; the activity of associations, contiguities, carryings-over coincides with a liberation of symbolic energy'.[13] The text is plural, not simply in that it has several meanings, but that it is irreducible, an explosion or dissemination. He suggests that 'the plural of the Text depends ... not on the ambiguity of its contents but on what might be called the *stereographic plurality* of its weave of signifiers'. This plurality is 'woven entirely with citations, references, echoes, cultural languages ... which cut across it through and through in a vast stereophony'.[14] He suggests that such a text is playful, and that the reader plays twice over in re-producing it both as an inner mimesis and in the musical sense of playing.[15] Such a text, he argues, is 'bound to jouissance, that is to a pleasure without separation ... the text is that space where no language has a hold over any other, where language circulates'.[16]

While Barthes' theorising refers only to language and not to performance, nor does it draw on cognitive neuroscience, it is possible that the processes that have now been described scientifically by observation of firing patterns in the brain have been predicted through observation and theory. The idea of a circularity of language can be read alongside the idea of a playful performance text whose images and meanings are individually blended and continually in flux. This process suggests that the way meanings are interpreted in a performance can be plural and simultaneous rather than individual and separate, and that the process of recognising and assimilating this plurality can be pleasurable and playful.

[11] Personal communication at *Kinaesthetic Empathy: Concepts and Contexts*, Manchester University, 22–23 April 2010.

[12] Tai-Chen Rabinowitch, Ian Cross and Pamela Burnard, 'Musical Group Interaction and Empathy – a Mutual Cognitive Pathway?', *Kinaesthetic Empathy: Concepts and Contexts*, Manchester University, 22–23 April 2010.

[13] Roland Barthes, 'From Work to Text', in *Image, Music, Text* (London, 1977), p. 158.

[14] Ibid., pp. 159–60.

[15] Ibid., p. 162.

[16] Ibid., p. 164.

This chapter explores the construction of some musical theatre texts that do not offer linear narratives, and do not necessarily use the tools of integration. Instead the focus here is on those musicals whose narratives are presented through combinations or collages of images and sounds so that audiences construct complex and playful narratives. This can be related to Barthes' stereographic plurality and the jouissance it stimulates, but the ability of audiences to blend their perceptions of characters, performers, situations and genres, and to respond communally to audiovisual stimuli might also provide a theoretical framework for the ability of non-linear, escapist and camp musical theatre to entertain. So in this chapter I will analyse some performances that do not rely on the linear presentation of narrative, and will consider the ways they might be interpreted and enjoyed.

Collage, Montage and Concept Musicals

Many theorists describe *Cabaret* as a concept musical. In a discussion of *Cabaret* Raymond Knapp describes the concept musical as 'less about a particular narrative than about establishing perspective'.[17] Scott McMillin describes it slightly differently while still acknowledging *Cabaret* as one of the earliest examples: 'The book of a concept musical is often controlled by a theme or a metaphor. Kander and Ebb's *Cabaret* (1966) is one of the earliest concept musicals.'[18]

The term 'concept musical' is somewhat imprecise as the examples above demonstrate. Like the term 'integrated', it has been applied in diverse ways to slightly different groups of works. It is most often used in common parlance in relation to the production concept of a director or designer, where it applies to specific productions rather than to the structure of works. So, for example, Rob Marshall's 1998 production of *Cabaret* has a different concept from that of Harold Prince in 1966. However, in writing on musical theatre the term is often used loosely to classify those musicals that have a meta-narrative interacting with the narrative such that an ideological theme emerges, as in *Cabaret, Chicago* and *Kiss of the Spider Woman*. It is also used to describe those musicals that are based on a thematic idea rather than a linear narrative such as *Company, Assassins, Cats* or *Starlight Express*. It is even used to describe those musicals that have a non-chronological narrative structure, like those described in Chapter 4; *Merrily We Roll Along* and *The Last 5 Years*. Overall, the term appears to be used for

[17] Knapp, *The American Musical*, p. 241.

[18] McMillin, *The Musical as Drama*, p. 22. He goes on to describe how Cabaret condensed 'an idea into a metaphor – the rise of Nazism seems to take place in a seedy Berlin nightclub', arguing that '[t]he plots of the concept shows are unpredictable and original. They are driven by confidence that the book has become a narrative art in itself, requiring new ways of relating book to number'.

any works that do not conform to a linear narrative construction.[19] Given this imprecision I will avoid the term as much as possible, and refer to examples of these works within the groups described above.

Even when there is a linear narrative, one might read the dramatic structure of a musical as a collage of elements in different media that contribute to a single reading. For example, one might read *Oklahoma!*[20] entirely against the grain, and certainly against the received wisdom, as a combination of songs, dances and scenes that combine to suggest a linear narrative. Indeed, Scott McMillin notes that when Bertolt Brecht saw *Oklahoma!* he 'praised its plot as providing "scaffolding" for the "inserts" of the numbers'.[21] Read as a blend of images, the dream sequence, for example, might be both enjoyable dance fantasy and an explanation of Laurie's motivation. The dance styles in Agnes de Mille's choreography make connections to different theatrical forms that can be enjoyed intertextually, and create a plot sequence using character stereotypes. The musical materials of this sequence can also be read as contributing to the story through the motivic connections linking the character stereotypes they signify, as a combination of melodies that create different atmospheric states, and as a means of providing different dynamic ranges. The farmer and the cowhand sequence leading into the social dance is both pure joyous dance, fast-paced and uplifting musical stimulation, and exemplification of developing community. I won't pursue this reading of *Oklahoma!*, but instead will introduce readings of musical theatre works where the separation of narrative and number is perhaps more apparent, to argue for the multiplicity of interpretation – the 'both/and' of blending rather than the 'either/or' choice of viewpoints.

The Producers with its zimmer-tapping grannies and other escapist production numbers is much more easily read as 'non-integrated' since it contains libidinally excessive production numbers that might appear to be totally unnecessary to the plot.[22] In this case what these numbers offer is libidinal excess and intertextual reference, ideas which I will return to in Chapter 7, but there are other types of dramatic construction that challenge the linear reading in much more fundamental ways.

In *Cabaret* the introduction of a show within a show allows for commentary on, or comparison with, the linear plot, while framed as meta-theatrical performance. The audience is likely to perceive commentary between the political situations

[19] Steve Swayne includes an appendix on the concept musical in relation to the works of Stephen Sondheim in *How Sondheim Found His Sound* (Ann Arbor, 2005), pp. 257–9, in which he stresses the problematic nature of the term.

[20] Music by Richard Rodgers, Lyrics and Book by Oscar Hammerstein, 1943.

[21] McMillin, *The Musical as Drama*, p. 26. Note 24 identifies the source of this information as a diary by Ferdinand Reyher who accompanied Brecht to the performance on 30 September 1946.

[22] Music and Lyrics by Mel Brooks, Book by Mel Brooks and Thomas Meehan, Director and Choreographer, Susan Stroman, 2001. I will return to escapist texts in the next chapters which deal with so called 'jukebox' musicals and compilation musicals.

within and without the theatre, the characters' relationships in the plot, and the cabaret songs.[23] The use of montage is particularly apparent in the dreams and fantasies in *Kiss of the Spider Woman*, but is a technique that is also used in the 'realistic' scenes.[24] The dream and fantasy sequences give access to a subconscious world and potentially to surreal or camp escapist moments that amplify understanding as well as causing libidinal eruptions to continuity. In the 'real' scenes, montages are used to juxtapose materials and suggest diverse and complex readings of characters and situations in brief moments of exposure, while musical continuity serves to unify and draw together the materials that audiences are likely to read against each other in order to blend and interpret communally and individually.

Assassins is further removed from any sense of causal relationship. It contains multiple narratives presented in a non-chronological order.[25] The musical tells the stories of nine historical figures who have, or who have attempted to, assassinate a president of the United States of America. The characters meet in a collage of scenes that allows the individual narratives of the characters and the themes of violence and anarchy within the American dream to emerge.

Where meta-narratives comment on the plot, or where there is a thematic focus rather than a linear narrative there is a blending of images performed by audiences that opens up the possibility of gaps, intra and intertextual associations and, potentially, a playful access to jouissance. *Cabaret* and *Kiss of the Spider Woman* contain linear narratives, but they are presented in parallel with meta-narratives. *Assassins* has a thematic focus rather than a linear narrative, but it includes the narratives of the individual protagonists and some narration. The material in all these works is presented through episodic structures, juxtapositions and disruptive contiguities, montages of conflicting images, and composites of verbal signifiers, visual images and musical atmospherics.

Cabaret

Cabaret (1966) has a book by Joe Masteroff based on the play by John van Druten and stories by Christopher Isherwood, with music by John Kander and lyrics by Fred Ebb, though the influence of Harold Prince, as producer and director, on the development of the show is also notable.[26] *Cabaret* takes place in a Berlin nightclub where Sally Bowles works and in the rooming house where she moves in with Cliff during the rise of Nazism. The German landlady falls in love with a

[23] Music by John Kander, Lyrics by Fred Ebb, Book by Joe Masteroff, 1966.

[24] Music by John Kander, Lyrics by Fred Ebb, Book by Terence Mc Nally, 1992.

[25] Music and Lyrics by Stephen Sondheim, Book by John Weidman, 1990.

[26] For more information on Hal Prince's influence on the development of this and other works see Miranda Lundskaer-Nielsen, *Directors and the New Musical Drama* (New York, 2008), pp. 29–33.

Jewish grocer, mirroring the love affair between Cliff and Sally. Both love affairs ultimately fail. All these events are reflected and commented on in songs in the Kit Kat Klub. By the time the play and stories became a musical the structure of the work had changed considerably. After a trip to the Taganka Theatre in Moscow in 1965 Prince realised there were alternatives to linear structures in musical theatre that derived from Russian expressionism and the conjunction of diverse theatrical styles. So instead of a planned introductory montage of Berlin nightlife performed by the MC, Prince returned and 'took all those numbers and peppered them throughout the show'.[27] So the scene structure in the script contains an almost complete alternation between Kit Kat Klub scenes and 'narrative' scenes. '[T]he song-and-dance formats inserted into the Isherwood story about the rise of Nazism jostle the show into political connections between fascism and popular entertainment, and since audiences at *Cabaret* are themselves watching popular entertainment, the metaphor opens out into the show's performance itself.'[28]

The show begins in the Kit Kat Klub with the MC welcoming the audience with the song 'Willkommen'.[29] Scene 2 takes place on the train to Berlin where Cliff meets and gives assistance to Ernst as the border guards check their passports and luggage, before a reprise of 'Willkommen'[30] in the club finishes the scene. This sequence appears to suggest simultaneity between these two events in a linear reading of the plot because of the insertion of the scene within the framework of two parts of the song, a type of montage. At the same time the content of the scene and song are both overtly welcoming the stranger to Berlin, while also depicting the seamier side of the city – smuggling on the train and the sexual availability and depravity in the club. Thus, the potential reading of the club scenes as a simultaneous and parallel commentary to those in the 'real' world is established here. There is also the possibility of reading the train scene as diegetic within the club because of its framing within the song and the easy complicity with criminality, linked with the depravity of the club that it depicts.

There is a sense of completion in Act Two, Scene 7 when Cliff is leaving the city, again on the train, having his passport checked as the MC sings a final version of 'Willkommen'.[31] This finale version contains dream-like echoes of the end of the two love affairs and of Sally's final song 'Life is a Cabaret', before the MC concludes with the words 'Auf wiedersehn! A bientôt'[32] and, with a drum roll, he bows before the final orchestral fortissimo chord. This montage of images of

[27] Recorded in Lundskaer-Nielsen, *Directors and the New Musical Drama,* p. 32, referring to Kander, Ebb and Masteroff, *Colored Lights,* p. 63.

[28] McMillin, *The Musical as Drama,* p. 23.

[29] *Cabaret,* Vocal Score, p. 5. In this description I am referring specifically to the stage version as it is reproduced in the Vocal Score. More recent productions tend to incorporate some of the musical material from the film, a strategy I will discuss below.

[30] Ibid., p. 15.

[31] Ibid., p. 193.

[32] Ibid., p. 200.

the show reintroduces narrative uncertainty. Does the circle recur with another foreign visitor to Berlin? Was the whole a diegetic performance dictated by the MC? Did the nightmare only appear in Cliff's head? Which is the 'real' and which the commentary? Given the relationship between the club audience and the theatre audience, how are the audience implicated in the escapism and acceptance of the fictions? None of these possibilities can be taken as a single position, but rather, all of them to some extent are contained within an amalgam of possibilities, a collage of events and uncertainties, a disturbance or a blend.

This uncertainty is continued as, in between these bookends, some scenes are enacted in the club and provide an overlap between the 'real world' and the club. In Scene 4/5 Sally sings 'Don't Tell Mama' as diegetic performance,[33] which is followed, still in the club, by a scene in which Cliff and Sally meet on the telephone, before the club's New Year celebrations continue with 'Telephone Dance'.[34] This scene depicts the club as a place for both girls and boys to act as hosts, dance with the audience members or possibly provide sexual favours, again using the songs as a framing device and commentary for the scene. Other overlaps occur that are the result of Sally's presence both as a performer in the club and in the 'narrative' of Berlin life. After the final scene at the club between Sally and Cliff during which Sally refuses to leave Berlin, and after Ernst's attempt to persuade Cliff to undertake another 'urgent errand',[35] Sally is left singing 'Cabaret', enjoining listeners to 'start by admitting from cradle to tomb isn't that long a stay. Life is a cabaret'.[36] Simultaneously, Cliff packs to leave and Herr Schultz also takes his leave. The difference between Cliff's awareness of the horrors to come and Sally's decision to enjoy herself whatever the cost is amplified by this montage of events.

Only one song makes the journey from the club to the 'real world', and that is 'Tomorrow Belongs to Me',[37] which is first sung in Act One, Scene 9 by the waiters – so could be argued only to exist in the 'real world' as it is not explicitly part of the stage show. It is reprised by Fraulein Kost in Act One, Scene 13 at the party to celebrate the betrothal of Fraulein Schneider and Herr Schultz. Here the singing of the song is largely responsible for Fraulein Schneider beginning to see the position in which she will be placed by marriage to a Jewish man. This could be perceived as the influence of the club spreading out into the 'real world'. Or it could be interpreted that the waiters in the club are promulgating Nazism without realising that their own life styles might be unacceptable to the regime; representing the blindness of many citizens to the consequences of Nazi policies. These songs make potential connections and provide disturbances between the club and the society in which it exists, as well as indexing the world outside the theatre which the audience inhabits.

[33] Ibid., pp. 27–37.
[34] Ibid., pp. 44–57.
[35] Act Two, Scene 5.
[36] *Cabaret*, Vocal Score, song pp. 182–91, this reference, p. 190.
[37] Ibid., pp. 82–5, reprised pp. 135–7.

The second plot, already referred to above, concerns Fraulein Schneider, the aging German landlady of the rooms in which Cliff and Sally live, and Herr Schultz the Jewish owner of the grocery shop. Fraulein Schneider – originally played by Lotte Lenya – has a parallel framing of her story with two songs at her first and last appearances. The first is 'So What'[38] in Act One, Scene 3, which she sings to Cliff when deciding to let a room to him. Here Schneider is given the opportunity to flesh out her history in between refrains that establish her feelings of disempowerment, what Knapp describes as her 'jaded indifference'.[39] She sings, 'it will all go on if we're here or not, So who cares? So what?'[40]

After the brief moment of optimism and joy provided by her affair with Schultz her position is again reflected in a song to Sally and Cliff who are planning to leave. This time, and with a sense of hopelessness, she sings 'What Would You Do?' in Act Two, Scene 4. This song articulates the position of many people who feel unable to fight oppression, as evidenced in the lines 'suppose simply keeping still means you manage until the end? What would you do, My brave, young, friend?' She continues: 'Grown old like me, with neither the will nor wish to run, Grown tired like me ... Grown wise like me, who isn't at war with anyone, Not anymore!'[41] These two non-diegetic songs frame Schneider's journey, draw an empathetic connection with her decision to do nothing, and offer a contrast to the vaudeville style of the MC's songs and a comparison with Sally's opening and closing songs of escapism.

Sally's opening and closing songs, 'Don't Tell Mama' and 'Cabaret', occupy a position in both the 'real world' as soliloquy or autobiography, and in the club as diegetic performance.[42] The paralleling of these two songs with Fraulein Schneider's two songs draws the two love stories into comparison, with both Cliff and Schultz leaving at the end. For Cliff this is a return to America and safety, for Schultz to an uncertain future, while both women, for different reasons and with different emotions, determine to continue as before. The point here is that connections can be made between the two love stories that offer opportunities for audiences to compare the competing and contradictory positions. Sympathy is evinced by the women's songs, which encourages the audience to perceive and empathise with the tragedy of the hopeless, escapist or blinkered positions. So the juxtapositions and parallels offer opportunities for complex and stereographic interpretations.

Herr Schultz woos Fraulein Schneider with fruit in the delightfully touching comic duet 'It Couldn't Please Me More' about a pineapple that would give

[38] Ibid., pp. 16–25.

[39] Knapp, *The American Musical*, p. 244.

[40] *Cabaret*, Vocal Score, p. 17 and repeated in subsequent refrains on pp. 19–20, p. 22 and p. 24.

[41] Ibid., pp. 171–6. This reference, pp. 173–5.

[42] Ibid., pp. 27–38 and pp. 182–91.

Schneider gas, and so is 'not to eat, but see',[43] and in the waltz of hope, 'Married'.[44] However, Schultz also sings the diegetic 'Meeskite' at the betrothal party, about an ugly boy falling for an ugly girl whom he will treasure because 'I thought there could never be a bigger meeskite than me'.[45] The song ends as the song's protagonists produce a 'gorgeous' baby. This story has a similar moral to 'If You Could See Her Through My Eyes' performed later in the club, proposing that one should look below the surface. But that sentiment is distorted in both cases by the reference to Jewishness and the holocaust to come, with optimism in Schultz's song and sarcasm in that of the MC. It also works in the plot to draw attention to Schultz's Jewishness, to the extent that Schneider is warned by Ernst of the danger to her if she proceeds with the marriage.

Other songs that comment on the actions in the 'real world' are those sung by the MC as diegetic songs in the club and comprise 'Two Ladies', 'Sitting Pretty' and 'If You Could See Her' as well as 'Willkommen' already mentioned above. 'Two Ladies'[46] occurs after Sally has moved in with Cliff while making it apparent that Ernst also helps her pay her way. The song depicts the MC in a sexual relationship with the two ladies of the title, which is simultaneously an outrageous comic song, a reference to a sexual fantasy, and a comment on the triangle between Cliff, Ernst and Sally.

'Sitting Pretty'[47] occurs after Sally, now pregnant, has persuaded Cliff to pick up a parcel for Ernst in Paris and bring it back – a simple task that will be well rewarded financially as well as with the certainty that 'you are giving help to a very good cause'. Cliff's response is 'Well, whatever it is, please don't tell me. I don't want to know'[48] and he proceeds to smuggle money across the border for the Nazi Party. The song is prefaced by the MC's comment 'You see, there's more than one way to make money'. All the characters listed in the song are short of money, except the singer who has 'all the money I need'. The dance sequence is a reflexive revue style depiction of dancers from different countries appearing dressed as currencies introduced with double entendres by the MC, who sings of the 'talents which build up my balance'.[49] It comments on the trips being made by Cliff to earn money, but also on the economy of sexual exchange.

The third of the trio of Cabaret songs, 'If You Could See Her'[50] occurs after Fraulein Schneider begins to see that it may not be wise to marry Herr Schultz

43 Ibid., pp. 76–81. This reference, pp. 79–80.

44 Ibid., pp. 109–12, reprised p. 163.

45 Ibid., pp. 125–34. This reference, p. 129.

46 Ibid., pp. 68–75.

47 Ibid., pp. 91–107. This song is sometimes replaced by 'Money, Money' from the film in recent stage versions, as was the case in Rob Marshall's Donmar Warehouse Production recorded on film in the TOFT collection.

48 Act One, Scene 10.

49 Act One, Scene 11, and *Cabaret*, Vocal Score, p. 94.

50 *Cabaret*, Vocal Score, pp. 164–9.

because of the rise of the Nazi Party. The song is a paean of praise to the gorilla the MC is wooing, made explicitly provocative and relevant to the narrative by the final lines 'If you could see her through my eyes, She isn't a meeskite at all'. The connection and commentary between this song and the Schneider/Schultz story and Schultz's song 'Meeskite' is absolutely clear. However, the original version 'She Wouldn't Look Jewish at all' that is written in the score and used in the film version is even more explicit.[51] This connection raises the question of the agency of the MC in the external events, and so again leaves the audience to recognise the plurality of interpretation. This can be amplified in direction and design in performance to provide a commentary on bigotry and hatred in society.

The songs provide a commentary and draw parallels whether diegetic or not, so that characters, situations and images are continually revisited and reinterpreted as new material is added. Raymond Knapp deduces that through the many layerings and commentaries in this musical the audience is encouraged to adopt multiple perspectives, enjoying it 'straight' while relishing its knowing artificiality. Then another layer of insinuation is added 'implying a realm of unparalleled sexual perversity and decadence'.[52] He concludes that:

> Implicitly, part of the appeal of the cabaret is that it is a *constructed* reality, seemingly under the control of the actors. But escaping to the cabaret, so as to construct an alternative fantasy world, involves renouncing the capacity to wield constructive control in the outside world ... The feeling of control offered within the world of cabaret is in the end illusory.[53]

The fantasy world and the loss of control are momentary for Cliff, and are referred to specifically in his song 'Why Should I Wake Up?'[54] and as he leaves Berlin, he refers to himself and Sally when he says 'we were both fast asleep'.

In the reading above, interpretation is in flux throughout the performance, challenging the simplicity of the suggestion that the club songs comment on the narrative. Moreover, there is at least one other level of interpretation than that proposed by Knapp, since most audiences will see the stage show through the lens of the extremely successful film, and read the characterisation of Sally in relation to that by Liza Minnelli, and of the MC in relation to that of Joel Grey. Performances I have seen include not only the film but an actor musician version at Harrogate Theatre, a student production at RADA in London[55] and a video

[51] Act Two, Scene 3 and *Cabaret,* Vocal Score, p. 170.

[52] Knapp, *The American Musical,* p. 241.

[53] Ibid., p. 247.

[54] *Cabaret,* Vocal Score, pp. 86–90.

[55] I was musical director for both of these productions and so saw them many times in rehearsal and performance. My knowledge of the intricacies of script and score is derived from work on these two productions.

recording of the Donmar Warehouse Production,[56] choreographed and directed by Rob Marshall, and starring Natasha Richardson as Sally and Alan Cumming as the MC in New York. All these productions are blended in my reading of the work, though Marshall's production with its imagery of the German Second World War concentration camps and the overt homosexuality and promiscuity in the club was particularly provocative and influential in the reading of the work above. John Bush Jones considers that this version is so extensively altered by the authors as well as the director, especially with the foregrounding of homosexuality, that it should be considered a new show rather than a revival.[57] However, both versions draw the attention of their audiences to the hate crimes and human rights violations of their particular historical periods, the post-Aids discrimination against homosexuality in Mendes' production, and the civil rights movement in the 1966 production.

The use of the grotesque, escapist or libidinal fantasy of the Kit Kat Klub offers the opportunity for the creative teams to incorporate popular genres from burlesque, vaudeville and revue to provide diegetic musical entertainment. So on one level there is the pleasure of libidinal excess in the club performances, but there is also the empathetic enjoyment of the non-diegetic numbers. This combination of overt and covert entertainment is blended with the slippery juxtapositions and parallels that, although historically set, expose uncertainty, gaps and disruptions between parts of the text that might provoke resonances with contemporary events. The potential for multiple readings between the 'real world' and the club, or between so-called diegesis and commentary, between intellectual engagement with multiple plots and libidinal enjoyment of escapist production numbers, or between the interactions and hierarchies of the various plots in different productions with contemporary events, offers audiences stereographic plurality. This opens the potential for access to playful interpretation, for seeing the piece anew at each encounter, for enjoying the libidinal excess of musical and linguistic pleasure, for blending images to produce awareness, entertainment and jouissance.

Kiss of the Spider Woman

The same composer, lyricist and original director were responsible for developing the musical version of *Kiss of the Spider Woman*. Terence McNally developed

[56] This recording was made for the TOFT archive in the Library of the Performing Arts at Lincoln Center, New York. It was recorded at the Roundabout Theatre Company in New York on 1 July 1998.

[57] In contrast to this, in *Remaking the Song* (Berkeley, 2006), Roger Parker discusses radically inventive re-productions of opera. His argument focuses predominantly on the need to recognise that opera is inherently mutable, and that this mutability offers new pleasures in new readings. Bruce Kirle has made a similar case in relation to musical theatre in *Unfinished Show Business*.

the book from Manuel Puig's novel with John Kander and Fred Ebb as composer and lyricist,[58] and Harold Prince as director. In the story Molina, a gay man, is imprisoned for 'corrupting a minor' in an unnamed South American country. In order to survive the brutality of his imprisonment he escapes into his subconscious to relive the movies of the actress, Aurora, whom he used to watch when going to work with his mother, a cinema usherette. Thus his memories of his childhood and his mother are to some extent bound up with the imagery of the star, Aurora. These movies are enacted in song and dance spectacles peopled by Molina and Aurora with the guards and prisoners who, in Prince's production, become the dancers in these numbers. The movie Molina fears most is the one in which Aurora appears as the Spider Woman who kills with her kiss. In the other movies Aurora plays a woman who sacrifices her life for love, movies with which Molina identifies.

Valentin, a political prisoner, is placed in the cell with Molina. The prison warden – a role that could be paralleled with the MC in *Cabaret* – manipulates the situation hoping that Valentin will reveal secrets to Molina that the warden will be able to prise from Molina through bribery, since Valentin is proving resistant to torture. However, Molina falls in love with Valentin, who is increasingly grateful to, and respectful of, Molina's kindness and humanity. Finally, although Molina has the information the warden wants, he dies without revealing it and surrenders to the Spider Woman's kiss. There are unhappy love triangles in this work. Molina is in a triangle loving both his mother and Aurora, where to some extent these two might be seen as overlapping with each other, and Valentin. Valentin, despite the growing friendship with Molina, loves his girlfriend Marta.

There are similarities between *Cabaret* and *Kiss of the Spider Woman* in the use of escapist musical numbers from diverse musical theatre styles. There are also similarities in the way the stories Molina recounts, and the numbers that are re-enacted, relate to the events of the plot, offering a type of meta-narrative. In this case the movie stories not only mirror the situation in the prison, but prefigure the end as Aurora repeatedly, and Molina finally, dies for love. The other similarity, though perhaps more developed and concentrated in this musical than in *Cabaret*, is the presentation of material in montages of short scenes in the prison, and between the prison and the fantasy world. These montages allow the extreme diversity of the images of the glamorous revue-style star and the degradation, torture and inhumane treatment of the prisoners to be amplified and highlighted. At the same time the fantasy movies offer opportunities for extravagance in musical, physical and visual imagery, moments of spectacle, excitement and camp comedy.

The musical incorporates a series of montage scenes. The first montage contains a voice-over of the Spider Woman enjoining Molina to 'Come and Find Me', images of prison life, the arrest for 'interrogation' of Valentin for passing travel

[58] This analysis draws on the production directed by Harold Prince with choreography by Susan Stroman which is recorded for the Theatre and Film and Tape Archive NY at the State University at Purchase on 16 June 1990. This production later came to London, where I saw it, and then Broadway.

documents, a repeated voice-over by the Spider Woman and then the introduction of Molina. This is a montage in which time is compressed or events are happening simultaneously and the sequence is united by a musical theme and by continuous music. This is similar to the opening sequence in *Cabaret* in which the arrival in Berlin is enacted both in the club and on the train. In this case, the continuous and unifying music encourages the linking together of the elements of the montage, though how the various elements might be interpreted is not yet clear.

There are several occurrences of the song 'Over the Wall', sung by the prisoners. It appears first when Valentin is thrown into Molina's cell. Later the song recurs in a longer sequence that is almost filmic in the quick cutting between scenes. In this sequence the prisoners, behind bars, sing the refrain interrupted by Molina being told the warden wants to see him, then by the interview with the warden, and then by the attempted escape of a prisoner who is shot. A gunshot, marking the shooting dead of an escapee, and the climax of the song occur simultaneously, and they occur just after the warden has said 'We encourage hope', and 'We are compassionate men'. The *gestic* parody of compassion and hope is made apparent by its juxtaposition with the torture and shooting dead of a prisoner, and the code that suggests the images should be read together derives from the musical continuity.

The effect of this type of layering is that a lot of diverse materials are brought together so that information is communicated through a musico-dramatic shorthand, and the juxtaposition of images can create an emotional understanding in the gaps between what is presented. In the longest version of 'Over the Wall', the warden describes himself to Molina as compassionate even as that information is undermined by the song lyrics, the chase and the shooting. These events make the warden's calmness and Molina's possible belief in his compassion far more chilling, and the reasons for the prisoners' fear become evident, at least to the audience. The sense of hopelessness and the climax of anger and frustration are achieved through the combination of scenes and song in the montage. Moreover, the continuous musical accompaniment not only gives unity, but also provides a lyrical and musical context for the material. This adds another layer of signification, and harmonically and vocally drives the montage's pace, atmosphere and volume. The harmonic development and orchestral and vocal crescendo ensure that the scene builds to a powerful musical climax.

Another reprise occurs overlaid with Valentin singing of his girlfriend Marta. This moment represents a further link in the chain that now includes not only the narrative information that has been gathered, but the particular material that relates to the various occurrences of this song. A web of intratextual links is being created. A further reprise occurs towards the end of the performance when Molina is to be released and Valentin gives him a message to take out of the prison. This is what the warden has planned, but Molina tries to dupe him with false information. So this song not only creates unity within each of these montage scenes, but draws the various stages of the influence of the warden and the horror and inhumane torture in the prison together. The song ultimately unites the shooting of the escapee in the

earlier scene with the threats, blackmail and manipulation practised by the warden and the shooting of Molina at the end. The powerlessness of the victims in the face of the nameless, state-imposed ideology is thus enacted through the repetitions of this refrain.

A different type of montage is produced during the quartet 'Dear One' which occurs after Molina encourages Valentin to think of his girlfriend, Marta, as an escape from the degradation and humiliation of the prison. As Valentin thinks of her she appears, as does Molina's mother who he has been talking about. The two women in their separate worlds sing of their love for their missing dear ones, which turns into a quartet in which each inhabits her/his own world singing of their absent 'dear one'. This type of montage has a much longer history in musical theatre and opera, and the example of the Quintet from *West Side Story* will be discussed in the next chapter. This device allows audiences to be simultaneously aware of the different emotional positions of a number of characters while drawing them together into a harmonically and emotionally consonant presentation and a vocal and orchestral climax.

There are other spectacular uses of montage in the scenes in which Molina recounts the films starring Aurora, and which are re-enacted as a vision of what he sees in his mind. This is an escapist tactic so that he doesn't hear what he doesn't want to, but also allows the authors to prefigure and link events that will occur in the prison story. This has the effect of creating dramatic irony as the audience anticipates the death of Molina even as the character becomes most hopeful. The final scene of the first act begins with Valentin being poisoned, but since he would give away information if given morphine in the infirmary, Molina cares for Valentin and distracts him with the story of the film 'Birds of Paradise'. Aurora is a bird in a cage in a Vegas-style showgirl costume who is imprisoned but will never betray the man she loves. The dance is a sexy mambo with a long drum break and high trumpet solo that rises to a climax as Molina joins in. A scene in the warden's office is interjected in which Molina lies about Valentin's girlfriend, after which the movements in the birdcage become increasingly violent and frantic and the music is overlaid with distorted nightmarish sounds. These images of the captured bird dying for love create a montage with the scenes in the prison of Molina caring for Valentin and then lying to protect him. The birdcage thus mirrors their imprisonment, and the bird's frantic attempts to escape embody the impotence of Molina and Valentin, Molina's futile attempts to resist the warden, and the torture they will both endure before Molina, having become politically active for love of Valentin, like the captive bird, dies.

In 'I do Miracles' Aurora takes over from Molina's narration wearing white tie and tails to perform a song and dance that turns into a big production number accompanied by the prisoners as chorus boys who lift and throw Aurora in a vaudeville inspired jazz routine. The costuming and style of this number prefigure the final scene when Molina, attempting to help his lover Valentin, and believing he can do miracles, dies in the arms of the Spider Woman. The final scene is also linked to the movie story of the 'Flame of St Petersburg'. In this film Aurora is a

Russian singer engaged to a wealthy Russian, performing for her adoring public, mirrored by Molina. She returns to her dressing room to find a note saying that her secret lover will be shot. She risks everything for her secret lover and leaves her fiancé. In a scene of melodramatic excess she runs to her lover, there is a gunshot and she collapses, but she puts on a smile and in a tragi-comic moment of outrageous camp, sings as she dies, reviving and singing several times, before finally dying, proclaiming the words 'Viva la revolucion'.

In the final scenes Molina is released and agrees to make a phone call for Valentin. He is followed, re-captured and tortured but refuses to give up Valentin's girlfriend's name and, finally, is shot. Molina escapes into his fantasy world, in white tie and tails, and sings 'Only in the Movies' with two male dancers before acting out a melodramatic death-scene mirroring that in the 'Flame of St Petersburg' film. The Spider Woman joins him and they tango in white tie and tails. The dance includes comic visual references to the dying swan of *Swan Lake* and the pose of Michelangelo's Pièta with Molina in Aurora's arms, before finally he kisses her to rapturous applause.

Although each of these scenes is constructed as a montage there is also an intratextual connection between the fantasy scenes and a meta-textual connection between these scenes, the narrative, the book from which it was drawn and the film of the book, as well as a *gestic* link to human rights violations and hatred of homosexuality around the world. There are other features of montage here, too, that allow information to be communicated in compressed time, and that allow the juxtaposition of images so that the audience has the opportunity to interpret diverse materials, blending the images together in a process of continual transformation and playfulness. Important too is the camp reference to the performance history of musical theatre, not only because of the associations derived from the presence of Chita Rivera as the Spider Woman, but because of the incorporation of musical theatre styles in music and choreography. There is the Hollywood film imagery of white tie and tails and the Vegas showgirl imagery of the caged bird sequence and so on. These fantasy moments are eruptions of musical and choreographic excess created through visual and aural reference that produce camp and ironic spectacle. These playful, libidinal moments increase the contrast between light and dark, high and low, comic, melodramatic and tragic. Such eruptions relate to Barthes's construction of pleasure in the excesses of the text, and jouissance in the gaps created within the text, so that increasingly dark themes can be addressed in a form that is perceived as light-hearted and escapist.

Assassins[59]

In *Assassins*, by John Weidman and Stephen Sondheim, there is no single plot, but a fantasy linking the stories of the assassinations and attempted assassinations of American presidents presented as a fairground shooting game. The narratives of the would-be assassins are enacted, but there are also fictional interactions between the historical figures who lived in different times and places.[60] The thematic link is the attempt to kill the president, but the content of the musical engages with the sense of frustration, alienation or misguided patriotism that leads to these extreme responses. The musical language contains a combination of parodies and pastiches of musical styles drawn from popular culture that, as Knapp remarks, evoke time periods and musico-historical landscapes that are 'eerily distressed'.[61] Knapp comments on the connections of the practice of disrupting the genre parody to the works of Brecht and Blitzstein, though he also clearly locates this work in the 'mainstream tradition of the American musical'.[62] He identifies intertextual links the musical makes with several other well known musicals; *Oklahoma!, Guys and Dolls, Show Boat* and later *The Music Man.*[63] Meanwhile Thomas P. Adler makes the case that it employs 'Arthur Miller's *Death of a Salesman* (1949) with its "independent, proud … decent man who tries and tries but never gets a break" as an explicit intertext',[64] and that it is reminiscent of *A Chorus Line* in its 'denial of unlimited possibility'.[65] This combination of intertextual links with other musicals and parodies of popular music genres opens the potential for audience interpretation and the intellectual playfulness of conceptual blending.

The musical also combines many of the structural features discussed above. It is framed by the song 'Everybody's Got the Right to be Happy', just as *Cabaret* is framed by 'Wilkommen'. Also, like *Cabaret*, it has a 'puppet master' who oversees events. This role is played by the fairground proprietor who turns out to be John Wilkes Booth, the first assassin who then encourages the others. There is also a

[59] This analysis refers to the production by Roundabout Theatre Company recorded at Studio 54 in New York on 9 June 2004 and available in the TOFT archive. It was directed by Joe Mantello with musical staging by Jonathan Butterell. The Musical Director was Paul Gemignani.

[60] This is a strategy that has also been seen in Caryl Churchill's *Top Girls* (1982) and Michael Frayn's *Copenhagen* (1998) among others.

[61] Knapp, *The American Musical*, p. 165.

[62] Ibid., p. 166.

[63] Ibid., p. 167 and 174. In fact the reading of *Assassins* in relation to American Identity is particularly interesting to a British outsider – a point which Knapp explores in relation to the different responses in the UK and US, pp. 162–76.

[64] Thomas P. Adler, 'The Sung and the Said: Literary Value in the Musical Dramas of Stephen Sondheim', in Goodhart, *Reading Stephen Sondheim*, p. 56. This is a quotation from the script of *Assassins*, p. 93.

[65] Ibid., p. 57.

balladeer who narrates 'The Ballad of Booth'. He tells the stories and interjects choruses between the other scenes before, in the final scene, turning out to be Lee Harvey Oswald. There is a connection between these two characters which frames the musical with the first and most recent US presidential assassinations. As in *Kiss of the Spider Woman* there are montage scenes, such as the execution of Guiseppe Zangara, which is set against a series of witnesses telling their stories to the media. This is mirrored at the end with testimony of how people remember the moment of the shooting of Kennedy. Other montages occur to draw similarities and differences between the motivations of the protagonists. John Hinckley sings of his love for Jodie Foster alongside Squeaky Fromme singing of her love for Charles Manson. Both decide to kill for love. A later montage involves all of the protagonists explaining the reasons why they were driven to do what they did, to which the narrator responds that 'it didn't mean a nickel you just shed a little blood'.

The material itself is challenging as it is presented from the perspective of the assassins, some of whom seem mad, while others seem to be taking extremist positions that they are driven to by society. The histories and life situations of the characters are presented as comic vignettes so that the audience laughs at but also, in some cases, begins to empathise with the situations. The love song sung by John Hinckley and Squeaky Fromme draws the audience into empathy with the beautiful song and sentiments, which makes the plot situation absurd and the consequences all the more chilling. Sam Beck records fictitious conversations with Leonard Bernstein explaining his motives during which the audience laughs at the comedy, discovers Beck's bizarre employment history, and also begins to understand and empathise with the essential loss of faith in politicians that drives him, even while denouncing the extremism of his solution. So a comic situation of a fanatic railing at an unseen celebrity becomes something more chilling in light of the apparently reasonable argument about political sleaze and the writer's ability to make the character seem outrageous but also funny.

The time frame of *Assassins* is not chronological, and nor does it present a linear plot. It contains multiple narratives, intertextual references and individual histories, drawn into a juxtaposition that requires the audience to interpret. To do this it employs strategies that draw together moments of comedy, melodrama and tragedy with generically recognisable but disrupted music that provides escapism, libidinal excess and, alongside the stereographic plurality of all parts of the text, jouissance.

Conclusion

Narratives and a linear plot are not necessarily the same thing, and musicals can be held together other than by the linear narrative of the book musical as has been seen in the examples above. Musicals can be based around a thematic concept, as in *Assassins*, or include complex meta-narratives as in *Cabaret* and *The Kiss of the Spider Woman*. Montage structures can be used in any of these forms, or indeed

in a musical with a linear narrative. Unity can be provided by the continuity of characters and performers as well as by the development of situations. All this suggests that there is enormous variety in the forms musical theatre can take, that it can be adaptable to its content, and that it offers the potential to present diverse subjects through those diverse forms, though predominantly with a focus on human relationships.

The result of these alternative narrative strategies, montage, collage, or non-linear time-structuring, is that a gap can be created for the audience to imagine or to construct meanings or interpretations. These forms make that possible, but they require a particular type of content and production to open up the possibility of a *gestic* interpretation. The gap created by the juxtaposition of materials in a complex form might be a gap for pleasure or bliss. Any particular text is dissolvable, made up of traces of other meanings, other texts, which undo any received meaning, and are replaced by the transporting pleasure of being constructed through the play of signification. Reading this type of multiple text gives the reader pleasure through its own multiplicity, even disintegration.[66]

In all of these three works there are 'tragic' endings that are arrived at through escapism, camp and intertextual association, melodrama and comedy. These musicals also contain gaps and disruptions that allow audiences to perceive a more fundamental tragedy if they make *gestic* connections between musical theatre's escapist entertainments, tragi-comic or melodramatic plots and the real world. So these musicals function on many levels, levels which audiences read and blend as they choose. The blending of images constructed by audiences at performances of these works opens up the possibility of individual and communal interpretation. Communal experience results from the entrainment or synchrony of the audiovisual text, while the individual response derives from a personal interpretation of blended stimuli and from subconscious decisions about how to react to the experience of synchrony. The stereophony or multiplicity of the associations created both within and without the text allows the audience to be entertained even as it is made aware. The cliché of musical theatre making audiences laugh and cry in a cathartic excess is enacted in these musicals, which, whether or not they provide catharsis, contain an excessive dynamic range from fantasy and comedy to melodrama and tragedy. Moreover, the audiovisual combination produces synchrony in interpretation that allows audiences to experience the pleasure of bonding even as individual interpretation offers different blends of the plural, libidinal and dynamic text. This combination of stereographic plurality, libidinal excess and dynamic range might begin to account for the ability of musical theatre to entertain.

[66] Janelle Reinelt, 'Introduction to Deconstruction and Semiotics', in Janelle Reinelt and Joseph Roach (eds), *Critical Theory and Performance* (Ann Arbor, 1992), pp. 109–16.

Chapter 6

Illusions of Realism in *West Side Story* and Actor-Musician Performances

I've argued above that musical theatre relies on a construction of integration that is signified and codified by individually disjunctive elements and blended by audiences into an individual and communal interpretation. But where does that leave the performer in a book musical who attempts to create a coherent characterisation? Having identified the opportunities for alienation that can be created between performer and character, speech and song, narrative and real world, the question is raised whether those gaps or disruptions always alienate the audience's acceptance of the coherent character or situation. What tools does musical theatre employ to assist the audience in making sense of the disjunction of speech and song? Scott McMillin argues that such discrepancies create the crackle of difference that is one of the joys of musical theatre. He describes the two orders of time in musical theatre as 'book time' and 'lyric time' in which the latter is that 'time organized not by cause and effect (which is how book time works) but by the principles of repetition (which is how numbers work)'.[1]

Musicals that might be termed 'integrated' or that wish to present a linear narrative rely on a construction of realism in which audiences ignore the theatrical frameworks within which they are created and the movement between book time and lyric time. Suspension of disbelief allows that audiences 'don't see' and 'don't hear' the orchestra in the pit during non-diegetic songs. More importantly, audiences are expected to ignore the moment of disruption and the change of tempo and language as the performer moves from speech to song, or as groups sing together, or even – possibly – as performers pick up musical instruments, step outside their characters and play the accompaniment to the song being sung by another performer/character. The identification of performer with role and narrative is assumed to be complete, and in many cases attempts are made within the performance to foster that illusion.

This chapter will build on the idea of the conceptual blend that audiences read into the diverse elements of musical theatre, drawing on specific examples from *West Side Story*. These examples will be used to explore the moments of transition from speech to song, the alterations of time in narrative and number, and the importance of the vocal cry and the choral climax, in order to demonstrate some of the ways in which the perception of 'realism' is constructed or replaced. Finally, some examples from performances using actor-musicians will be introduced to

[1] McMillin, *The Musical as Drama*, p. 9.

challenge the extent to which performer and character can be perceived as separate within a linear narrative, and the consequences this has for understanding and for pleasure.

Realism

'Realism' in the nineteenth-century drama was 'a less extreme form of naturalism' in which playwrights rejected the artifice and exaggerated theatricality of the well-made play in favour of 'the portrayal of life with fidelity'.[2] The portrayal of life with fidelity has important consequences for the style that performers used, but realism was never designed to represent life accurately, it was designed to create that illusion. As Marvin Carlson notes, George Henry Lewes' treatise *On Actors and the Art of Acting* of 1875 suggests that actors should 'represent character with such truthfulness that it shall affect us as real, not to drag down ideal character to the vulgar level'.[3] Lewes believed that daily speech and actions should be purified so that spectators 'recognising these expressions, are thrown into a state of sympathy', and that the acting style should be adapted for the particular play and the audience.[4] Although realism was very soon superseded by symbolist, surrealist and modernist approaches in some forms of theatre, this style of acting later became important as the basis for the representation of characters for performers in book musicals. Realism requires the performer to create a depiction that portrays the inner workings of the mind of the character such that there is consistency between emotional responses and the events of the drama; psychological realism. Bert States notes that in what he terms 'the representational mode'[5] actors perform in ways that signify 'realism' within the performance genre, and that 'what we call realism is no closer to reality than many forms of representation we would call stylized'.[6] He continues: 'It depends only on the power of the image to serve as a channel for what of reality is of immediate interest to the audience.'[7] So the idea of realism is simply a constructed framework that gives audiences and performers guidance as to how to act and what to expect. Audiences then blend the information about character and story with admiration for the continuity of expression in song and speech, or appreciation of the technical vocal expertise. They appreciate the

 [2] J.A. Cudden, *The Penguin Dictionary of Literary Terms and Literary Theory* (London, 1999), p. 732.

 [3] Lewes, *On Actors and the Art of Acting*, pp. 112–13, quoted in Carlson, *Theories of the Theatre*, p. 230.

 [4] Ibid, p. 124 quoted in Carlson, *Theories of the Theatre*, p. 230.

 [5] Bert O. States, 'The Actor's Presence', in Phillip Zarrilli (ed.), *Acting (Re) Considered* (New York and London, 1995), p. 23.

 [6] Ibid., p. 36.

 [7] Ibid., p. 37.

whole performance that is simultaneously read as both performance and narrative, performed by actor/singer and character.

Music and lyrics can be written in ways that signify the movement from speech to song as 'realistic' so that all other elements appear to serve the plot and each has a role in supporting and contributing to a narrative line. Plainly, the moment a character begins singing there is a conflict of performance style as the performer is forced to move from a spoken interaction with fellow characters to a sung – or irrational – delivery. The speed of time passing can be either compressed or expanded, and the interaction with other characters alters in its relationship to a 'realistic' expression, especially in duet, ensemble or choral singing. However, as Karen Gaylord argues, part of the understanding of any theatre event is the knowledge of the mode, the signification of the genre gained through previous experience of the genre, knowledge of the expected behaviour, as well as external production signs – venue, marketing materials and so on.[8] Individual audience members recognise a particular frame for the performance of musical theatre and suspend their disbelief according to their expectations of the genre. In the case of musical theatre the audience expects the performers to break into song and so accepts that reality as the 'realism' of the performance. Susan Bennett identifies Gaylord's notion of two frames, the playing space and the external signification of genre and expectation when she remarks, 'it is the intersection of these two frames which forms the spectator's cultural understanding and experience of theatre'.[9]

So audiences expect and therefore accept performers breaking into song, but that does not necessarily mean that the moment music or song begins is not disruptive. As identified above, reflexivity can cause a disruption in identification with the characters or narrative and create distance between audience and performance because of its separation from the continuum in which it is embedded.[10] Even as it does this, the content is incorporated into the understanding of the performance by the audience.

In musical theatre, as has been seen in the previous chapters, reflexivity can be used very effectively not only for dramatic effect in distancing the audience from empathy with a character, but perhaps in creating empathy with a character, as in the portrayal of Sweeney Todd as villain and victim, or in the persona of the narrator in *Into the Woods*. Equally, designers and directors can frame a performance with an internal stage or false proscenium, or create audience performer relationships through seating arrangements, walkways and so on that contribute to a reflexive reading throughout the performance, as in *Cabaret*. Performers need do no more than look, nod or wink at the audience and a new complicit relationship is established that can contribute to the perception of reflexivity and a double reading

[8] Karen Gaylord, 'Theatrical Performances: Structure and Process, Tradition and Revolt', in Jack Kamerman and Rosanne Martorella (eds), *Performers and Performances: The Social Organization of Artistic Work* (New York, 1983), pp. 135–50.

[9] Susan Bennett, *Theatre Audiences* (London and New York, 1997), p. 2.

[10] Abbate, *Unsung Voices*, p. 29.

of performer and character that alters the understanding of the 'realism' of the plot while contributing to the understanding of the performance as a whole.[11]

However, notwithstanding the argument that audiences will accept the disjunction of a movement from speech to song, and perhaps because the start of music or song is likely to have a distancing effect, composers and directors have striven to render the beginning of non-diegetic musical accompaniment and the movement from speech to song invisible. As was seen in the discussion of *Sweeney Todd* above, musical techniques have developed, such as the use of underscore before the start of a musical number so that the performer merely carries on 'speaking' but with a greater range of pitch, more extension of vowel sounds, and greater rhythmic control. Arch structures based on a ternary form or its extension are a device for soliloquising so that audiences accept the performer easing into and out of the sung form almost seamlessly, as, for example, in 'Something's Coming' from *West Side Story*[12] or 'A Very Nice Prince' and its developed reprise 'On the Steps of the Palace' from *Into the Woods*.[13] In these examples the music begins underneath speech and continues as the performer begins with short phrases close to the pitch of speech before expanding into longer phrases and a greater musical range. The songs end with a return to the musical material of the start, returning the performer to the mood, vocal range and emotional pitch at which she or he began, and the music ends relatively unobtrusively.

Other formal structures can be used but the gradual movement from speech to song, through underscoring introductions and the use of a sort of speech-song or parlando is a feature of the verses of songs in many mid-century and later musicals. For example, 'Why Can't You Behave'[14] has an introduction that is designed to be played under dialogue, and 'Always True to You Darling in My Fashion', also from *Kiss Me, Kate*, has a verse that develops out of speech as a *colla voce* soliloquy before the sudden change of mood and style for the refrain. In *Cabaret* all the non-diegetic songs have a gradual development from speech to song. This is exemplified by Fraulein Schneider's 'So What' that begins with a spoken section over a free accompaniment, gradually moving into song for a line at Bar 8 before returning to speech until the start of the verse in an allegretto ¾ time. 'Why Should I Wake Up' has an underscored section at the start, and at the end of the first verse Sally and Cliff continue the scene over the musical continuation of the song before Cliff reprises the second half of the verse. In all these cases the start

[11] A very interesting article by Celine Parrenas Shimizu, 'The Bind of Representation: Performing and Consuming Hypersexuality in *Miss Saigon*', *Theatre Journal*, 57/2 (2005), explores the ways the nuances of a performance can critically challenge an intercultural and gendered reading.

[12] Music by Leonard Bernstein, Lyrics by Stephen Sondheim, Book by Arthur Laurents, 1957.

[13] Music and Lyrics by Stephen Sondheim, Book by James Lapine, 1988.

[14] *Kiss Me, Kate*, Music and Lyrics by Cole Porter, Book by Sam and Bella Spewack, 1948.

of the music is disguised to create a sense of fluidity and maintain the character's arc of development. The scene continues within or between sung sections, but the end of the song is less disguised if applause or a move to another scene is desired. So the formal musical structures are used to signify continuity or change, and cue the disruption of applause or the transition back to speech to an audience that understands the genre.

It is notable that these are devices confined to the non-diegetic songs of these show-within-a-show musicals, where integration is considered desirable. To some extent they reduce the awareness of the movement into song or between speech and song. The effect of this overlapping of dialogue and music, or parlando before full song, is to make the start of a song a gradual and imprecise process rather than a defined moment. However, rather than hiding the disjunction, the end result is to signify the moment as 'natural' or 'realistic' so that audiences continue to suspend disbelief. Through the use of such devices audiences have learned to accept the disjunction of performance modes and continue to engage with the music and lyrics as a development of the plot, or as a development of the emotional understanding of the character. These patterns have continued in many musicals as a technique that allows the musical to signify itself as 'integrated' and to signify that there is character and plot continuity.

Stephen Banfield has argued that since the 1960s, the advent of deconstruction and the socio-politics of the time have made the construction of classic integrated texts troublesome.[15] As was apparent in the last chapters, Sondheim with various book writers, and Kander and Ebb with their collaborators, have explored a range of constructions other than the linear.[16] But the reflexivity of musical theatre has always been present in the show-within-a-show musicals,[17] in the use of pastiche and genre stereotypes to suggest time and place, and even in the simple act of breaking into song. As was seen in the first scene of *Sweeney Todd* above, Sondheim has at times developed and refined the movement between song and speech and the interaction between company and individual in ways that render the joins almost unnoticeable. And yet, as was seen in that discussion, at all levels of the dramatic and musical structure there is play with the emotional distance between audience and performance that undermines a simple interpretation of integration. However, for performers, the work may still be performed using the techniques of a constructed 'realism'.

'Realism' has two very clear purposes. Firstly, it separates two realities, the external world and the theatre world so that the illusion is created that the theatre imitates an external reality without the external reality being presented for direct comparison. Secondly, it gives audiences the opportunity to empathise with

[15] Banfield, *Sondheim's Broadway Musicals*, p. 41.

[16] Notably Harold Prince has worked as director on 'deconstructed' musicals by both of these writing teams.

[17] As argued in relation to film by Jane Feuer in *The Hollywood Musical* (London, 1993).

characters despite the characters behaving in 'irrational' ways, such as singing about their feelings. The audience chooses to believe in the illusion of coherent behaviour and causal relationships, supported by particular musical constructions, as 'realistic'. Moreover, the assumption of a realistic approach to narrative or to character portrayal encourages the audience to an empathetic reading of narrative and character.

However, the reality is that an actor is standing on stage, listening to the orchestra and starting to sing. The character takes a leap from a spoken enacted portrayal, and, although the performer may maintain a realistic psychological development from one moment to the next, the act of singing and the intrusion of the orchestra alter the mode of representation. The audience may still accept the performance as realistic within the genre, but the vocal technique, the beauty of the voice, the harmonious interaction with the orchestra, and in some cases the simultaneous delivery by several performers all allow the mechanics of the performance to be revealed. This could be equated with States' 'self-expressive mode', in which the artifice and artistry of the performer is revealed, even while both narrative construction and character development are maintained.[18] But the question here is what does this do to the illusion of realism at this moment when the mode of performance changes and a multitude of images, musical, physical and verbal, are simultaneously presented? In this chapter it is argued that this offers opportunities for variations of time-structuring in the narrative, and consequently increases the opportunity for empathy. On the other hand, at extreme moments the vocal utterance can be argued to remove awareness of time and place completely, so that the awareness of character, performance and narrative are all subsumed by the visceral and corporeal thrill of vocal and musical excess.

West Side Story

In order to explore these ideas, three moments from *West Side Story* will be analysed.[19] They are: Tony's solo 'Something's Coming';[20] the duet between Maria and Anita, 'A Boy Like That';[21] and the company finale to Act One, generally referred to as the Quintet, but officially entitled 'Tonight'.[22] This musical is a useful model because it creates a supposedly realistic portrayal of character and urban society through extremely stylised means. As Carol J. Oja remarks, '*West Side Story* was perceived immediately as not just another musical comedy, but,

[18] States, 'The Actor's Presence', p. 24.

[19] The show has been repeatedly revived following the success of the film version and at the time of writing is playing on Broadway. I will refer to the Vocal Score published by Chappell and Co., to a European tour of the show in 1986–7, and to the film version.

[20] Vocal Score No. 3, pp. 27–34.

[21] Vocal Score No. 15, pp. 180–90.

[22] Vocal Score No. 10, pp. 111–26.

rather, as a work of art. It was treated as a hybrid – a fusion of musical theatre, dramatic tragedy, dance, and opera – and critics embraced it as innovative'.[23] Raymond Knapp notes the 'oft-remarked motivic integration' of the music as different to nineteenth-century models but 'it serves a similar dramatic and integrative function'.[24] He suggests that the musical fabric creates the affective logic of the piece, 'gives the basic premises of the world it creates a tangible shape, and thereby encourages belief'.[25]

West Side Story opens with an instrumental prologue during which the Jets and Sharks are introduced performing stylised fighting and running sequences. The prologue culminates in a fight that is interrupted by the police. The Jets have a short scene at the end of which Riff, their leader, leaves to persuade Tony to go with them to a dance that evening at which they will challenge the rival gang, the Sharks, to a fight or rumble. The next scene takes place outside the drugstore where Tony is now working. In it Riff reminds Tony of their childhood together and calls on Tony's loyalty in persuading him to come to the dance. Tony speaks of a different life that he is starting to carve out for himself, and that there is a better future waiting for him. When Riff leaves, Tony sings of his anticipation that life is going to change for the better in 'Something's Coming'.

Throughout the scene the two friends address each other in familiar language, though there remains the formality of 'realistic' theatre in that they never interrupt each other or digress. The pace of the exchange is that of ordinary speech, Tony is anxious not to interrupt his work so keeps attempting to get back to his job, while Riff delays him until he agrees to the request. The scene is, in fact, very short and allows only the briefest of character exposure; we learn that Tony's parents took Riff in so they grew up, effectively, as brothers. At this point the audience can believe in the scene which is presented with what is arguably a 'realistic' approach.

During Riff's final comment 'Maybe what you're waiting for will be twitchin'' at the dance' the music begins. The syncopated melodic motif over a regular triplet pattern in the bass begins the sensation of anticipation and excitement that pervades the song. Over the accompaniment the melody consists of short excited phrases and long sustained notes as Tony weaves his dream of the future. After the opening two sustained phrases, that are slow in terms of speech pacing but fairly realistic in terms of pitch shape, the rhythmic pattern of the words suddenly takes on a most unrealistic phrasing with the syllables alternating in groups of one then two as follows: 'There's /something / due // any / day;// I will / know //right a / way'.[26] This might be played as the excitement of someone who can

[23] Carol J. Oja, 'West Side Story and The Music Man: Whiteness, Immigration, and Race in the US during the Late 1950s', *Studies in Musical Theatre*, 3/1 (2009): pp. 13–30. This reference p. 15.

[24] Knapp, *The American Musical*, p. 209.

[25] Ibid., p. 211. Knapp provides a useful analysis of the signification of the motivic and structural devices in the musical on pp. 204–15.

[26] Vocal Score, p. 28.

barely get their breath, or the uncertain delivery of a character who doesn't dare speak the words aloud for fear of dispersing the image – it is for the actor and director to interpret the emotion behind the delivery. The phrase culminates in the longer phrase: 'Soon as it shows', which is sustained over four bars. This entire phrase, although rhythmically altered, retains a rough congruency with the pitch of speech, though its rising and falling patterns are more symmetrical than might otherwise be anticipated.

The harmony is repetitive so that although the tension is signified rhythmically, there is no harmonic development. This could signify that Tony is feeling excitement about the future, but there is no movement forward yet. So the music's commencement followed by the beginning of half-sung speech has moved beyond a realistic representation, but the signification of music and lyrics continues to enhance the psychological understanding of the character. The middle section of the song contains a much longer lyrical phrase that rides above the excited accompaniment and contains a much greater vocal range rising a seventh above its starting note: 'Around the corner or whistling down the river, come on, deliver to me.'[27] This line is echoed in the penultimate line: 'The air is humming, and something great is coming! Who knows?'[28] with the climax of the song on the word 'great'. Finally, the excited speech returns as the orchestra and the voice decrescendo: 'It's only just out of reach, down the block, on a beach, Maybe tonight ... '.[29] The overall structure moves from speech in the scene to stylised song/speech in the first part of the song, to lyrical singing, and then returns to stylised song/speech as the scene ends and the music fades.

Several features become apparent. First, the pace of speech is altered and its rhythms become much less 'realistic' than in the scene. Second, the pace of the vocal delivery and its dynamic range both vary through a much greater range than during the spoken scenes. Thirdly, the accompaniment adds to the amount of information being assimilated by the audience during the song. These features may all appear to be self-evident, but for both audience and performer they require a step-change in reception as the artistry of the performer playing the character is revealed through his technical proficiency and vocal control. This song is carefully designed so that the performer is able to make a smooth transition between speech and song in an arch-like structure, but there is still a marked difference. For the performer there is an attempt to maintain the illusion of a causal relationship between the scene which provides the catalyst for the song, and the consistency of the character. But the actor moves from addressing another actor to addressing himself or the listening auditorium – a move away from a realistic address, since he is now vocalising what the audience can only assume to be his inner thoughts and emotions. There is also the musical accompaniment that creates a framework and pace that the actor must incorporate into his understanding

[27] Ibid., pp. 31–2.

[28] Ibid., pp. 33–4.

[29] Ibid., p. 34.

of the scene. For the audience, there is the equivalent change of address from two performers conversing behind the fourth wall to the position where a single performer is soliloquising in song, with an accompaniment that contributes to the signification and atmosphere. This is a more reflexively theatrical form of address. The performer doesn't acknowledge the audience's or the orchestra's presence, but the material is presented in a form of soliloquy.

Excitement is communicated through the driving rhythms of the musical accompaniment, so there is a second level of information and atmosphere that contributes to understanding the character. The repetitive structure of the song signifies the start and end of the song as similar, so that the song itself appears to represent a moment 'out of time'. A bubble world is created that is consistent with the psychological reality of the character, and expresses his emotional mood, but is separated from its mode of delivery and time structure. This change of pace can be considered as similar to the possibilities in novels, in which a particular event or attitude can be focused on in great detail. As Seymour Chatman argues in 'What Novels can do that Films can't (and Vice Versa)', descriptive passages in novels are of a different 'kind' from the narrative proper, since the timeline of the narrative is stopped and the characters appear as in a *tableau-vivant*.[30] There is a similar effect in the musical theatre in moments such as this song, in which the time frame alters and allows the audience to be drawn into a closer examination of the character through the verbal and musical information of the song.

The change of pace and address thus draws the focus of the audience onto a particular character, situation or event, and delays the development of the plot. At the same time, the change of timeline reveals the illusion of the theatre, while the performer is continuing to 'realistically' portray the intentions of the character. The move to a new mode of delivery, singing, highlights the separation of the external world from the theatre world and reflexively reveals the artificiality or illusion that the audience is choosing to accept as 'reality'. However, the focus on a particular moment and character and the change of pace that allows that to happen are an opportunity for character revelation, and for the complexity of image that the combination of music and lyrics makes possible, and so contributes to the possibility of identification and empathy. In addition, the vocal range, the lyrical phrasing and the technical facility of the performer signify the character as heroic.

Finally, however, there comes a point, especially in the high, lyrical middle section of the song, when the vocal sound becomes its own reason and object. There is pleasure in hearing the voice that supersedes character, performer and situation and allows the voice to become a profoundly moving corporeal presence that joins listeners and performers in a moment of blissful excess. For some theorists this can be perceived as a moment of disembodiment or vocal autonomy but for others it is a moment of kinaesthetic presence.

[30] Seymour Chatman, 'What Novels can do that Films can't', in W.J.T. Mitchell (ed.), *On Narrative* (Chicago and London, 1981), pp. 117–37. This reference p. 119.

Patrice Pavis perceives a split between the act of singing and that which is being sung and by whom. He places the voice-object on both sides of what he describes as the 'Gestic Split', as it belongs simultaneously to the 'shown' part of the text, character, and the 'showing' part of the text, performer.[31] The performer is not only singing, but showing a person singing. In this formulation two of Bert O. States' modes of acting, the representative mode, character, and the self-expressive mode, performer, are simultaneously present.[32] Using conceptual blending, audiences can remain simultaneously aware of both of these aspects of performance and 'realism' is maintained. However, as Calico points out, Carolyn Abbate takes a further step. She suggests that the voice-object introduces a third autonomous level, separated from the music and the singer:

> Following Michel Poizat, Abbate distinguishes among a rational, text-oriented mode of vocalism (recitative); that of the voice-object; and a third level 'at which either of the first two are breached by consciousness of the real performer, of witnessing a performance.'[33]

In light of this Calico develops Pavis' *gestic* split, saying that the fetishisation of the singing voice, as opposed to the speaking voice, in musical theatre and opera suggests that its function is quite different. Rather than the song being the result of the scene, the scene could be read as the excuse for the moment of vocal display. In this case, the *gestic* split would be

> between the act of singing and that which is *literally* sung (the voice-object), which the act of singing produces, rather than between the act of singing and that which is sung, meaning the text and melody the singer *re*produces.[34]

Since the voice-object and the irrationality of singing is what is argued to induce intoxication or ecstasy, the singing voice could render the disruption of *gestus* impotent. If the scene is merely the excuse for vocal display and corresponding ecstasy in the audience the steps taken to begin the song, whether seemingly real or integrated or not, become relatively unimportant.

However, Dominic Symonds develops an argument from Roland Barthes and others to disagree with this formulation. He argues that both Poizat's and Abbate's theories 'though conceptually appealing, are problematized by the material requirements that sounding music inevitably demands'. Abbate acknowledges

[31] Patrice Pavis, 'Brechtian Gestus and Its Avatars in Contemporary Theatre', *Brecht Yearbook*, 24 (1999): pp. 177–90. Referred to in Joy Calico, *Brecht at the Opera* (Berkeley, 2008), p. 73.

[32] States, 'The Actor's Presence', p. 23.

[33] Calico, *Brecht at the Opera*, p. 73. Calico refers in this quotation to Poizat, *The Angel's Cry* and Abbate, *Unsung Voices*.

[34] Calico, *Brecht at the Opera*, p. 74.

this when she says that the 'live voice suggests the individuality and autonomy of the singer is a phenomenon that cannot be dismissed'.[35] Symonds therefore concludes that '[i]n theatricalized performance such phenomenological presence is not only aurally but also visually, kinaesthetically and corporeally witnessed'.[36] This suggests the importance of the audiovisual link between character, performer, voice and body, as well as a relationship between voice and audience.

Katie Overy and Istvan Molnar-Szakacs look at both the neural and emotional responses to music and dance in their paper 'Leaping Around in Our Minds'.[37] They have built up a body of evidence that suggests that musical sound is perceived not only in terms of the auditory signal, but also in terms of the expressive gestures of the performer. They suggest that motion information from the performer is processed by the mirror neuron system, while the limbic system allows information to be evaluated in relation to one's autonomic and emotional state. This leads to a complex emotional response to music based on both the sight and sound of the performer so that

> the expressive dynamics of heard sound gestures can be interpreted in terms of the expressive dynamics of personal vocal and physical gestures, allowing music to convey a sense of agency – a sense of the presence of another person, their actions and their affective state.[38]

So, just as it has been argued that the musical, lyrical and narrative contents, when interpreted, create more than the sum of their parts, it is also proposed that the voice does more than communicate words and musical text. It is also an expression of human corporeality that cannot be separated from the musical and textual parts of the vocal delivery and its reception by a listening body.

In the case of the character Tony singing 'Something's Coming', the musical structure creates an emotional arc from speech to song and back so that the performer can make a gradual movement while retaining the illusion of realism. The musical characterisation contributes to the appearance of realism through word painting, accompaniment figures that depict emotional states or energies, and harmonic structures that support character state or development. The performer maintains the appearance of psychological continuity in the representation of character, the type of verbal communication, and the emotional energy. At the same time, reception relies on a complex blend of positions of receptivity where audiences can interpret character and performer, follow the story and emotional

[35] Abbate, *Unsung Voices*, p. 200 quoted in Dominic Symonds, 'The Corporeality of Musical Expression', p. 168.

[36] Symonds, 'The Corporeality of Musical Expression', p. 168.

[37] Katie Overy and Istvan Molnar-Szakacs, 'Leaping Around in Our Minds', Poster presentation, *Kinaesthetic Empathy: Concepts and Contexts*, Manchester University, 22–23 April 2010.

[38] Ibid.

trajectory, interact with the physicality of the performer/character, admire the vocal technique, understand the musical and verbal signs, be moved by the musical and harmonic patterns and the dynamic shape of the song, and be intoxicated by the vocal sound. As for how this plays into realism; it allows the audience directly to 'experience' the song and the emotions of the character/performer.

To return to another example from *West Side Story*; the duet between Anita and Maria 'A Boy Like That' followed by 'I Have a Love' occurs towards the end of the musical after Tony has killed Bernardo. In it Anita is angry, having discovered Tony in Maria's bedroom, and her anger moves her to express herself in song. The vocal lines at the start are roughly at the pitch and pace of speech, though, as in 'Something's Coming', the rhythmic stylisation and the pauses in speech for musical accompaniment create unnatural breaks in the delivery. Actors often strive to fill these breaks with action, though they are in fact already filled with atmospheric musical information.[39] The musical meter moves between 4/4 and 3/2, keeping listeners and character/performers off balance. The middle part of Anita's section is more lyrical as Anita tries to reason with Maria,[40] but as the pitch and volume rise her anger returns, arriving at the high belt sound of 'very smart' which is sustained for two bars and operates as the climax of Anita's emotional journey.

The lower angry figure returns before Maria interrupts with a high A flat on the first 'no' during the descending phrase 'Oh no Anita no, Anita no'.[41] The high pitch or climactic 'cry' that Maria emits in desperation at Anita's tirade has the effect of stopping Anita in her tracks and changing the mood. Maria sings a lower intense and rhythmic phrase, before the two sing a polyphonic duet each using their own motifs.[42] Anita is finally silenced as Maria climaxes with a repeat of the phrase 'Oh no Anita, no' this time rising to B flat before descending. Maria then sings the sustained solo section 'I Have a Love'[43] culminating in the sustained cry on G natural marked *f cresc*. The final part of the song is a simple statement that both women sing in intense but quiet harmony 'when love comes so strong there is no right or wrong' before the volume builds to the final notes and the crashing orchestral climax and quieter echo after the words 'your love is your life' sung by both women.[44]

An important feature here is that the two characters don't sing in close harmony until the resolution of the song after 'I Have a Love', when Anita has decided to help the lovers. So the musical counterpoint mirrors the story of the characters' dispute and reconciliation. This is moving into operatic territory, where the emotional journey of the characters is reflected in the musical structure. At the same time the orchestration, melody and harmony all contribute to the signification

[39] Vocal Score Bernstein, 1957, p. 180.

[40] Ibid., p. 182.

[41] Ibid., pp. 183–4.

[42] Ibid., pp. 185–7.

[43] Ibid., pp. 188–9.

[44] Ibid., p. 190.

of the changing emotions from the brass and timpani expressing Anita's anger, to the woodwind and strings and the *andante sostenuto* marking for 'I Have a Love' leading to the reconciliation.

At this point, what is realistic for the audience? Certainly this is the most overtly emotional scene in the musical, and so the question is raised about the ability of music to enhance the delivery of emotional material set against the reflexive distance created between audience and characters at the moment the characters break into song. There is a lack of realism in the long solo sections that each character sings to represent an angry exchange, though this is to some extent mitigated by the duet section in which each continues her own line mirroring an angry scene with each not listening to the other. But more fundamentally, here we see the illusion of realism in full swing again, in its alteration of performance time. Each character continues her psychological development through the song and into the rest of the plot. The music is written in such a way as to enhance the emotional exchange and allow for the reconciliation between the two. So, even as the music slows the delivery of individual words and phrases, the emotional journey is accelerated by the musical enhancement of the scene and the characters arrive at a speedy reconciliation.

For the audience there is a different journey. The audience chooses to accept the illusion that the exchange between Anita and Maria continues in the same vein – a realistic spoken exchange – even as it is moved by the musical fireworks that orchestrate the scene, and the heightened vocal expression that each singer delivers. This moment becomes an important focus for the tragic denouement that follows because of the musical compression of the emotional journey the characters undertake, which makes possible the mimetic and empathetic understanding by the audience. Here, realism is replaced by the compression of time, the enjoyment of sound, and especially the many opportunities for vocal cry or vocal excess that are offered to both characters, but particularly Maria. The audience blends the illusion of the continuation of plot and empathy with characters because of the continuation of causal relationships that allow emotional understanding, but also because of the enjoyment it experiences in the rollercoaster of emotional currents and vocal excess that replaces the representational delivery. It is also possible that this sequence exemplifies the movement from spoken to sung communication alongside the material presence of the voice. The audience might gain an embodied emotional understanding as it reads the information, feels the emotion and atmosphere, and responds to the aesthetic pleasure of the voice. This combination encourages the blissful acceptance of the unlikely plot developments.

A third example of vocal material challenging the arrangement of 'realism' in *West Side Story* occurs at the end of Act One, when many of the characters sing a dramatic and complex quintet. This has parallels with operatic finales, for example in *The Marriage of Figaro*, which offers the opportunity to draw the protagonists together so that the dilemmas of the plot are embodied for the audience, achieving both a dramatic and an aural climax before the interval. In *West Side Story* each character or group is signified by their musical and vocal material in an exciting

and darkly premonitory outpouring. The two gangs' similarities are shown in the fact that they sing similar musical material, and Anita develops the same theme. Tony and Maria sing a reprise of their love duet, 'Tonight', which creates a sense of unity between them. What the audience sees or perceives in this finale is the emotional state of these principal protagonists so that the potential for tragedy is made starkly clear. Again there is a situation in which each performer can maintain an illusion of psychological realism in the development of character, but the totality of what the audience sees as each group or individual sings their musical material, ignoring but harmonising with the other voices on the stage, is not a realistic scenario. But this exposes the theatrical illusion and both compresses and extends time.

The volume and attack of the large group has a dynamic impact that contributes to the emotional climax of the situation. The realistic progression of the plot is sacrificed for an emotional and musical climax that creates tension in anticipation of the forthcoming tragedy, and pleasure in the blissful enjoyment of the vocal and corporeal expression. The multiple voices, each articulating its separate needs, gives a simultaneous presentation of the narrative tensions that are pulling in different ways and so making the tragic outcome inevitable. Three things are happening here: the possibility of hearing multiple viewpoints simultaneously; supported by the representation of a dramatic and atmospheric accompaniment; at the same time as the sensuous enjoyment of voices produced at their highest emotional, dynamic and pitch ranges allows audiences to interact with the physicality of the voices and bathe in the acoustic vibrations. The characters are maintained and in conjunction with the plot create the energy of conflict and anger. The performers work together in creating the massed sound of the company, while each also contributes to the effectiveness of the other. The orchestra plays an equal part in this community of sound as each part of the concerted effect is exceeded by the whole. Together there is an intensity of sound, energy and vibration whose diegetic meanings are both hopeful and premonitory, and whose phenomenological experience is both intellectual and libidinal.

Actor-Musicianship

Actor-musicianship might well be one of the most disruptive forms of performance, perhaps removing the possibility of interpreting the performance as 'realistic'. One of the first actor-musician shows to reach London's West End was *Return to the Forbidden Planet* in 1989. It began at Bubble Theatre Company, directed and created by Bob Carlton with musical director Kate Edgar, then played at Liverpool Everyman Theatre and Tricycle Theatre before arriving in the West End in 1989. It was a composite of a version of *The Tempest* with the science fiction film *Forbidden Planet* that featured a number of 1950s and 1960s rock'n'roll songs sung and played by the cast. Bubble Theatre Company's director used this format in other shows at Bubble, at Liverpool Everyman and the Queen's Theatre,

Hornchurch. These shows inspired other directors to use actor-musicians to create high energy, and at first predominantly rock'n'roll shows, including Peter Rowe at Theatr Clwyd and John Doyle at York Theatre Royal and Newbury Theatre. John Doyle's work has become the most widely acclaimed and the most musically diverse. His productions include actor-musician versions of *Candide*,[45] *Company*, *Sweeney Todd, Carmen* and *Mack and Mabel*.[46] It is in the work of John Doyle that actor-musicianship has been attempted within potentially 'integrated' texts and using a 'realistic' approach to acting. Symonds says of Doyle's production of *Carmen* that it 'employs music both as atmosphere and metaphor, evocative of Mediterranean life, images of that life and the passion of those images'.[47]

A programme to train actor musicians began at Rose Bruford College of Speech and Drama and continues at E15 in response to these developments. The result is that the skill of actor musicians has developed in the intervening years so that Charles Spencer of *The Daily Telegraph* could write in response to Doyle's production of *Sweeney Todd*:

> Mrs Lovett has no sooner sung a song about her dreadful pies than she is blowing a mean trumpet solo. The sinister bald, pimping Beadle doubles impressively on keyboards, and the rest of the nine-strong cast all play instruments, too, including cello, double bass, flutes and accordion.[48]

Something that had its roots partly in a pragmatic response to economic limitations has blossomed through the development of training courses and through the increased experience of performers, directors and musical supervisors into a performance style that has a different aesthetic from other musical theatre performances in its negotiation of distance. Actor musicians are present in the performing space; that is, they are not just placed at stands onstage but they move around the space, interacting with other performers and occupying the space. Their presence while playing instruments contributes to the sense of 'liveness', but the music is given a different quality and texture in relation to the story as a result of characters/performers playing instruments in the performance space.

The importance of the actor-musician shows might initially seem to be the possibility they afford the director for creating a reflexive or disruptive text, but as Ben Brantley reports in his review of *Sweeney Todd* on Broadway:

[45] I was one of two non-acting musicians in that production. I have also been involved as musical director of actor musician productions of *Cabaret* by other directors.

[46] John Doyle's production of *Company* is available on DVD. His production of *Sweeney Todd* ran in the West End and on Broadway, and *Mack and Mabel* played at the Criterion Theatre in the West End in 2006.

[47] Symonds, 'The Corporeality of Musical Expression', p. 178.

[48] Charles Spencer, 'Glorious Blend of Beautiful Lyricism, Magnificent Score – and Gallons of Blood', *Daily Telegraph*, 11 February 2004.

because the performers are the musicians, they possess total control of those watching them in a way seldom afforded actors in musicals. They own the story they tell, and their instruments become narrative tools. It is to Mr. Doyle's infinite credit that while he ingeniously incorporates the physical presence of, say, a bass fiddle into his mise-en-scène, 10 minutes into the show you're no longer aware of this doubling as a self-conscious conceit.[49]

The persona of the performer could be argued to vacillate between character and performer/musician. Equally, the musician's role as supporter of the sung material of another character may offer challenging conflicts to 'realism' by suggesting that the community of players, who are also the characters of the piece, have separate roles as musical performers and deliverers of the narrative. But that may be a simplification of the imagery of the performance. There is a reflexivity here that for some is a challenge to the emotional and empathetic engagement of the audience with the performance. Those audiences perceive the performance from an objective position, from which they can admire the multi-talented performers, even as they engage intellectually with the content of the plot.

But it could be argued that there is a blurring between musician, performer, character and voice so that a song becomes a composite presented by the unified company of players and singer(s) who then seamlessly transform into other composites of musicians, characters and voices. The performance is thus composed of a continually transforming hydra such that at one moment the character Sweeney Todd is at its head supported by a company who enact, for example, 'Epiphany' through their instruments in support of Todd's vocal performance, and at another Tobias' voice comes to the fore accompanied by the other performers in a performance of 'Not While I'm Around'. In this aesthetic the instruments become voices that together with the singer create a composite text, just as the performers of the Quintet from *West Side Story* both enacted characters and embodied a unified vocal performance. As Symonds phrases it, it is the uniting of 'that which we understand to be performance with that which we understand to be diegesis – that most ostensibly encapsulates the new aesthetic'.[50]

That aesthetic in performance challenges audiences to simultaneously perceive multiple realities as performers are seen as musician, actor, character and vocalist. So the blending between actor, musician and character is part of the process of creating and understanding the actor-musician performance, as it is with all performances, but the blend in this type of performance may be analysed as further along a continuum of multiple frames. How the audience members individually perceive the blend of simultaneously presented realities is open. Some may choose to focus on the character and plot, others on the skill of musician and actor, others on the theatricality of the performance, but there will always be a

[49] Ben Brantley, 'Grand Guignol, Spare and Stark', *New York Times*, 4 November 2005.
[50] Symonds, 'The Corporeality of Musical Expression', p. 179.

blend of all of these. 'Actors and spectators adjust their blends throughout every performance, interacting to sustain and/or modify their enjoyment of theatrical doubleness.'[51] However, the dynamic structure of the work is the result of all the performers engaging in creating a musical world. The instrumental performance signifies the effort, energy and emotion of the character almost as clearly as the vocal performance. It is an effort and energy that is substantially different than that created by a professional orchestra accompanying the performance, whether onstage or off. The audience can respond to the climaxes, gestures and excesses of this sonorous performance as well as the vocal delivery of the character.

Conclusion

The question of the construction of realism has to be discussed in relation to a particular context and perspective. Performers can maintain a psychological realism through the moment of singing while moving from one performance mode to another so that different aspects of the character become the point of focus. The pace of performance time can alter to allow for the *tableau-vivant* of soliloquy or the speed of compressed emotional journeys enhanced by musical information. At the same time performers maintain the technique of performance and awareness of the stage space, other actors, other performances, the audience, and so on. For writers musical theatre contains the possibility of manipulating time and focus, and creating tension and climax during songs that makes the sacrifice of a realistic mode of delivery and time continuity worthwhile. There is also the opportunity to create atmosphere and add dynamic energy, volume, harmony and climax that enhances the understanding of character and situation.

For audiences the question of genre and expectation is likely to have an impact on how they react to the interruptions to the mode of representation. There may be moments of tension as a character elevates the emotional level and changes the mode of representation in order to sing, while the psychological development of the character is likely to be reasonably consistent. The plot may demonstrate causal relationships between situations, but the working out of those situations may not always be carried out through realistic scenarios. However, linear plots offer an illusion of realism because of the psychological continuity of the characters and the causal relationships of the events of the plot that the audience can accept and factor into its understanding of the overall narrative. On the other hand, the manipulation of time, pace, focus and emotional range offers other advantages that more than compensate for the loss of 'realism'. The theatrical illusion and the blend of genre understanding, alongside the material and cognitive experience of the voice, encourage audiences to accept the musical and singing images as a channel for the blend of realities and intoxication they choose to construct. Moreover, the vocal and instrumental sonorities and the excesses of vocal cry

[51] McConachie and Hart, *Performance and Cognition*, p. 19.

allow audiences to move beyond the constructed realism to moments of physical and emotional connection.

Chapter 7

Experiencing Live Musical Theatre Performance: *La Cage Aux Folles* and *Priscilla, Queen of the Desert*[1]

In the previous chapters some proposals have been made to begin to explain why audiences continue to attend and be entertained by live musical theatre performances. This chapter expands on that understanding, asking whether there is an experiential difference between live and mediatised forms. And if mediation has altered live forms so that there is little difference between the live and the mediated, why do audiences choose to attend the live? Or perhaps the fact that many popular performances are not reproduced – using intellectual property laws to resist reproduction in different media – may encourage a behavioural anomaly? These questions provide a catalyst for an examination of the live performances of *La Cage Aux Folles*[2] and *Priscilla, Queen of the Desert*[3] seen in London's West End during 2009.

La Cage Aux Folles focuses on the relationship of two gay men, Georges, the MC of the gay nightclub of the title, and his partner, Albin, a drag artist and star of the show. Together they have raised Georges' son, Jean-Michel, from his marriage to Sylvia. Jean-Michel has announced his engagement and wants to bring his prospective, and deeply conservative, in-laws to meet his parents. He first asks Albin to leave so that Georges and Sylvia are presented as his parents. Then, when Sylvia is not available, Albin steps in and plays Sylvia. Naturally the subterfuge is revealed as Albin, at the end of a song as Sylvia, does what he always does at the end of his drag performances and lifts off his wig for the 'reveal'. But of course

[1] A shorter version of this chapter was first published in *Popular Entertainment Studies*, 1/1 (2010): pp. 44–58. I am grateful to the Popular Entertainment Working Group of the IFTR for comments on an earlier version of this chapter, and to the editor and peer reviewer of *Popular Entertainment Studies* for feedback in developing the chapter, and to the editor for permission to develop it here.

[2] Book by Harvey Fierstein, Music and Lyrics by Jerry Herman, based on the play *La Cage Aux Folles* by Jean Poiret which has been filmed as *The Bird Cage*. Attended on 3 August 2009.

[3] Book by Stephan Elliott and Allan Scott, Songs selected and interpolated by Simon Phillips. Based on the Latent Image/Specific Films Motion Picture distributed by Metro-Goldwyn-Mayer Inc. Attended on 6 August 2009.

it all works out and the young lovers are united and Georges and Albin return to their happy partnership.

Priscilla, Queen of the Desert concerns two female impersonators, Tick/Mitzi, Adam/Felicia and a transsexual, Bernadette. They are all performers in Sydney's drag clubs. Tick discovers he has a young son living in Alice Springs, the result of a former relationship, so he persuades the other two to go with him on a road trip to perform there. They travel in a coach they name Priscilla. The plot is the road trip during which the characters' former lives are revealed and changes are made. Bernadette meets a man en route and at the end of the trip decides to stay with him in Alice Springs. Tick finds his son and begins to take some responsibility as a father, taking him back to Sydney for a holiday.

There are a number of similarities between these two shows. Both concern the lives of characters who are drag artists, and encourage empathetic engagement of audiences with characters.[4] Both also contain diegetic performances by those drag artists: they incorporate the show-within-a-show format that is a feature of the musical theatre canon. Both also incorporate the layering of performer, character and character's alter ego. Where they differ from each other is in the ways they promote audience attachment and involvement, especially in relation to the vocal identity of the performers.

In *La Cage Aux Folles* the principal drag artist, Albin, sings in his own – male – voice so that the attachment between audience and performer is maintained through the 'show' songs. These diegetic songs are original music composed for the show. The show songs are, consequently, perceived as contributing to the character revelation. In contrast, the 'show' songs in *Priscilla, Queen of the Desert* are a combination of materials gathered from popular culture and interpolated into the show. The songs are performed by the characters lip-synching to a group of visible, onstage, pop 'divas'.[5] This strategy clearly references the lip-synching performances of Sydney's drag scene, from whence the film and show derive. They also contribute to the production of texture and complexity in the interpretation of the combination of source music, live performance and lip-synched performance.[6] This creates a different construction of vocal identity for the characters' 'onstage' performances that encourages audiences to read 'onstage' and 'offstage' performances differently. The result is that the diegetic performances have a different function in the promotion of audience involvement and entertainment and the perception of 'liveness' in these two shows. In both cases, though, there are factors that counter Philip Auslander's argument that live performances are simply replications of, or raw material for, mediatisation.[7]

[4]　Not of direct relevance to this argument, both also concern the relationship between drag artists and their children.

[5]　They are identified as 'Divas' in the programme.

[6]　The reading of drag performance derives from Carol Langley, 'Borrowed Voice: The Art of Lip-Synching in Sydney Drag', *Australasian Drama Studies*, 48 (2006).

[7]　Philip Auslander, *Liveness* (London and New York, 1999), p. 162.

In *Liveness* Philip Auslander concludes that most performances include technology – at the very least in amplification. Some live performances are reshaped to the demands of mediatisation, others recreate mediatised performances in live settings. This is certainly true of musical theatre in which the transferrals between stage and film are increasingly numerous. Auslander argues that over time the relationship between live and mediatised changes, such that at first the mediatised is modelled on the live, but gradually the mediatised usurps the place of the live in the cultural economy. This results in a reversal so that the live form then replicates the mediatised, which he suggests is apparent in the contemporary – as of his writing in 1999 – relationship of theatre and television.[8] He draws on two other theories to conclude that the mediatisation of live events is a means of making those events respond to an audience desire for televisual intimacy.[9] This relies on Jacques Attali's argument that the economy of repetition emerged when production of unique objects was no longer profitable,[10] and Walter Benjamin's proposal that the audience's desire for reproducible cultural objects resulted from a relationship characterised by proximity and intimacy.[11] Auslander concludes that mediatised forms enjoy more cultural presence, prestige and profit than live forms, and that 'any change in the near future is likely to be toward a further diminution of the symbolic capital associated with live events'.[12]

Auslander's arguments are persuasive in identifying the fact that technologies have always affected live performance and that live performance is often repeated within a commercial framework. However, they raise the question of why audiences still attend live performances unless the experience has some fundamental differences from mediatised forms. The particular works that have been chosen as examples here are available in filmic portrayals, albeit in different productions and with different musical scores. What I will argue here is that there is a cognitive communication in live musical theatre performances that can be stimulated in different ways. This can produce an experience of co-presence at a unique moment, intimacy, cognitive empathy and emotional contagion that remains important in the continuing popularity of live musical theatre as entertainment.

Strategies for Signifying Intimacy and the Unique Moment

British pantomime and stand-up comedy use particular strategies for signifying the uniqueness of each performance that are instructive here. Pantomime is reproducible from performance to performance with as many as 13 performances

8 Ibid., p. 158.

9 Ibid., p. 159.

10 Jacques Attali, *Noise: The Political Economy of Music* (Minneapolis, 1985).

11 Walter Benjamin, 'The Work of Art in the Age of Mechanical Reproduction', *Illuminations* (London, 1992[1936]), pp. 211–44.

12 Auslander, *Liveness*, p. 162.

per week for between three and 12 weeks, and from year to year. Commercial companies like QDos rework the production of an existing pantomime for 10 years or so. Other companies, especially repertory companies, generally have a shorter run of eight to 12 shows per week for three to five weeks and produce a new show each year.[13] Given this level of repetition the performance becomes slick, physical comedy is detailed and precise, and pantomime might be assumed to exemplify the idea that performance can attain the efficiency of its televisual or recorded cousins. However, pantomime incorporates strategies that make it unique at each performance – or at least signify that it is unique. Live performance is necessarily unique because performers and audiences will respond differently to each other on each occasion – so the essential fact of live performance causes infinite variation within defined parameters. But pantomime and to some extent other comedy and clown performances also incorporate particular strategies that both signify the event as unique or actually create unique moments in each performance. This relates to Benjamin's theory that an audience desires a relationship characterised by proximity and intimacy and Attali's reference to the importance of the unique object. What these strategies do is replace the intimacy of the small scale with the intimacy of the unique object or the 'personal' touch.

The events that make each performance distinct include the incorporation of audience members in the comedy. This can be accomplished by throwing sweets into the audience, chasing through the audience or asking audience members for information or some other contribution to comedy or narrative. Some of these strategies are used in stand-up comedy and others in circus clowning. The point here, though, is that this incorporation of the audience lends spontaneity and playfulness to the performance. It also signifies to the audience that the performance is particular to them and unique to that occasion. There are other strategies in pantomime to signify uniqueness, such as topical reference and cod corpsing that may not, in fact, be specific to an individual performance.[14] However, pantomime maintains the appearance of playfulness so that each performance is not only live in terms of the co-presence of audience and performers but also unique in the liveness of those moments. Through these moments of contact pantomime creates a sense of intimacy and connection between audience and performers.

This is highlighted when variety acts are incorporated – a feature that is in decline in repertory pantomime but still apparent in some commercial productions and in circus.[15] When feats of physical skill, high energy or danger are performed

[13] These figures and the examples in the following discussion derive from my work on pantomime produced in *British Pantomime Performance* (Bristol and Chicago, 2007).

[14] To corpse is to laugh inadvertently and out of character during a performance onstage, which has the effect of allowing audiences to see the performer behind the character. The cod corpse is a planned version of the corpse that, if done well, can be perceived as a unique moment of direct contact between performer and audience.

[15] Variety performance has been given a much higher profile recently by television talent shows such as *Britain's Got Talent*. It will be interesting to see the consequence of

the audience is assured of the reality of the event by the sight of the performance. Visual identification plays a part in verifying skills that could be manipulated in a recorded environment. The triple somersault a performer turns or the impossible and dangerous leap she makes are seen to be real by an audience who are present, but could be dismissed in a recording as faked through editing. The same is true of magic tricks and illusion. The skill of the performer and the wonder of the illusion are verified by the immediacy of live performance, or of sight and sound. The performance of song can use the same strategy, especially as the performer incorporates the emotional sob, or the impossibly high climax that is verified by the shared experience. The presence of musicians onstage or in the pit, or reference to them, creates a reflexive circularity and simultaneously authenticates the live musical performance. Even the appearance of celebrities relates to this argument because their presence is verified by visual and aural identification. Intimacy with the revered 'other' of celebrity or stardom results from the sharing of the space and time of performance in place of the usual mediation through television or film. It is also notable that television pantomime and variety shows are filmed in front of a live audience to recreate this sense that there are witnesses to the veracity of tricks, illusions or appearance.

These examples link to Auslander's discussion of performativity and the importance of speech acts in court cases that use individual witnessing to assure the truth of individual testimony and memory.[16] Despite limited use of recorded evidence, the use of video in court cases hasn't become widespread because presence, or temporal and spatial simultaneity, is deemed to contribute to the legal process of discerning 'truth'. Mladen Dolar remarks that '[w]e should note in passing the link between the voice and establishing the truth: there is a point where truth has to be vocal and where the written truth, although literally the same will not do'.[17] Equally, popular performances that contain variety acts – both pantomime and variety – rely on visual and aural verification by the audience. This encourages audiences to a greater awareness of the 'danger' of a particular acrobatic leap, the magical illusion, or, indeed, the presence of the performer.[18] The importance of the live witnessing to the efficacy of these acts may contribute to the continuing popularity of such performances.

this profile on other types of popular entertainment.

[16] Auslander, *Liveness*, pp. 114–31. The relationship between the perception of 'truth', the performance of knowledge and voice is argued from a philosophical perspective in Dolar, *A Voice and Nothing More*, pp. 108–12.

[17] Dolar, *A Voice and Nothing More*, p. 109.

[18] Potentially dangerous acts are rehearsed to the point that they are not, in fact, dangerous. There is, however, a perception of their difficulty that is promoted by the participants. The achievement of the act, despite its perceived danger, is highlighted and verified by audience presence. Equally, with magical tricks that are clearly illusions, the illusion is witnessed and becomes efficacious as a result of that witnessing.

Stand-up comedy uses similar devices, incorporating the audience into the event so that it is unique and particular to each audience and each occasion. In his recent tour of the UK and Ireland Dara O'Briain made a point of the particularity, liveness and uniqueness of each performance as created by the audience interaction.[19] The experience of watching the televised recording of this live performance is to be an outsider, separated from and looking in on, the live event. In effect, the filmed recording works not only as a mediated version of the event, but as a marketing device in creating a desire to experience the live event. This is a form of mediatisation, but one that promotes liveness as a desirable experience.

Musical theatre rarely incorporates the variety skills, direct audience interaction or the physical and slapstick comedy of pantomime or stand-up comedy, and has certainly conformed to one aspect of Auslander's depiction of mediatisation with theatre musicals adapted and reproduced for film during the golden age,[20] and, more recently, the re-production of film musicals on stage.[21] The movement remains a two-way street, however, with recent filmed versions of *Chicago* and *Mamma Mia* and staged versions of *Priscilla, Queen of the Desert* and *Hairspray*.

Also conforming to Auslander's argument about a mediatised world is the increasing commodification of live performance. This is notable in the globalisation of some musical productions with very little accommodation for location or even sometimes language.[22] At the performance level Susan Russell records that even actors have to conform to the staging decisions and dramatic interpretations of an original production. Speaking of *Phantom of the Opera* she records that '[w]hen a new actor enters the Broadway show, they are taught how the original actor did the role, and the new actor is expected to simulate a frozen image that is retrieved by management from a documented past'.[23] Later she refers to Foucault's *Discipline and Punish* to frame the experience of disciplined and docile bodies 'precipitated by hours of surveillance'.[24] Her reading of Baudrillard's *Simulacra and Simulation* leads to the conclusion that 'corporate culture cannot allow anything other than simulations, and the end result of simulation is the death "of the true, of [the] lived

[19] *Dara O'Briain Talks Funny: Live in London*, recorded at Hammersmith Apollo in 2008, broadcast on BBC Television, 19 July 2009. A similar opening speech is available on www.youtube.com/watch?v=dKczVtVFi70.

[20] Such as the Rodgers and Hammerstein musicals, variously filmed by Twentieth Century Fox and Metro-Goldwyn-Mayer.

[21] Such as *The Producers*, and the Disney musicals *The Lion King* and *Beauty and the Beast*.

[22] This is discussed in Jessica Sternfeld, *The Megamusical* (Bloomington, 2006), p. 4.

[23] Susan Russell, 'The Performance of Discipline on Broadway', *Studies in Musical Theatre*, 1/1 (2007): p. 99.

[24] Ibid., p. 101.

experience"'.[25] Finally, Russell asks 'Is not live theatre made living by the endless possibilities within time, place, and space?'[26]

Despite Russell's experience and the increasing commodification and globalisation of some musical theatre performances, these practices are only one part of the story. Whether or not these practices are used by all companies is debatable especially in local or regional productions, but the effects for audiences even at 'commodified' productions can be more diverse. There is an experience of liveness that has been identified above in pantomime and comedy that contains strategies for the involvement of audiences that is necessarily different from a recorded or technologically reproduced production. The production of *La Cage Aux Folles* contains some of these strategies.

La Cage Aux Folles

In autumn 2008 the Menier Chocolate Factory – a small fringe venue in London that opened in 2004 and is establishing a reputation for the production of musicals that transfer into the West End – mounted a new production of *La Cage Aux Folles*.[27] I saw the production in August 2009 after its transfer to a fairly intimate West End venue, the Playhouse Theatre. The production incorporated many of the features of intimacy and the signification of uniqueness that have been identified above. The design of the production incorporated a second proscenium arch with a small forestage so that the diegetic performances could be presented and the theatre audience had the experience of being involved in the performance as the club audience. Four tables were raised at the front of the auditorium around which were seated audience members who were repeatedly spoken to, gestured to, sung to, and incorporated into the performance. The row of boxes that were populated by audience members in the auditorium was extended into the set to house the band, some of whose members could be seen from stage and auditorium, with whom the characters interacted.

The interaction with the audience began immediately after the overture as Georges, as club MC, introduced the evening's events, spoke to and shook hands with audience members. In the introduction to the 'midnight show' later in the first act Georges included a short stand-up comedy routine with audience interaction by encouraging the audience to lean to one side, which the stalls audience all did. This interaction continued in all the club scenes and created the sense of a club performance, but also signified this performance as uniquely created in interaction with this group of audience members. Even though it is certainly virtually identical on each occasion the effects of participation create a different level and type of

[25] Ibid., p. 105.

[26] Ibid., p. 106.

[27] Directed by Terry Johnson, with choreography by Lynne Page. I saw Roger Allam as Albin and Philip Quast as Georges.

involvement for audiences. In the Cagelle's opening number, 'We Are What We Are', there was reflexive upstaging as individual dancers competed with each other, commented to the stage manager offstage and threw beach balls into the audience.[28] Later in 'La Cage Aux Folles' dancers danced on the audience tables and caressed men sitting at them.

Even in some of the early 'realistic' scenes Georges addressed the audience in scripted asides about Albin such as 'See how she listens to me'. During scenes at the café by the sea, Georges commented about and to the accordionist on the balcony. Solo songs were addressed to the audience whether staged as diegetic performance in the club, or backstage. During the song 'Mascara', Albin sang partly to the audience and partly to himself while dressing for the show. These are all strategies that encourage audience members to interact and therefore to respond to the performance as a playful and live event. These strategies also encourage the reflexive awareness of the theatrical event.

In Act Two Albin is persuaded to pretend to 'be' a woman (Jean-Michel's mother, Sylvia) rather than a female impersonator so that his stepson's new in-laws will accept him/her. In the restaurant, Chez Jacqueline, s/he performs 'The Best of Times' sitting on the front of the stage in an intertextual reference to mediated images of Judy Garland. In the course of the song s/he takes the hand of an audience member to whom s/he sings the first part of the song. The confusion between drag performance and 'pretend real' performance, alongside the reference to the iconic performance of Judy Garland and the interaction with the audience makes this a particularly interesting moment. The question of who is singing is complex with layers of Roger Allam (the performer), Albin (the character), Sylvia (who Albin is pretending to be) and Garland (in the imagery of the performance and in the iconography of drag performers). The oscillation between these various facets of the actor/character that the audience categorises and understands is described by Bruce McConachie as 'conceptual blending' and has been discussed above.[29] The argument here, as in previous chapters, is that audiences blend their readings of the various roles, 'spectators combine actors and characters into blended actor/characters'[30] and that there is a cognitive adjustment in the audience's reading of the relative balance between the various personas in different types of performance.

In this performance the clarity between diegetic and non-diegetic performance is deliberately blurred. The audience is drawn into the performance as participants inside and outside the restaurant and the club. They are also involved as active interpreters of the performance and the theatre event, a role stimulated by the complex layers of cognition that are activated. All these features create the sense

[28] The Cagelles are the chorus of (cross-dressed male) dancers at the club.

[29] Bruce McConachie, 'Falsifiable Theories for Theatre and Performance Studies', *Theatre Journal*, 59/4 (2007): pp. 556–61. In this article the cognitive explanation of this oscillation derives from Fauconnier and Turner, *The Way We Think*, pp. 92–102.

[30] Ibid., p. 559.

of a unique performance even though the actual difference from night to night is limited. These types of playful interactions increase the sense of engagement the audience has with the performance; laughter, clapping along, and emotional response to the story are all increased as a result.

This is only one example, but it demonstrates that by no means do all musicals or productions conform to the practices that Russell describes in *Phantom of the Opera*. Moreover, it is possible that even in those large scale productions that do enforce rigid practices and a particular type of discipline among performers, vocal and musical gestures still have the power to communicate and make cognitive connections with audiences. Where *La Cage Aux Folles* was particularly effective was in the stimulation of the sense of co-presence at a unique moment of intimacy with the performer/characters and an emotional involvement in the characters' lives.

Experiencing the Live Event

So why do audiences go to live musical theatre performances that don't espouse these practices of signifying liveness if all they are getting is a reproduction that they could see equally well on television or film? First of all, there is the obvious answer that most musical theatre performances are not recorded on film in the same productions that they are performed on stage. Intellectual property law is used by many producers to limit or ban video recording of performances except for their own archival reference. Archives that contain footage of live performances include the Royal Shakespeare Company, Royal National Theatre, the Victoria & Albert Museum's Theatre Collection in London and the Theatre on Film and Tape archive in the Library of Performing Arts in New York. All of these can only be viewed, with permission, within the archives where no copying is possible.

When watching footage in these archives the viewer is aware of the fact that this is recording of live theatre performance because of the limited camera positions. These recordings do not conform to contemporary cinematic practices because they are staged for theatre, the human eye, and generally a frontal and panoramic viewpoint. The music and sound are arranged differently, the acting style demonstrates the awareness of audience size and position. Speech patterns, diction and vocal range indicate the size and type of performance space. And, in musical theatre, song and dance intervenes in ways that are no longer common in film – though there are exceptions such as *Moulin Rouge*. The viewer of the archived performance is seeing a mediated aide-memoire that in no way recreates the experience of attendance at a live event, and, since it doesn't conform to established cinematic practices, it may appear awkward or less polished.[31]

The result of this is that the only possibility for consumers to experience the show is through the live experience, and attendance is made necessary through

[31] For more on this see Gay McAuley, 'The Video Documentation of Theatrical Performance', *New Theatre Quarterly*, 38 (1994).

saturation marketing to increase the desirability of the event. This process is generally argued to have begun with Cameron Mackintosh's pre-opening release of the music and the pre-opening publicity campaigns for the original productions of *Jesus Christ Superstar* and *Cats*, which introduced the phenomenon of global brand identification to musical theatre.[32]

Large scale productions may conform to Auslander's view that theatre directors have been influenced to become more filmic in their concepts and designs as a result of the ubiquity of cinema and television. On the other hand Miranda Lundskaer-Nielsen argues that in the 1980s and 1990s the influence of classical theatre and epic social drama 'equipped [directors] to tackle musicals using different staging vocabularies than the great Broadway choreographer-directors'.[33] These vocabularies relied on less realistic sets and designs, greater use of the chorus and fluid movement between times and places. These practices may have been influenced by cinema but, especially in design and use of chorus, are not like those of cinema. However, there is no doubt that musical theatre is highly technological using electronic instruments and microphones, computerised lighting and sound systems and sometimes computerised scenery operation. This has consequences for how the performer is perceived given the argument above about the relationship of live presence, witnessing and perceptions of theatrical 'truth' or 'reality'.

The Experience of Empathy[34]

Cognitive science is now being applied by researchers to dance, theatre and music to begin to understand the experience of attendance at performances. The concept of kinaesthetic empathy has developed in dance partly from the theory of *Einfühlung* proposed by Theodor Lipps.[35] It suggests that when audiences are watching dance they experience the dance mimetically as though they are undertaking the movement. Ann Daly argues that 'although it has a visual component, [dance] is fundamentally a kinesthetic art whose apperception is grounded not just in the eye but in the entire body'.[36] More recently Beatriz Calvo-Merino et al. have proved that some parts of the brains of audience members watching dance are stimulated

[32] Sternfeld, *The Megamusical*, pp. 3–4.

[33] The development of directorial practices in musical theatre is explored in Miranda Lundskaer-Nielsen, *Directors and the New Musical Drama* (New York, 2008), pp. 143–6. This quotation, p. 59.

[34] Some parts of this section build on an earlier article 'Don't Dream it, be it'.

[35] (1909) www.watchingdance.org/research/kinesthetic_empathy/index.php, accessed 30 May 2009.

[36] Daly, 'Dance History', 1992, quoted on website.

as though they are undertaking the physical activity themselves.[37] This relies on the activation of mirror neurons in the pre-motor cortex of the brain through which audiences mirror the gestural activities they observe. Such mirroring derives in part from basic learning instincts. Children learn through imitation and mirroring, and most early learning relies on copying.[38] This remains a feature of skills acquisition in humans throughout their lives. Bonnie Eckard records that the activation of mirror neurons in the brains of audience members activates the synapses as though the watcher were carrying out the gesture. Since embodying emotions or physical actions can stimulate the memory and the feeling of that emotion, memories and emotions are stimulated in the audience from which they extrapolate meaning.[39]

Bruce McConachie applies the work of Paula Niedenthal et al. to the theatre audience.[40] He concludes that in the theatre, where empathy is encouraged, 'imitation and embodiment tend to be heightened'.[41] The process can have four parts. Individuals embody imitated emotions, which produce corresponding emotions. Imagining people and events, or watching performers embodying a character's emotions, also produces emotions and feelings in the watcher/listener, and those embodied emotions mediate cognitive responses.[42] Moreover, these responses are often too small to be consciously recognised but impact on behaviour so that as a species we are able to attune to each other. 'Embodying others' emotions produces emotions in us, even if the situation is an imagined or fictitious one.'[43] Although these responses are subconscious, audience members can choose to resist identification, but through this cognitive awareness they can empathetically sense what characters/performers are feeling within the safe frame of the performance situation and, when aware of the emotion, can choose to be moved or to resist. More importantly for narrative performances, audiences can attribute meaning to the observed gestures.

[37] Beatriz Calvo-Merino et al., 'Action Observation and Acquired Motor Skills: An fMRI Study with Expert Dancers', *Cerebral Cortex*, 15 (2005): pp. 1243–9. There is an AHRC project underway exploring kinaesthetic empathy in dance and relating it to the pleasure experienced by the observer. A sub-area of that research project mentions the relationship with music and sound and its effect on empathy and pleasure.

[38] E. Tolbert, 'Untying the Music/Language Knot', in Linda Austern (ed.), *Music, Sensation, and Sensuality* (New York and London, 2002), p. 87.

[39] This is developed in a conference paper by Bonnie Eckard, 'Power of the Body: Mirror Neurons and Audience Response', *International Federation for Theatre Research*, Lisbon, July 2009.

[40] Paula M. Niedenthal et al., 'Embodiment in the Acquisition and Use of Emotion Knowledge', in Lisa Feldman Barrett et al. (eds), *Emotion and Consciousness* (New York, 2005). Quoted in McConachie, 'Falsifiable Theories', p. 563.

[41] McConachie, 'Falsifiable Theories', p. 563.

[42] Niedenthal quoted in McConachie, 'Falsifiable Theories', p. 562.

[43] Ibid., p. 563.

Similar processes are apparent in response to musical gesture, and several scientific studies make similar claims about mirror neurons activating sub-vocalisation or vocal mirroring.[44] Istvan Molnar-Szakacs and Kate Overy survey recent work on neuroscience to claim that 'Music has a unique ability to trigger memories, awaken emotions and to intensify our social experiences'.[45] An important point here is that this emotional contagion or empathy is not only a response from audiences to characters onstage, but something that is communicated between audiences at an event, whether staged or otherwise, and is also an effect that is communicated from audiences back to performers. Performers comment on 'good' and 'bad' audiences, and to some extent this can be the result of less focused performances or performers having had a bad day themselves. However, there is also an experience for performers of the audience – perceived as a homogenous group – and their response to that particular performance. This is communicated through silence as much as sound, through concentrated attention or raucous laughter, but the aural and physical communication that suggests attention and engagement is the result of an emotional connection between audience and performers, and is created partly through the mirror neuron system. The sounds created in the audience are culturally appropriate to the enacted situation that is being shared by the audience as a group and as individuals – assuming they have a common cultural context. This effect, according to Scherer and Zentner, is heightened in musical performance.[46] The combination of music that intensifies social experience, vocal expression that reveals the emotional body of the performer, and intellectual empathy with the enacted situation, leads to a high level of emotional identification for audiences at musical theatre performances.

Although all the above suggests that emotion can be stimulated by music, there remain doubts about the specificity of the production of emotion as a result

[44] J.D. Smith et al., 'Subvocalisation and Auditory Imagery: Interactions between the Inner Ear and Inner Voice', in D. Riesberg (ed.), *Auditory Imagery* (Hillsdale, 1992).

J.D. Smith et al., 'The Role of Subvocalisation in Auditory Imagery', *Neuropsychologia*, 33 (1995): pp. 1433–54.

Other scientific work on vocal and physical mirror imaging or motor facilitation has been undertaken by V. Gazzola et al., 'Empathy and the Somatotopic Auditory Mirror System in Humans', *Current Biology*, 16/18 (2006): pp. 802–4. V. Gallese, 'Embodied Simulation: From Mirror Neuron Systems to Interpersonal Relations', *Novartis Foundation Symposium*, 278 (2007): pp. 3–12; discussion pp. 12–19.

G. Rizzolatti et al., 'Premotor Cortex and the Recognition of Motor Actions', *Brain Research: Cognitive Brain Research*, 3/2 (1996): pp. 131–41. A.P. Saygin et al., 'In the Footsteps of Biological Motion and Multisensory Perception: Judgment of Audio-visual Temporal Relations are Enhanced for Upright Walkers', *Psychological Science*, 19/5 (2008): pp. 469–75.

[45] Istvan Molnar-Szakacs and Kate Overy, 'Music and Mirror Neurons: from Motion to "E"motion', *Social Cognitive and Affective Neuroscience*, 1/3 (2006): pp. 235–41.

[46] K.R. Scherer and M.R. Zentner, 'Emotional Effects of Music', in Patrik N. Juslin and John Sloboda (eds), *Music and Emotion* (Oxford, 2001), p. 370.

of listening to music without other stimuli, though physiological arousal has also been scientifically proved.[47] However, Isabelle Peretz summarises current knowledge about musical emotions from a biological perspective, looking at facial expressions and neural correlates of musical emotions. She analyses vocal emotion focusing on the tone of the voice and non-verbal expression which has been proved to be remarkably specific.[48] She says that 'within the speech signal, the recognition of vocal cues that are emotionally meaningful is clearly dissociable from the recognition of vocal cues that are semantically informative'.[49] What this suggests in terms of the current argument is that voice and song in musical theatre have the capacity to move audiences through pre-motor responses and mirror neurons that create a mimetic response to the portrayal of emotion in the voice and body of the performer. This is amplified by the musical stimulation and a physically embodied witnessing of the performance events. In other words the presence of music and the response to song has the capacity to elicit a greater emotional release than performance without those elements. This has been borne out by recent studies mentioned in previous chapters on the effect of synchrony produced by audiovisual stimuli.

This does not necessarily suggest a different response to live performance than might be achieved by recorded performance, but does suggest that musical and physical actions create an effect on the viewer/listener that is greater than might be assumed simply from the intellectual stimulation. When these effects are linked with co-presence with performers, interaction and cognitive blending, and the experience of 'atmosphere' or 'energy' created between audience and performers, it becomes clear that the experience of live musical theatre performance can be substantially different from a recorded or mediatised performance.

Vocal Touch

The body of the speaker is involved in the creation of sound, imbued with cultural and emotional signals as well as semantic information. The vibrations of the vocal sound expand into the space, reverberating and articulating the space even as they touch the ears and body of the listener. So the sound is produced inside one body and is sent out into space where it impacts on other bodies that perceive the sound as both externally created and internally perceived.[50] Simon Frith talks about the

[47] Ibid., p. 375.

[48] Isabelle Peretz, 'Listen to the Brain: A Biological Perspective on Musical Emotions', in Juslin and Sloboda, *Music and Emotion*, pp. 105–34. The section on vocal emotions is pp. 122–6.

[49] Ibid., p. 123.

[50] Many writers have spoken of the materiality of the voice in philosophical, physical and biological terms including Dolar, *A Voice and Nothing More* and Steven Connor in 'Phonophobia: The Dumb Devil of Stammering', a talk given at the conference *Giving*

possibilities for exaggerating the effect of vocal touch that are made possible by amplification in *Performing Rites*. Amplification allows the vocal performance to become more intimate and self-revealing, but it also adds an unreality to the sound and, potentially, a distancing of the bodily communication.[51] As Richard Middleton remarks, 'one recalls Lefebvre's idea of music as the socializing of bodies. For Schafer (1980: 11), "Hearing is a way of touching at a distance and the intimacy of the first sense is fused with sociability whenever people gather together to hear something special"'.[52] Frith concludes that 'in the context of a widespread "dehumanization" apparent in bourgeois art, the centrality of the voice in popular music – attesting to the presence of a human body – is a mark of a certain "humanizing" project'.[53] This may be true, and technology can allow singers to appear to be closer and more intimate with their audiences, but technology can also break the connection between singers and listeners, and this sometimes occurs as a result of the separation of sound and body – visual from aural image – that is apparent in the aesthetic choices in the sound design of some large scale musical theatre spectacles.

I don't want to relate these effects simply to the use of technology, though, since the production of *Priscilla, Queen of the Desert* took place in a large theatre and was heavily amplified, but, rather, perhaps to an aesthetic espoused in some performances that fails to retain the connection between the visual and aural sound sources when using technology to augment sound. The result is that the potential for intimate singing or communication to a greater number of people is increased, with the potential for audience contagion if the emotion is mimetically reproduced in the audience members, but the absence of the relationship between sound and singing body seems to be disorienting or alienating. Not surprisingly, this effect is more pronounced in larger theatres, but may be a consequence of mediatised strategies of sound design – trying to recreate the equivalent of recorded sound in live theatre performances.

Voice University of Aberystwyth, 8 April 2006, available at www.stevenconnor.com/ phonophobia. I began exploring this idea in an earlier article 'Exploring the Grain: The Sound of the Voice in Bruce Nauman's *Raw Materials*', *Studies in Theatre and Performance*, 26/3 (2006): pp. 289–96.

[51] Frith, *Performing Rites*, p. 210.

[52] Richard Middleton, *Studying Popular Music* (Milton Keynes and Philadelphia, 2002 [1990]), p. 258.

[53] Ibid., p. 262.

Some Experiences of Musical Theatre Performances

In the autumn of 2008 I attended a performance of *A Little Night Music*[54] at the Menier Chocolate Factory. It has about 160 seats rising in a rake from the stage floor, and on this occasion I sat on the front row where I was so close to the action that I had to move my feet as actors walked past on the stage. The musicians and musical director were on a raised platform stage right, within view of the audience. The effect of this proximity was to increase the sense of witnessing, and certainly to increase the contact with the emotional drama being enacted feet away from me. The fact that this was the first preview and there had been no dress rehearsal meant the adrenalin for the performers was also heightened and there was the tension of a public dress rehearsal. The voices, although there were microphones to assist the balance with the orchestra, were located in the bodies of the individuals – there was no sense that the voices were distorted or mediated between the speaking/singing performers and my ears, and the sound came from the performers not from speakers at the side of the stage. This was a moving and emotional performance even though the event had to be stopped on a couple of occasions because of technical difficulties. My experience was of a conspiracy or collaboration simultaneously with the performers in the technical uncertainties of the first preview and with the characters in the enactment and emotional expression of the story.

At around the same time I attended a performance of *Wicked*[55] at the Apollo Victoria in London whose aesthetic is very different. The theatre has almost 2,500 seats[56] and is an enormous barn-like space. From the moment of arrival I had the impression of being herded into the theatre, and merchandise and refreshments were sold everywhere, even in the auditorium, as audiences waited for the show to begin. In fact the event felt more like a sales opportunity than a performance, though, of course, managing an event on this scale daily or twice daily needs this type of organisation. My seat was on the left hand side of the auditorium quite close to the front proscenium where a speaker was hung. The consequence of this was that I heard the show not from the stage but from the speaker, and it was overwhelmingly loud. This separation of the sound from its visual source had a detrimental effect on my enjoyment and on my ability to relate to the show – as did my awareness of the mass marketing. In the second half I moved to a seat about halfway back in the stalls and the experience was much improved, but there was still a significant separation of sound from visual source as the speakers emitted sound loud enough to be heard throughout the large space, but there was some

[54] Book by Hugh Wheeler, Music and Lyrics by Stephen Sondheim. This production was directed by Trevor Nunn. Attended 22 November 2008.

[55] Book by Winnie Holzman, Music and lyrics by Stephen Schwartz, based on the novel by Gregory Maguire, directed by Joe Mantello. Attended on 14 August 2008.

[56] 2,420 seats approximated from the seating plan at www.albemarle-london.com/PickList/SeatingPlan.php?Theatre_No=17.

uncertainty in group scenes and songs as to who was speaking/singing since the sounds were not located in the bodies of the speakers. This had the consequence of separating facial gesture and body language from verbal communication.

I had a similar experience attending *Monkey: Journey to the West*[57] at the O2 arena during which there were surtitles to watch too, but the main source of disorientation in the enormous arena was in not being able to discern who was speaking and so relate facial gesture and body language to sound. More interesting in this case was that I was sitting quite close to the orchestra and booth singers and often found myself more engaged by their performance of the music rather than watching the performance taking place on the stage. Here I found the proximity to the musical performers and their concentration on their task to be more compelling than the highly technological performance being enacted beside them.

Moreover, at a performance of the rock show, *Next to Normal*,[58] on Broadway this effect was augmented by the ornamentation of melody and distortion of sound required by the rock style, and by the excessive volume of the show. The effect was of performers singing and emoting as loudly as they could, accompanied by loud and aggressive music that was clearly designed to mirror the disrupted lives and psyches on the stage, but had the effect of being virtually inaudible because of the distortion of the sounds, the excessive volume, and the absence of the ability to relate the sounds to the bodies.

Clearly my own tastes are enacted in these descriptions and this is merely a sample of my own experiences within a western cultural tradition. There are many effective larger scale productions, there are productions where disembodied voices are related to absent bodies – as in radio and sound recording – and within rock shows there is bound to be a different musical aesthetic. However, the separation in the theatre space of bodied sound from its visual source appears to have a disruptive or alienating effect, and the greater the ornamentation or distortion of vocal line the harder it becomes to mimetically partake in the emotional communication and empathise with the characters. On these occasions the distortion of musical tone is linked with the alienation of facial gesture and body language to the extent that the communication of intellectual imagery and the somatic mirroring of emotion failed to occur; the audiovisual connection was lost, and with it the entrainment or synchrony of the audience.

The separation of voice from body is an issue that Jonathan Burston has discussed in his article 'Theatre Space as Virtual Place: Audio Technology, the Reconfigured Singing Body, and the Megamusical'.[59] Here, Burston problematises theatre sound design that attempts to recreate the sound of the recording studio at the expense of

[57] Conceived, written and directed by Chen Shi-Zheng, Composed by Damon Albarn, Visual concept, Costume, Design, Animation by Jamie Hewlett. Attended 5 December 2008.

[58] Book and Lyrics by Brian Yorkey, Music by Tom Kitt. Attended 30 April 2009.

[59] Jonathan Burston, 'Theatre Space as Virtual Place: Audio Technology, the Reconfigured Singing Body, and the Megamusical', *Popular Music*, 17/2 (1998): pp. 205–18.

the audiovisual experience, and the commercial, technical and aesthetic models of production in global touring musicals that fail to take account of individual theatre acoustic environments.[60] Burston draws on an article by John Corbett to argue that 'production standards in popular music have worked to eliminate the grain of the voice, and thus "to widen the gap between the bodies of performers and the sound of their music"'.[61] He argues that this situation has been transferred to the theatre so that the changing sounds of the body in motion are replaced by a sound matrix that is more constant in tone and decibel level and free of other evidence of performative effort. It is also generally louder to cater for the larger audiences in larger theatres.[62] He suggests that 'as a consequence of the widespread, multi-directional, and frequently careless deployment of loudspeakers, we see bodies singing, and yet sound often ... appears *not* to emanate directly from them'.[63] This destroys the spatial relationships onstage and creates a sense of disembodiment. It is employed alongside increased volume and digital processing to remove the sounds of labour from the performing body. These strategies together can have the effect of increasing the experience of solitary listening in attending live theatre performance. However, there are occasions when contemporary audio design can enhance the performance. Burston refers to innovation in *Phantom of the Opera*, *Les Misérables* and *Sunset Boulevard*. I will make a different argument below in relation to the London production of *Priscilla, Queen of the Desert*.

Priscilla, Queen of the Desert

The stage musical version of *Priscilla* is particularly interesting because it capitalises on the distancing effects of vocal disembodiment for its comedy and spectacle, and the emotional attachment created through hearing the voice as embodied for empathy. The show opens as three 'divas' are flown in – they remain hovering high over the stage – singing 'Downtown'. In the subsequent scene in a Sydney nightclub the divas again sing. This time they perform 'I've Never Been to Me' while Tick, dressed in his drag queen outfit as his alter ego, Mitzi, lip-synchs the song with exaggerated gestures and flamboyant poses in an onstage diegetic performance. In a number of the other diegetic performances during the show such as 'Shake Your Groove Thing' in Scene 13, 'Girls Just Wanna Have Fun' in Scene 14, and 'Hot Stuff' in Scene 15, the divas sing while the drag performers provide lip-synching, exaggerated gesture and elaborately costumed spectacle.

In other scenes in which the characters are expressing 'themselves', they sing in their own voices. Examples include 'Always on My Mind' sung by Tick to his

[60] Ibid., pp. 205–6.

[61] Ibid., p. 210 quotes John Corbett 'Free, Single and Disengaged', *October*, 54 (1990): p. 91.

[62] Ibid., pp. 210–11 and 214.

[63] Ibid., p. 213.

son Benji, 'Come into My World' sung by Adam and 'Both Sides Now' sung by Adam, Tick and Bernadette. In these songs the voices appear to emanate from the bodies of the characters and contain emotion that can be realistically derived from the plot, and empathetically mirrored by the audience.

At other times in the show there are fantasy moments such as when Felicia dresses up and sits on top of the travelling bus to lip-synch to 'Sempre Libera' sung by the divas in Scene 9, and the company and the divas appear in the middle of the desert to sing 'Macarthur Park' in Scene 16. Though these moments could be read partly as rehearsals they develop into excessive spectacles. For example, in 'Macarthur Park' the chorus appears in the middle of the desert clothed in fairy cake dresses with candles on their heads, carrying umbrellas. Scene 12 is also clearly an illusion in which Bernadette's youth in *Les Girls* is re-enacted by a large chorus to the song 'A Fine Romance'. Bernadette disrupts the fantasy by explaining the techniques of lip-synching that she has perfected, adding another layer of vocal uncertainty. Carol Langley describes the moments in Sydney drag performances when performers draw attention to the reveal either through removing their wig or stopping singing during a lip-synched performance.[64] Here the reveal occurs on occasions throughout the performance because of the presence of the divas as well as through other devices like Bernadette's explanation of technique. The playfulness of excess and spectacle is promoted alongside the reflexivity of the disembodied voice.

The separation of voice and body is celebrated in the lip-synching sections, especially when reinforced by the presence of the divas who are actually singing. The audience can watch the divas who are singing with no semblance of 'realistic acting'. These are pop performances with clearly audible sound processing and the gestures of pop performance. Or the audience can watch the lip-synching performer who is using melodramatic gesture, wearing flamboyant costume and attracting attention through size and spectacle as well as through the carefully observed lip-synching. I found myself equally engaged, torn between the images as well as fascinated by the artistry of the lip-synching itself. These moments are interesting because of the distance created by the presence of both types of performance. They highlight the artificiality and the comedy of the lip-synched performance, and, in fact, become a joyous and contagious celebration of artificiality.

The moments of camp comedy and spectacle are enjoyed through the knowing disruption of vocal embodiment that results in comic spectacle and is shared in a contagious wave of energy, with audiences experiencing an emotional contagion of laughter and pleasure. This disruption is caused by the parodic recognition of the song, sung by the divas and its performance outside the show by another star performer in a different situation. Simultaneously there is the blending of character, performer, and lip-synched vocal and physical imagery in the drag performances. This is similar to the moment in *La Cage* when Albin's imagery was reminiscent of Judy Garland. But the number of musical offerings and the diversity of genres and

64 Langley, 'Borrowed Voice', p. 16.

performance styles is exaggerated here in a reflexive theatricality and a reminder of a host of popular performances, musical revue and Sydney drag performances.

However, the show clearly demonstrates the desire for certain moments and songs to be perceived as 'realistic' within the plot and puts them in the mouths of the characters when they are vulnerable or emotional, and when the emotions are intended to be read as 'truthful' to the characters and story. The sound design and the characterisations contribute to the reading and to an empathetically experienced emotion. There is still a blend between performer, character and the previous imagined performances of a particular song, but audiences clearly understand these moments differently. The sound of the voices in these songs is technologically reproduced in ways that locate the sound in the body of the performer, and the emotion of the character is perceived simultaneously in the rendition of words and music. There is a different aesthetic of sound design and performance style here that encourages audiences to understand the particular blend of character/drag performer as weighted heavily towards character, even while observing the playful incorporation of known songs.

This leaves the moments of spectacle that are identified in spectacular costume, excessive design and disembodied voice to be perceived as 'unreal', larger than life and heightened camp. This creates a relationship between a performance of emotional 'truth' and a performance of 'artifice'. Langley suggests that such moments of deconstruction are 'an act of defiance; the performer who exposes the mechanics of the act is, in a way, more defiant and more in control than the one who strives to present a seamless show'.[65] Here, perhaps, is a defiance of the trope of integration in musical theatre that offers comedic, parodic and spectacular opportunities for excess. Audience attachment and empathy is juxtaposed with distance, reflexivity and spectacle, and this binary is enacted through vocal embodiment.

Conclusion

This doesn't suggest that live performance is any different from, for example, a filmed performance in terms of the audience identification with characters and plot situations and empathetic response to emotional, physical or vocal gestures. It does suggest that live performances contain some features that are different from mediatised performances, and stimulate different types of attachment in audiences. In live musical theatre performances many things are happening simultaneously. Live performance can stimulate the experience of witnessing, intimacy and co-presence at a unique event, the contagion of social mirroring within the audience and in interaction with the performance, the effects of vocal touch and cognitive empathy, and constructed perceptions of 'truth' and 'artifice' in characterisation. All these are blended together in individual interpretations

[65] Ibid., p. 12.

and responses. Moreover, each production or type of musical theatre performance might contain some of these features in different degrees and so might appeal to different audience members in different ways. The two performances analysed here contain a different balance of these features so that *La Cage* is perceived as 'integrated' but unique at each performance, and emotionally engaging. *Priscilla* is a revue style spectacular that creates a joyously outrageous and disruptive camp comedy, but also an emotionally contagious and moving experience.

The effects of witnessing and co-presence certainly appear to be more apparent the more the performance is perceived as live, and it is here that musical theatre can be particularly successful at engaging audiences in an interaction that is unique at each performance. The effects of intimacy produced by vocal touch are augmented by technology – though there appears to be an optimum beyond which the opposite effect is achieved, and intimacy is replaced by the alienation of the audiovisual split or the disembodiment of the performer/character relationship and insularity for the listening subject. When linked with co-presence, physical gesture and music, vocal embodiment can lead to an intensity of experience and the perception of an emotional connection that is different from that in recorded performance. Equally, physical movement is re-enacted by spectators in all performances, but is linked to witnessing and again a perception of attachment and 'truth' in live and especially live vocal performances.

Live musical theatre performances are mediatised in that they exist in a commercial market where they are endlessly repeated. They use technology and have intertextual interactions with film, television and other media. However, vocal signification and kinaesthetic embodiment of emotion and action alongside the unique moments in any performance give rise to a physical witnessing that derives from the live presence of audiences and performers, and feeds back into the energy and atmosphere of the performance and the entertainment of audiences.

Chapter 8

I've Heard that Song Before:
The Jukebox Musical and Entertainment in
Jersey Boys, *Rock of Ages*, *Mamma Mia* and
We Will Rock You

Perhaps most distant from perceptions of the integrated musical are revue style
or so-called 'jukebox' musicals. These are hugely popular entertainments that use
many of the same features as other musicals, but they also have some aspects that
are more strongly featured. In particular, audiences may know most of the music
of these musicals before seeing them, and that knowledge may be linked to a wider
intertextual field and offer a different type of dissonance from its context than in
'integrated' musicals. Audiences combine a different balance of features as they
interpret and interact with this body of musicals.

Musical constructions of this type are not new to the later twentieth century,
though. In the early part of the twentieth century musicals built around a series of
songs and sketches were popular as revues with Florenz Ziegfeld's *Follies* (1907–
31) and the *George White Scandals* (1919–27) being the most popular. Orly Leah
Krasner remarks that the Ziegfeld formula consisted of 'balancing comedy and
songs with gorgeous girls in lavish and revealing costumes', while the *Scandals*
'harnessed the streamlined energy of the roaring twenties' and 'included pop
standards like "I'll Build a Stairway to Paradise" and "Somebody Loves Me"'.[1]
Krasner concludes that burlesques can still be found in *Forbidden Broadway* and
revues in 'works like *Riverdance*, *Smokey Joe's Café* and *Songs for a New World*
not to mention seasonal extravaganzas like the Radio City Music Hall Christmas
show'.[2] Vestiges of the revue formula attached to a story are also present in
the extravagant song, dance and costume spectacles in, for example, the stage
production of *Priscilla, Queen of the Desert* and in British pantomime.

At the same time composers who wrote for the *Follies* and the *Scandals*, such
as the Gershwins, Irving Berlin and Jerome Kern were contributing songs to, or
writing complete scores for musical comedies from the 1910s to the 1930s and
beyond. The musicals of this period 'remain accused of lacking strong books' but

[1] Orly Leah Krasner, 'Musical Theatre in New York, 1900-1920', in Everett and
Laird, *The Cambridge Companion*, p. 42.
[2] Ibid., pp. 45–6.

critics 'did not seem too disturbed about it', and audiences 'did not mind either'.[3] Geoffrey Block continues: 'the central legacy of musical theatre of all types during this period remains the songs ... Every successful show and the majority of those otherwise forgotten, offered one or more songs that continued with a life of its own'.[4] The majority of the songs in these shows used the structures of popular songs of Tin Pan Alley with a verse that provided the bridge between speech and song, followed by a 32-bar chorus that was most frequently divided into the AABA scheme, though there were a number of variations. These shows were revived with very little concern for the integrity of the original scores or compilations, and were then further adapted for film, with perhaps new songs or a different selection chosen to fit a new book or lyrics and the whole thing built around contracted film stars.[5] Block concludes that though these musical comedies were extremely popular they are difficult to reconstruct given the alterations demanded by the pragmatic circumstances of production and revival, and, more importantly, these musical comedies 'appear more susceptible to the ravages of time than more obliquely topical genres'.[6] Perhaps one of the reasons they are difficult to revive is that the way they stimulate and entertain is strongly rooted in the current and recent popular experiences of the audiences, so that revivals too far out of time fail to activate the intertextual associations and so fail to entertain.

Compilation shows are still very popular, with a relatively unimportant story as the excuse to revive groups of songs by particular composers or pop or rock groups. *Mamma Mia* (1999), for example, uses the songs of Abba with a story written around them by Catherine Johnson. *Blues in the Night* is a musical revue without dialogue conceived by Sheldon Epps in 1980 and tells the stories of the three characters through blues and jazz songs of the 1930s by Bessie Smith, Duke Ellington, Johnny Mercer and others. *We Will Rock You* (2002) is a compilation of hit songs by Queen with a story woven around them by Ben Elton. This group of musicals also includes the documentary style compilations (bio-musicals) whose texts are biographical rather than fictional, such as *Jersey Boys* (2004) – the story of Frankie Valli and the Four Seasons – and *Buddy* (1989) – the story of Buddy Holly. These musicals appear to eschew developed or complex narrative in favour of a simple plot or biography as the excuse to revisit favourite songs.

The direction of travel of the songs has altered – in the 1930s songs moved from shows into popular awareness, while in many of the recent shows the reverse is true, songs are being re-used in musicals. However, even in the 1930s some popular songs were re-used, especially in film musicals, and in recent musical

[3] Geoffrey Block, 'American Musical Comedies of the 1920s and 1930s', in Everett and Laird, *The Cambridge Companion*, p. 85.

[4] Ibid., p. 86.

[5] Ibid., pp. 90–4.

[6] Ibid., p. 97.

theatre the advanced release of albums[7] – alongside marketing campaigns – has developed a following for a show before it is staged, so there is transference in both directions. The focus of this final chapter is those musicals of the last 30 years that are composed from well-known and highly popular songs, because it is the familiarity of the musical materials that creates the attraction for audiences.

Most musical theatre scholarship ignores this group of musicals completely or uses terms such as 'jukebox musicals' to denigrate them as less interesting or worthy of study than their 'integrated' cousins – though the term is used in other materials simply as a descriptor.[8] But this is similar to the issues that have been problematic throughout the development of popular musical theatre scholarship as discussed in the Introduction, which draws attention to the focus on integration and therefore the plot as the central focus for analysis. And, indeed, looking back through the pages of this text the predominant focus has been the relationship between book, lyrics, music and performers. I don't want to dwell on gaps in contemporary scholarship, or my own and other scholars' acceptance of a particular version of history as this is a rapidly developing area, and these gaps are likely soon to be filled. Rather, building on the arguments about the plurality and dissonance in many contemporary musicals, the purpose of this chapter is to draw attention to the entertainment functions of some types of musicals where the story is not really the main point of concern for audiences, and should therefore perhaps be given less weight in the associated scholarship.

The 'camp' of musical theatre derives from a particular type of clear and acknowledged debt to other forms of entertainment and to the clichés that have developed in musical theatre itself, and is necessarily intertextual. The term 'camp' is used to denote a particular level of style, artifice and cliché in musical theatre, and, as Pamela Robertson explains in relation to the films of Busby Berkeley, 'the dissonance between the purported object represented ... and the mode of representation which gleefully abandons verisimilitude'.[9] She argues that Berkeley's camp effect relies on the primacy of extravagant style over plot and the pleasure principle over reality. However, she maintains that the camp of the numbers must be read as having a function in relation to narrative, or as parts of a whole.[10] So, for example, the camp of *Priscilla, Queen of the Desert* in Chapter 7, derives from the re-placement of popular music in unexpected places in a narrative, and the artifice and spectacle that result from the abandonment of verisimilitude

[7] Jessica Sternfeld identifies *Jesus Christ Superstar* as the first show to use this marketing strategy that has subsequently become more widespread, in *The Megamusical*, p. 3.

[8] See *Time Out* review for *Rock of Ages*: http://newyork.timeout.com/articles/ theater/73407/rock-of-ages-at-brooks-atkinson-theatre-theater-review.

[9] Pamela Robertson, 'Feminist Camp in *Gold Diggers of 1933*', in Steven Cohan (ed.), *Hollywood Musicals: The Film Reader* (London and New York, 2002), p. 131.

[10] Ibid., p. 131.

during the musical numbers. But the camp effect would not be apparent without the dissonance between narrative and number.

The re-use of existing songs in new settings, which is a feature of bio-musicals, compilation musicals and revues, allows intertextual and personal associations in reception as well as the response to the dissonance and comedy of camp. This contributes to the sense of familiarity and nostalgia experienced by audience members, which in turn allows them to be removed from their everyday lives, to relive fantasies and memories, and to participate in singing and dancing. This infectious experience of joyful community involves the audience as participants in the event, which contributes to the entertainment felt as a result of attendance. And entertainment is the point. Many compilation and revue style shows are extremely good at entertainment. The questions here, then, are: what are the strategies these musicals use to entertain their audiences? What are the results of those strategies for reception, audience involvement and sensation?

Bio-Musicals – *Jersey Boys*[11]

Jersey Boys concerns the rags-to-riches story of The Four Seasons followed by the disbanding of the group and the re-formation as Frankie Valli and the Four Seasons. The story contains the excitement of links to the mob, the corruption or naivety of group members, and the gambling and bad management which inevitably led to the financial collapse and break up of the group, all accompanied by the songs that 'have provided the soundtrack to an entire generation'.[12] Different versions of parts of the story are told by different group members creating a sense of conflict and pointing to the complexities of history and memory.

This story may not be surprising to fans who already know the story, though the programme suggests that the mob connections were not public knowledge.[13] But to those audience members who don't know the facts of these celebrities' lives the plot is interesting – as Rick Elice explains it is 'about revenge and betrayal and crime and punishment and family and women'.[14] But whatever the complexities, and this is certainly an interesting approach to telling the story, it, like those of *Buddy* or *Jolson* could be told, as above, in a few sentences. So the story is there, it provides structural glue and some information, and allows the audience to identify and empathise with the journeys the characters take, and particularly with the developing power relationships between the members of the group. What is

[11] Book by Marshall Brickman and Rick Elice, Music by Bob Gaudio, Lyrics by Bob Crewe, directed by Des McAnuff. I saw the performance at the Prince Edward Theatre on Tuesday 19 August 2008.

[12] Mark Shenton, 'Four Seasons, Four Lives', Programme note for *Jersey Boys* London production, 2008.

[13] Ibid., n.p.

[14] Ibid., n.p.

more important here are the songs with which the audience members are given opportunities to participate: the format of many bio-musicals is to end the show with a concert performance of many of the greatest hits during which audiences are encouraged to sing, dance and join in. At this point in each performance the clarity of concert and theatrical performance become confused as the performer/ characters reprise the famous and favourite songs.

In August 2008 I attended a midweek matinee of *Jersey Boys*; a day and time of performance that one might imagine to be the least likely to promote audience participation. The audience began clapping along with the singer in response to the very first song 'Oh What a Night', and so it continued, with the middle-aged and older audience members singing along with most songs, suggesting a level of anticipation of content and knowledge of the material that was extremely high. Many of these audience members were clearly fans who had invested some part of their sense of identity in this music at some point in their lives and were enjoying reliving the music as concert performance. This activity in the audience relates to the emotional or mimetic contagion discussed in previous chapters so that a feeling of communitas was created.

Some songs were presented as diegetic numbers performed as onstage concert pieces which had a clear finish with a bow from the performers. These generated enormous applause from the live audience who engaged with the experience both as concert and theatre piece. The sense of attendance at a concert performance was also promoted by the amount of music staged as concert performance for the audience, signifying the audience's presence at a concert as well as at a theatre event.

In general there was a sense of fluidity between the narrated and re-enacted storytelling and the moments of diegetic concert performance. The construction of the performance as a flashback related by different members of the band allowed this fluidity as performers moved between direct address and 'realistic' acting. The continuity of backing music in some scenes allowed for smooth transitions between singing and performing songs and between speech and song. One example was the transition from 'practice' to 'performance' of 'My Eyes Adored You' between Mary and Frankie leading into the performance of the song by the whole quartet. However, there are examples of the juxtaposition of images as discussed in previous chapters. One of these occurred when the band sang 'Sherry' while 'holding up a convenience store and rolling a safe out of the back and putting it in the trunk of their car and trying to get away before the police come'.[15] This gave a sense of seeing the concert personas and simultaneously gaining an insight into the 'real' experiences of the characters' lives, and it is this type of simultaneous presentation of different images as a montage that offers audiences the opportunity simultaneously to relive the songs, and to extend their knowledge of the lives of the celebrities who created them. As the writers explained: 'it is easy to hear this music in a cursory way ... but, casting it in the light of what their lives were like,

[15] Ibid.

makes it more interesting, too.'[16] Audiences blend these images of the music and the celebrities' stories with their prior knowledge and create a personal as well as a social and cultural understanding of the work.

Although I knew many of the songs they didn't feel part of my history or identity, yet, nevertheless, as a member of the audience group I felt the contagion and was uplifted and transported to stand and clap along and was thoroughly entertained by the excellent performances. I am as guilty as anyone of denigrating these shows, though I found this one to be well crafted, but going along in the right spirit led to a real sense of joy in the experience. This was not only the result of intellectual stimulation, engagement with the story, satirical subversion or camp comedy. It resulted from a shared experience of emotional contagion and communitas with my fellow audience members, produced through recognition of the musical materials which activated personal associations and nostalgia, mimetic response to audience members and performers, and the physical activity of participation.

In the last chapter of *Performing Rites* Simon Frith discusses the place of the musical performance of pop music in the construction of identity. He suggests that in responding to a song, or to a sound, audiences are drawn into affective and emotional alliances.[17] As has been argued in the previous chapter the cognitive and emotional effects of embodied music listening, rather than their cultural associations, give access to a unique emotional intensity so that songs are absorbed into people's lives and the rhythms into their bodies. This has become even more pervasive since the introduction of the Walkman and now MP3 players that accompany many people through their lives. Frith suggests that this induces an intensely subjective sense of being sociable.[18] The mirror imagery through which people learn also helps initially to establish a sense of identity around musical tastes and cultures, by allowing an experience of collective identity with the sub-group who identify with the same music. So the song or music is doing two things, first it is creating a direct relationship with the listener through embodied response, but it is also creating an association, through co-presence, with a musical culture and a collective social identity. The created identity is always ideal and idealised, and allows the listener to participate in 'imagined forms of democracy and desire, imagined forms of the social and the sexual. And what makes music special ... is that musical identity is both fantastic ... and real: it is enacted in activity.'[19] Frith quotes Paul Gilroy's discussion of black identity to suggest that identity results from 'language, gesture, bodily significations, desires' that are condensed in musical performance through the interaction of performer and crowd.[20]

16 Ibid.
17 Frith, *Performing Rites*, p. 273.
18 Ibid., p. 273.
19 Ibid., p. 274.
20 Paul Gilroy, 'Sounds Authentic: Black Music, Ethnicity, and the Challenge of a *Changing* Same', *Black Music Research Journal*, 10/2 (1990) quoted in Frith, *Performing*

People hear the music they identify with as something special, as a part of life that reflexively encourages a sense of self-recognition and specialness, a feeling of transcendence. This reinforces one's own social narratives and creates a fusion of the imaginative fantasy and the bodily engagement with music.[21] Frith goes further in suggesting that '[i]dentity is necessarily a matter of ritual: it describes one's place in a dramatized pattern of relationships – one can never really express oneself "autonomously"'.[22]

This argument suggests that it is possible that attendance at a bio-musical focusing on a musical genre or performer with whom the audience member identifies can trigger these feelings of transcendence through the reinforcement of social narratives and imaginative identity. Such responses are then augmented by the shared experience and the mirroring of responses within the audience.

Victor Turner's definition of 'spontaneous communitas' is useful here. He describes it as the experience of a group of compatible people who together experience

> a flash of lucid mutual understanding on the existential level, when they feel that all problems … could be resolved, whether emotional or cognitive, if only the group … could sustain its intersubjective illumination. This illumination may succumb to the dry light of the next day's disjunction, the application of singular and personal reason to the 'glory' of communal understanding.[23]

The memory of the experience of communitas can lead avid fans to try to replicate the event by repeated attendance at the performance, which can lead to more dangerous consequences for group members as they lose sight of the real. Of course this type of response can be triggered within other group situations, and it can be resisted, but the theatre space offers a safe location in which to indulge in the pleasure of having one's emotions manipulated before returning to the real. Moreover, this type of experience does begin to account for the engagement and participation of audience members with shows where the story is already known or relatively simple, but where the music activates particular types of identification.

Turner describes mass entertainments as liminoid activities; activities that are playful or leisured, separate from work activities, and existing within an industrial society. Liminal activities are a function of ritual, relate to defined group activities and 'invert but do not usually subvert the status quo'.[24] The importance of a defined group allows these shows to begin to create a transference or a flexibility between the liminoid experience of mass entertainment and the liminal – a sharing or joining with others in a desired membership. However, since the desired

Rites, p. 274.

[21] Frith, *Performing Rites*, pp. 275–6.

[22] Ibid., p. 275.

[23] Victor Turner, *From Ritual to Theatre* (New York, 1982), p. 49.

[24] Ibid., p. 41. More complete definitions of liminal and liminoid are at pp. 53–5.

membership is unlimited and available simply by buying a ticket the liminality is always superficial.[25] Nevertheless, a shared fandom calls on genre understanding and experience of the same events, concerts or musical theatre performances so that these songs are placed into new surroundings and provide the experience of reinforcing shared fantasies and idealised identities and removing the listener from established contexts into the liminoid space. Here, new intertextual associations are created in experiencing the music in its new context, but more importantly the audience members become part of the group and can share in the momentary transcendent experience of communitas. The participation in singing and dancing in the final stages of many of these types of performances further extends the feeling of group identity. The audience is encouraged from the stage to participate, which, when conformed to, leads to greater feelings of engagement and pleasure.

The Rocky Horror Show

In 1991 I was musical director for a European tour of *The Rocky Horror Show*[26] – not a compilation show but one that exemplifies some of the ideas of participation described above – that was rehearsed in Budapest. During the rehearsal period a group of students were brought into rehearsals and coached in the responses that have become commonplace for audiences to interject in performances. This small group of students were then encouraged to return to their colleges and universities and teach the responses to their peers. The result of this was that the audience members engaged in a participatory way with the performance even though they had no knowledge of the development of the participation in response to the film version. The enormous audiences returned to the performance repeatedly, partly because they had never seen anything like this, partly because the part of the narrator was being played by a celebrity Hungarian blues singer who had been critical of the communist regime and was by this time something of a hero, and partly because they felt the experience of joyful congregation and participation activated by the show and the learned responses. Clearly, though, the management was aware of the importance of participation to the cult success of the show and felt the need to re-create that through artificial means in order to ensure the success of the production.

The 2004 British tour moved further towards a rock concert in its stage presentation, and further towards a ritual event in its deliberate incorporation of the audience participation derived from the cult responses to the film version. The 2006 version reverted to a stronger focus on storytelling, but by directly addressing the audience, and allowing time and space for the audience interjections encouraged them as participants in the experience. The audience, in a deliberate extension of the spontaneous response to the late night film showings in New

[25] Ibid., p. 55.

[26] Book, Music and Lyrics by Richard O'Brien.

York, is encouraged to dress up or cross-dress, coming to the theatre wearing outrageous versions of the costumes of the leading characters. There is something grotesque and carnivalesque about the revelation of imperfect bodies, the cross-dressing and transgressive playfulness in the streets around the theatre before the performance begins and later as it spills back out into the streets. The atmosphere communicates itself, multiplies and feeds back into the performance so that each new performance builds on all the other experiences in a continuing re-creation and intertextual re-imagining.

Jill Dolan describes similar experiences of shared events and imagination in different types of performance in *Utopia in Performance*. The performances she describes are from contemporary performance genres and contain a different aesthetic than the one I'm describing here, and perhaps offer a greater radicalism, but the experience of theatregoing that she describes is potentially present in these works of commercial entertainment too. She says 'Such moments return me, too, to performance, lured by the possibility that in its insistent presence (and *present*), my fellow spectators and I might connect more fully with the complexities of our past and the possibility of a better future'.[27] The utopias she describes are fleeting and unstable, always in process and only partially grasped as a desire or a fantasy in the space of the performance. They exist in a performative that she relates to a Brechtian notion of *gestus* that offers spectators the opportunity to observe social relations in ways that offer the opportunity for critical contemplation and the hope for a more equal and less oppressive future. However, she is clear that such utopias are not enacted or demonstrated in the performances that she discusses, but rather 'spectators might draw a utopian performative from even the most dystopian theatrical universe'.[28] Dolan refers here to Sarah Kane's *Blasted* but the point remains that the experience of ephemeral moments of illumination or emotion are open to multiple interpretations that may be individually utopian and potentially transformative, and they may occur in response to all sorts of performances.

Dolan builds on Turner's exploration of communitas to suggest that disparate people become communities and that the simple fact of this grouping might encourage them to be active in other spheres. This is perhaps most apparent in some community theatre performances that have derived from the experience of audiences, such as at the Victoria Theatre Stoke-on-Trent under the direction of Peter Cheeseman, but the experience of community in performance can activate audiences. Dolan describes a play about a local football team and the impact it had on the fans in the audience, as well as helping those who were not fans to understand the experience of fandom. More importantly it was a space where the communities of theatre spectatorship, football field and city coalesced.[29] This is a utopianism, then, that reaches out from the theatre into other forms of social relations, and one that could be activated by the communitas of interaction or

[27] Jill Dolan, *Utopia in Performance*, p. 5.
[28] Ibid., p. 8.
[29] Ibid., p. 12.

participation with a commercially produced performance, though it is certainly less likely.

Dolan describes a moment of communitas in a performance by Peggy Shaw of *Menopausal Gentleman* when Shaw sang 'My Way' moving within the audience and making individual contact. I saw a similar moment in a performance by Peggy Shaw and The Clod Ensemble of *Must* in which she sang songs that were both familiar and new, including 'Ain't No Sunshine When She's Gone'. What I'm drawing from this is that the interactions may be between stage and audience or between audience members, but the experience of sharing a moment with both these groups acknowledges our shared attention and pleasure. This is the type of activation that has the potential to unite many different types of spectator in a momentary experience of communitas and a utopian pleasure. This type of pleasure is perhaps most obvious in musical theatre in those performances that activate a participatory and joyful coming together in an interactive or nostalgic musical memory.

Jukebox Musicals – *Rock of Ages*

Rock of Ages is a 'sexy feel-good romp'[30] with book by Chris D'Arienzo that I saw at the Brooks Atkinson Theatre in New York in May 2009.[31] The plot, narrated by Lonny, concerns a naive girl, Sherrie, who arrives in Los Angeles and gets a job at the Bourbon Bar on Sunset Strip. After being convinced that Drew – the hero and a waiter at the Bourbon – only wants to be friends she falls for an aging rock star. However, true love wins out. Drew has been signed to a recording contract but is turned from rocker to boy band star – a terrible fate for a rocker – and Sherrie is now working as a stripper. Both are disillusioned but realise they can't live without each other. As *The New Yorker* reports: 'In truth the plot – kudos for even having one – is really just a chain of segues into the hits of Styx, Journey and Twisted Sister.'[32] More important than the plot is the music and the knowing, comic self-reflexive stance the musical takes as the songs are inserted into the simple plot peopled by outrageous stereotypical caricatures. David Cote writes in *Time Out*:

> When it premiered Off Broadway last year, this jokey tuner impressed me as a conventional book musical, albeit one that constantly winked at its contrivances—a *Urinetown* scored to recycled songs by Journey, Foreigner, Pat Benatar and the like. Kristin Hanggi's sight-gag-stuffed production, in the transfer to Broadway, is now harder, louder and even more self-aware of its

[30] www.rockofagesmusical.com, accessed 3 August 2009.

[31] Music supervision, arrangements and orchestrations by Ethan Popp, directed by Kristin Hanggi.

[32] 'Is there a Tony Award for Baddassery?' *The New Yorker*, 20 April 2009.

silliness, and the fit is excellent: tribute rock and broad comedy reinforcing one another in perfect proportion.[33]

This is an excessively camp compilation musical that creates a new and unexpected context for the songs so that the dissonance creates comedy and irony. The show culminates with the song 'Sherrie' as the two lovers finally come together, a moment that has been anticipated since the introduction of the heroine named Sherrie.

There is a similar comic sense of anticipation and appreciation of the intertextual playfulness in the film *Moulin Rouge*[34] beginning when Christian sings lines from 'The Sound of Music' in the introductory scenes, and repeated throughout the film as other songs from recent popular music are introduced. The joyful sense of sharing a cultural language and the uncanny associations created by the new contexts induce a response to the comic juxtaposition, but also a sense of intellectual self-congratulation in that recognition, reinforcing the identity of the audience member and creating feelings of pleasure and transcendence.

Angela Ndalianis argues that in cinema and multimedia of the last two decades 'entertainment forms have increasingly displayed a concern for engulfing and engaging the spectator actively in sensorial and formal games'.[35] Rather than a focus simply on a story, the story is only a limited part of what is on offer. Instead she quotes Jay David Bolter and Richard Grusin in arguing that media have become networks revealing new convergences between themselves and alternative modes of reception.[36] Ndalianis says that the contemporary entertainment industry

> has embraced classical storytelling and placed it within new contexts, contexts that incorporate a further economization of classical narrative form, digital technology, cross-media interactions, serial forms, and alternate modes of spectatorship and reception.[37]

This is a conjunction that Ndalianis describes as the 'neo-baroque'[38] since she argues that the similarities with the Baroque period lie in the emphasis on serial

[33] David Cote, '80s Rock Hits Return in a Deliriously Fun New Jukebox Musical', *Time Out New York*, Issue 707, 18–22 April 2009.

[34] I'm referring here to the 2001 musical film written and directed by Baz Lurhman. Original Score by Craig Armstrong.

[35] Angela Ndalianis, *New Baroque Aesthetics and Contemporary Entertainment* (Cambridge, 2004).

[36] Ibid., p. 4 refers to Jay David Bolter and Richard Grusin, *Remediation: Understanding New Media* (Cambridge, 1999).

[37] Ibid., p. 4.

[38] This makes reference to the use of the term in Omar Calabrese, *Neo-Baroque: A Sign of the Times* (Princeton, 1992) and to Umberto Eco's use of the term in the Foreword to that text as discussed in Ndalianis, *Neo-Baroque Aesthetics*, pp. 71–3.

narratives and the spectacular as forms that address transformed mass cultures. However, the neo-baroque sensory experience is a product of conglomerate entertainment industries, multimedia interests and spectacle that is often reliant on computer technology.[39] This may not be entirely appropriate for a discussion of live musical theatre performance, but importantly for the discussion here, she argues that the 'baroque's difference from classical systems lies in its refusal to respect the limits of the frame that contains the illusion'.[40] This is clearly a feature of the intertextual compilation musicals discussed here. As identified above, storytelling is not the primary driver of these works, but reference to other media, in this case popular musical works, is integral and contributes to an open interpretation and to the processes of interpretation. So this type of intertextual citation engages the audience in a game or series of games that allow it to pay homage to, and renegotiate, the past. As with the types of film and gaming examples Ndalianis refers to, the resulting 'hyperconsciousness' permits participants to become engrossed in the narration in the conventional sense, but also to participate with the work on the paradigmatic level through the 'multi-layered intertextual references'.[41]

Ndalianis relates this to Walter Benjamin's writing on the Baroque in arguing that 'these entertainment forms function like ruins and fragments, evolving the existence of a past in the present while simultaneously transforming the ruin into a restored, majestic structure that operates like a richly layered palimpsest'.[42] While it might be fanciful to regard compilation or jukebox musicals as 'majestic', this argument does suggest ways in which these musicals fit into an understanding of the functions and practices of the mass media of their times. However, they are unlike works of the Baroque period since that period involved a synthesis of techniques and styles in order to perfect and transcend those techniques. Instead, these musicals, though they create a discourse between past and present and a self-reflexive attitude to the creative process, do so with less sense of critically engaging than of offering an entertaining and joyful event and potentially a ritual experience of communitas.

[39] Ndalianis, *Neo-Baroque Aesthetics*, p. 5.

[40] Ibid., p. 25.

[41] Ndalianis, *Neo-Baroque Aesthetics*, p. 73. Here Ndalianis refers to Jim Collins, 'Batman: The Movie, Narrative: The Hyperconscious', in Roberta E. Pearson and William Uricchio (eds), *The Many Lives of the Batman: Critical Approaches to a Superhero and his Media* (New York: Routledge, 1991), pp. 164–81.

[42] Ibid., p. 73.

Mamma Mia[43]

Mamma Mia is the world's most successful musical. As Malcolm Womack reveals in his recent article 'Thank You For the Music',

> *Mamma Mia!* is, without hyperbole, the most successful musical in the world. The production in London's West End has celebrated its tenth year, the Broadway production is currently in its eighth, and along with several international tours there have been resident companies of the show in Las Vegas, Hamburg, Moscow, Fukuoka, and twelve other cities ('mamma-mia.com'). Over thirty million people around the world have seen *Mamma Mia!* – about seventeen thousand audience members a night – and the 2008 feature film with Meryl Streep grossed over six hundred million dollars internationally, for an estimated audience of sixty million (Dawtrey et al 2009).[44]

The focus of Womack's article is the revisioning of the Abba songs through a feminist rewriting and re-attribution across genders in the musical, which is important here as an unsettling device that sees the songs used in altered contexts. This creates a sense of disruption of the nostalgic readings of the texts, and camp through the dissonant repositioning of the songs in the new contexts. Comedy is also created through production devices and comic spectacle as, for example, the singing of 'Mamma Mia' is accompanied by a chorus only seen as heads peering over a wall. Later, 'Lay All Your Love on Me' is accompanied by a chorus of men dancing in diving suits and flippers, while the rendition of 'Super Trouper' by Donna and the Dynamites is performed wearing white lycra imitations of Abba's costumes. All of these devices are comic, create distance from identification with the story, and create a new camp context for the songs.

The work functions as a musical in its own right containing a plot with songs that enhance moments within it. As John Peter writes in the *Sunday Times,* 'The fun of this show lies in the skill and wit with which the songs are fitted into the story, not just as decorations, but moving it along, almost as if they had been written for it'.[45] The plot and the production offer a comic and camp reading of the material that draws on the cultural understanding of the place of Abba as an iconic, camp pop group of the 1970s that became something of a cult both at the time

[43] Music and Lyrics by Benny Andersson and Björn Ulvaeus and some songs by Stig Anderson, Book by Catherine Johnson, Directed at the Prince of Wales Theatre in London by Phyllida Lloyd. I saw the production in August 2008.

[44] Malcolm Womack, '"Thank You For the Music" Catherine Johnson's Feminist Revoicings in *Mamma Mia!*', *Studies in Musical Theatre*, 3/2 (2009): pp. 201–11. The article he refers to is at www.variety.com/article/VR1118002072.html?categoryid=3592&cs=1, accessed 25 June 2009.

[45] John Peter, 'Thank you for the Musical!', *Sunday Times*, www.mamma-mia.com/worldreviews.asp, accessed 4 August 2009.

and subsequently as a result of the karaoke performances of *Sing Alonga Abba*. This complex reading is further nuanced by the placing of individual songs in new settings, sung from different gendered positions. This provides an intertextual irritant to the audience's reading of the plot.[46] Finally, and most recently, this is further overlaid by reading the live performance in light of the cinematic version with its star performances and beautiful locations. This multiplicity of frames and fragments allows the core musical to construct a story that reaches its audience in ways not available to writers of original musicals. As Charles Spencer records in the *Daily Telegraph*:

> Catherine Johnson's witty and ingenious script weaves the famous ABBA songs around characters you care about. At the end the whole audience is on its feet and swaying blissfully along to the hits. What a pleasure to see that girl, watch that scene and dig the Dancing Queen.[47]

Or, as Jeremy Vincent in *The Australian* remarks: 'What makes MAMMA MIA! work is the ingenuity with which the songs leap from the story – they come like brilliant bolts out of the blue and the audience roars its approval.'[48] Here there is the open acknowledgment that the songs function differently in a jukebox musical than in an 'integrated' musical, in that rather than simply amplifying and expanding on their context, they leap from it and make connections with other parts of the audience's lived experience.

Similar arguments can be made with reference to the translation or adaptation of musicals between film and theatre and to the importance of CD release, YouTube advertising and other marketing and merchandising on the impact of musical theatre of the late twentieth and early twenty-first centuries. The musical theatre offering becomes part of a series of offerings with which the spectator engages while simultaneously becoming involved with the plot of the particular show. Examples of this include the creation of live versions of several Disney films including *Beauty and the Beast* and *The Lion King*, both of which are necessarily altered in their mode of production for the stage, but which give the viewer a simultaneous reminder of the film and an experience of the live performance. Even more interesting in this argument is the recent integration of television game shows into this media circulation with UK terrestrial television running reality show competitions to cast the leading performers for West End productions of *The Sound of Music*, *Oliver*, *Joseph* and most recently, *The Wizard of Oz* with the active involvement of Lord Andrew Lloyd Webber.

[46] Womack, 'Thank You For the Music'.

[47] Charles Spencer, 'An Irresistable Enjoyable Hit', *Daily Telegraph*, www.mamma-mia.com/worldreviews.asp, accessed 4 August 2009.

[48] Jeremy Vincent '*******', *The Australian*, www.mamma-mia.com/worldreviews.asp, accessed 4 August 2009.

Clearly there is an effect in marketing terms as the television shows provide weeks of advertising and ensure sell-out runs of the theatre productions, but in terms of audience experience, the viewer becomes an interpreter of the story of the musical, its earlier theatre and film releases, its CD release and its star personas and rivalries through the television programme. In a sense the television programmes are creating a reflexive awareness that undermines the storytelling of the musical by encouraging a focus on the lead performer as celebrity above character. This is not really any different to the experience of cinema, but represents a democratising of the theatre experience in which the theatre cognoscenti have always been aware of star performers and their other roles, but which has now become more clearly a focus of mass public awareness. This intensity has, of course, changed the experience of performance, but perhaps this is a change of degree and scale rather than a change in the processes of interpretation. After all, Stacy Wolf's study of gender and sexuality in musical theatre, *A Problem Like Maria*, bases its arguments partly around the celebrity and appeal of its leading performers and refers to musical productions from 1930 to 1983.[49] The function of celebrity notwithstanding, the musical has become part of the circulation of mass media, and the texts of compilation shows give the clearest examples of the importance of intertextual interpretation in the entertainment of audiences.

We Will Rock You[50]

We Will Rock You contains a utopian story set in a dystopian world; a world where the music – rock – has died to be replaced by computer generated pop. The hero, Galileo, and heroine, Scaramouche, escape from the evil Killer Queen and her henchman Kashoggi and join a group of bohemians led by Brit and Meat – references to Britney Spears and Meat Loaf – before they release the hidden axe – electric guitar – and bring down the evil regime. This story carries deliberately strong echoes of Arthurian legend. In addition, the history of rock rests on a construction of rockers as rebellious urban youths, an association that is enacted in this story as the outlawed Bohemians subvert and eventually overthrow the ruling elite. These two fictions create an intertextual cultural framework within which the plot develops according to expectations.

The set reflexively signifies a rock concert with scaffolding supporting a light show, a runway into the audience for performances by the Killer Queen and Kashoggi and most of the songs performed concert-style, directly to the audience rather than in onstage interactions. More importantly, the intertextual associations

49 Stacy Wolf, *A Problem Like Maria: Gender and Sexuality in the American Musical* (Ann Arbor, 2002).
50 Music and Lyrics by Queen, Book and Direction by Ben Elton. Original West End Production Directed by Christopher Renshaw. I saw a performance at the Dominion Theatre London in August 2008.

with contemporary life are extended into the details of the script. The names of the principal characters are derived from Queen's lyrics, the songs are some of the most famous of Queen's hits, and the script is constantly updated with references to the history of pop and rock music and contemporary events. All the Bohemians have names of pop stars of the present, though often used across genders, the premise being that the names are known from old posters. So Britney Spears is a man in a kilt, Meat Loaf has become a woman, Madonna is a man complete with metal bra, and even Robbie Williams is present. There are many more references to contemporary culture that are satirical as well as intertextual: the X Factor television reality shows are responsible for the demise of music and culture; reference is made to Victoria Beckham and the Teletubbies; to the demise of the Northern Rock Building Society and there are references to the Beatles including the question 'Where is Penny Lane?'.[51] The list of performers who died young included Michael Jackson when I saw the show in August 2009. The list concluded with Freddie Mercury before a performance of 'Only the Good Die Young'. The show ended with a rendition of 'We are the Champions' during which the entire audience joined in and waved their arms in the air, before rapturous applause. Following the question from the stage, 'Do you want Bohemian Rhapsody?' and the vocal assent from the audience, it was played in full.

As with *Rock of Ages*, the story of *We Will Rock You* is the glue for what Fiona Sturges of *The Independent* refers to as 'A Queen song-fest – The songs will have even the most curmudgeonly punter tapping their feet and remind you just how fabulous Queen were',[52] while Neil Massey of *Q Magazine* records that 'The audience – love it. They cheer and clap and laugh a lot'.[53]

Perhaps, though, the story is more than glue. The utopian, Arthurian inspired story, the characters and the references to popular culture all contribute to an intertextual and contemporary re-appropriation of myth. It calls on the audience to make connections, to understand references and to participate in a nostalgic evocation of the music of a bygone era. There is a compression of past and future within a referenced present time, and recognition of the audience as an active body of participants able to engage with the materials and transcend the present moment through the communitas of the performance and its associations.

This could be regarded as hopelessly utopian – and clearly the plot is exactly that – but the utopianism Dolan discusses is not based on the plot alone. Rather it is based on the coming together of groups of people who form a community in their responses to a performance. The activation of that community around particular bodies of work, in this case by Queen, leads to a sense of identification and

[51] Such references are updated regularly, so this list is drawn from the performance I saw on 8 August 2009.

[52] Fiona Sturges, 'We Will Rock You', *The Independent*, 15 May 2002, www.wewillrockyou.co.uk, accessed 4 August 2009.

[53] Neil Massey, *Q Magazine*, June 2002, www.wewillrockyou.co.uk, accessed 4 August 2009.

reinforcement, while the experience of entrainment is enhanced by the audiovisual connections of narrative and number, singer and song. The incorporation of further materials that provide a satirical and reflexive glance at contemporary culture adds greater intertextuality, and the conflation of histories and media provides entertainment in ways that Ndalianis notes as features of contemporary cultural practice. So camp and nostalgia are linked, and both provide access to moments of transcendence and pleasure. In the end it is not surprising that the reviewer of *The Daily Mirror*, James Whittaker, reported that

> I loved every moment of the evening and so did everybody else in the packed auditorium. By the end we were all on our feet waving our arms. There were numerous calls for encores and, if we'd had our way, the cast wouldn't have been allowed home until breakfast.[54]

I saw the show on the 8 August 2009 and surprised myself by feeling the same.

Conclusion

This chapter has identified features of different types of musical that use existing music. Bio-musicals rely on the nostalgia for the music of a particular writer or group but are written as 'realistic' fictions so that the audience can identify with the characters and understand the events of the characters' lives. They create a sense of identification within the audience through reinforcement of social narratives and imaginative identity, so that the audience responds by participating in singing and dancing to the nostalgic re-creation. The jukebox musicals have another level created by the reconstitution of the songs within an entirely new plot, with songs sung in dissonant new contexts, and sometimes with new meanings produced by contexts, gender variations and the camp comedy of performance. While the bio-musicals draw on social connections and identity with particular bodies of music, the jukebox musicals give access to a sense of self-awareness, silliness and camp that provokes the audience to a greater intertextual and camp awareness that voluptuously exceeds the boundaries of a 'realistic' text. It is the voluptuousness and excess of these texts that flow into contemporary life and allow audiences the transcendental pleasure of attachment, intelligent interpretation and nostalgic re-creation.

[54] James Whittaker, *Daily Mirror*, 8 July 2002, www.wewillrockyou.co.uk, accessed 4 August 2009.

Conclusion

So what is it about musical theatre that audiences find entertaining? And what are the features that lead to its ability to stimulate emotional engagement, to move and to entertain?

At the start of the book I identified the background to current thinking on entertainment, moving from the idea of entertainment as the opiate of the oppressed masses, through acceptance of the dialectical relationship between commercial product and consumers, to Richard Dyer's reading of musical film as pleasurable, escapist, exciting and fun. Dyer goes further in finding that analysis of the formal and structural relationships in the musical film produces categories that reveal a utopian sensibility, and Barthes finds bliss in the gaps, contradictions and excesses of the text. Caryl Flinn and Jill Dolan both find utopias in the gaps in the reading of film or the experience of performance, so different theorists find utopian moments in work, readership and performance. It is this combination that I have attempted to explore here, beginning with the text as disrupted and excessive, and then finding the gaps in the performance text also to be revealing of discontinuities and excess. Finally, though, the introduction of discourses from cognitive neuroscience helps to locate the experience of musical theatre performance and its effects on the brains, emotions and physiology of audiences alongside these theoretical readings of work and performance.

Texts signify in time and place using structure and genre, but 'the text is not a line of words releasing a single theological meaning, but a multi-dimensional space in which a variety of writings, *none of them original*, blend and clash'.[1] This complexity of remaking that the audience undertakes is an essential part of reception, and, as Marvin Carlson remarks, has become now quite familiar. Carlson also notes that the performance text is more complex than the literary text in its more comprehensive manner of recycling. Moreover, memory is a key ingredient in the stimulation of motor activities in the brain.

Part of what I have been arguing above is that the signification of the musical theatre text is open to a variety of readings, perhaps even more than the theatrical text, because of the additional signification of song and music in the performance. In addition, each production is different, as Kirle argues, so that the reading the audience might conceive is infinitely mutable between productions and even between performances of the same production. This mutability or plurality also calls on intertextual references to genres, stereotypes and events and opens up disturbances and disruptions, whether creating synchronous and diachronous relationships within the text – as exemplified in *Mahagonny* – or creating

[1] Barthes, *Image, Music, Text*, p. 146, quoted in Carlson, *The Haunted Stage*, p. 4.

intertextual readings between media as in the jukebox and bio-musicals, or simply by using genre to create character stereotypes or parodies as in *Pinafore* and *The Rocky Horror Show*. Moreover, musical theatre texts that use non-linear narrative structures, or incorporate meta-narratives, or use montages within a linear or non-linear narrative structure, also create disruptions and disturbances that require the audience to read playfully between the various parts of the texts. So the audience brings a 'horizon of expectations' to the experience and interprets the text within parameters linking memory and experience, past and present in a playful and stimulating exchange. The gap created by the juxtaposition of materials might be a gap for pleasure or bliss, and potentially opens up the experience of jouissance for the reader who is positioned in a network of cultural markers in music, voice, performance, narrative, genres and productions.

In the gaps between what is presented and the implications of the complex mix of materials, audiences use conceptual blending to make connections between escapist entertainments, tragic, comic or melodramatic plots and the real world. The juxtapositions create a stereophony of associations that engulfs the spectator in experiences, associations and sensations. In addition to the intricacies of narrative, meta-narrative, inter- and intratextual associations, audiences move between awareness of characters and performers, narrative and theatricality, revealing and revelling in the frame of performance. The result of this multiplicity is that audiences are aware simultaneously of the plot, the characters – with whom they might empathise – the dissonances of irony, parody or camp, the performers in their roles, the theatre space, and the references to political, social or entertaining identities and realities. So the performance adds layers to the text that result from the identities of performers and the theatricality of performance.

How much each production or each work reflexively draws attention to theatricality varies, and audience members might prefer more or less reflexive, more or less 'realistic' productions of works. But simply by being performed, and especially through the interruptions and disruptions of music and song, musical theatre necessarily operates within a framework that is reflexive. The blend of experiences that are drawn into contiguity by a performance can be immensely complex, and can produce an intense experience of plurality of perception and emotional connection. This voluptuous excess and self-awareness allows audiences to access the transcendental pleasures of emotional attachment, intelligent interpretation, nostalgic recreation and camp silliness. And the performance is a channel for the blend of reality and intoxication audiences choose to construct from it.

There are two other features of musical theatre performance that result from live attendance. They are the emotional contagion of sharing the time and place of performance with the performers and with other audience members, and the physiological response to the vibrations and dynamic range of musical and vocal performance. Live performance stimulates the experience of presence, and it was argued above that intimacy with the performers and witnessing the event are important to audiences in the perception of a shared unique experience. In the

process of sharing the experience, cognitive neuroscience suggests that spectators embody the emotions and experiences of performers and characters through the functioning of mirror neurons. Their responses activate emotional and social responses that can lead to emotional contagion within the audience and in a process of circularity can feed back into the performance.

So audiences do not only perceive a character and plot situation intellectually, but respond empathetically to the emotions embodied by the performer/character in the plot situation, while still retaining awareness of the theatrical framework. Such embodied responses are stimulated more strongly by the vocal gestures of the performer/character enacting a psychologically realistic emotional journey. Audiences hear through the sounding voice and somatically mirror the emotion of the vocalist. Then the musical accompaniment adds another layer of text, emotion and dynamic shaping. The musical language is particularly adept at creating physiological responses such as excitement – for example at key changes or as tempo increases, or trance-like states as a result of extended repetition. Because of the combination of musical and vocal manipulations and mirroring alongside the empathetic stimulation of the plot, musical theatre has the potential to create the experience of voluptuous and excessive sensations for the audience.

At a recent conference on cognitive neuroscience and dance *Kinaesthetic Empathy: Concepts and Contexts*[2] it became clear the extent to which cognitive neuroscience can offer theories through which we can understand these processes scientifically, and begin to explain the ability of musical theatre to draw audiences into an empathetic connection or the experience of sensation. Grosbras, Jola, Kuppuswamy and Pollick have tested the way experienced and novice spectators respond to dance. They conclude that 'even without physical training, spectators can simulate the movements they are visually familiar with, and that empathy increases resonance with dance'.[3] Since it has been argued above that subvocalisation operates in a similar way so that melody is replayed in the mind of the audience – though it only activates the proprioceptive areas rather than all the same areas of the brain[4] – it is likely that empathy with the character and the plot also increases the resonance with the song. Moreover, it will do so increasingly the more expert the listener or the more familiar the song.

In the keynote address to the conference Christian Keysers explained how doing an activity as a group activates the reward areas of the brain and binds the participants together. It is possible that engagement simply in watching something

[2] Manchester University, April 2010. This research project is supported by the Arts and Humanities Research Council.

[3] Marie-Hélène Grosbras et al., 'Enhanced Cortical Excitability Induced by Watching Dance in Empathic and Visually Experienced Dance Spectators', Poster presentation *Kinaesthetic Empathy: Concepts and Contexts*, Manchester University, 22–23 April 2010.

[4] Christian Keysers, 'From Mirror Neurons to Kinaesthetic Empathy', Keynote Presentation, *Kinaesthetic Empathy: Concepts and Contexts*, Manchester University, 22–23 April 2010.

together could activate the same reward areas. So the audiovisual nature of the performance is likely to lead to similar emotional responses at the same time mirroring produces emotional contagion, but more than that, the communal activity or bonding this produces stimulates reward areas of the brain. In 1990 Marvin Carlson theorised that audiences will tend to respond in common with other audience members at performances and that individual spectators are unlikely to articulate a response different from that of the majority,[5] and there is now scientific evidence that supports this theory by proving that audiences are likely to feel good when engaging in communal responses. Moreover, Keysers suggested that the activation of multiple areas of the brain at a musical theatre performance was likely to produce an intense experience that might translate as pleasure – though that was likely to depend on the content and the context.[6] In terms of the potential of musical theatre to be entertaining, it appears that it can be an intense, involving, communal and entertaining experience if the form, content and context are effective.

In sum, then, it appears that musical theatre performances combine the disruptions and dissonances of a stereographic or multiple text that allow gaps for the audience to read playfully with pleasure and jouissance, with the voluptuous sensations of embodied emotion, contagiously and viscerally shared between audience and stage, and augmented through the presence of voice and music. The multiple stimuli activate many parts of the brains of audiences including mirror neurons, reward areas and areas that create social cohesion and bonding. The intensity of this experience in conjunction with comic, memorable or emotive content is likely to produce moving, entertaining and pleasurable sensations for audiences.

Musical theatre is a very difficult form – the archives are littered with musicals that flopped, and it would be interesting to analyse some of them against the structures that have been identified here as producing pleasure – but musicals that succeed do not seem to follow a particular formula. Some are 'integrated musicals' in which characters attempt to maintain psychological continuity within a linear narrative, while others are 'jukebox' musicals, reflexive and camp with dissonant reference to materials from other contexts, and there are all the stages of distance, disruption and dissonance in between. Some audiences prefer the more intellectual interplay of 'realistic' character, plot and politics in the narratives and meta-narratives of 'integrated' musicals. Others prefer the camp dissonance and ironic or parodic comedy of the jukebox or bio-musicals. The common factors are the signification through familiar signs and languages, the gaps and disruptions through which communication is enacted, and the sensation of presence and empathetic embodiment produced through voice and music.

Musical theatre is extremely nostalgic in its languages, even as it produces a strong experience and sensation through its present and presence. It gives the

5 Carlson, *Theatre Semiotics*, p. 13.
6 Personal communication.

experience of voluptuous excess even in its most 'real' moments, and when it exceeds the boundaries of even the most camp expectations, it can be silly, self-aware and pleasurably outrageous. Musical theatre is entertaining in the ways it signifies, through gaps, dissonances and disruptions that audiences blend together to produce an experience of synchronous similarity, in the clearly embodied stories and characters with which audiences can empathise, and most of all in the excesses and voluptuous sensations it creates for its audiences to experience.

Bibliography

Books and Articles

Abbate, Carolyn, *Unsung Voices* (Princeton: Princeton University Press, 1991).

Abbate, Carolyn, *In Search of Opera* (Princeton: Princeton University Press, 2001).

Adorno, Theodor, 'On Commitment', *Performing Arts Journal*, vol. 3/2: 3–11 and vol. 3/3 (1978): 58–66.

Adorno, Theodor, *The Culture Industry: Selected Essays on Mass Culture*, edited and Introduction by J.M. Bernstein (London and New York: Routledge, 1991).

Adorno, Theodor and Eisler, Hanns, *Composing for the Films* (London: Athlone Press, 1994 [1947]).

Agawu, V. Kofi, *Playing with Signs* (Princeton: Princeton University Press, 1991).

Allen, Graham, *Intertextuality* (London and New York: Routledge, 2000).

Altman, Rick (ed.), *Genre: The Musical* (London and New York: Routledge, 1981).

Altman, Rick, 'The American Film Musical as Dual-Focus Narrative', in Steven Cohan (ed.), *Hollywood Musicals: The Film Reader* (London and New York: Routledge, 2002).

Attali, Jacques, *Noise: The Political Economy of Music* (Minneapolis: University of Minnesota Press, 1985).

Auslander, Philip, *Liveness: Performance in a Mediatized Culture* (London and New York: Routledge, 1999).

Banfield, Stephen, *Sondheim's Broadway Musicals* (Ann Arbor: Michigan University Press, 1993).

Banfield, Stephen, 'Stage and Screen Entertainers in the Twentieth Century', in John Potter (ed.), *The Cambridge Companion to Singing* (Cambridge: Cambridge University Press, 2000), pp. 63–82.

Barthes, Roland, *The Pleasure of the Text*, trans. Richard Miller (New York: Hill and Wang, 1975 [1973]).

Barthes, Roland, 'The Grain of the Voice', in *Image, Music, Text* (London: Fontana Press, 1977), pp. 179–89.

Barthes, Roland, *Image, Music, Text* (London: Fontana Press, 1977).

Benjamin, Walter, *Understanding Brecht* (London: New Left Books, 1973).

Benjamin, Walter, *Illuminations*, ed. Hannah Arendt (London: Fontana Press, 1992).

Bennett, Susan, *Theatre Audiences* (London and New York: Routledge, 1997).

Bohme, G., 'Acoustic Atmospheres', *Soundscape,* 1 (2000): 14–19.

Bolter, Jay David and Grusin, Richard, *Remediation: Understanding New Media* (Cambridge, Massachusetts: MIT Press, 1999).

Borwick, Susan, 'Weill's and Brecht's Theories on Music in Drama', *Journal of Musicological Research*, 4 (1982): 39–67.

Boyd, Michelle, 'Alto on a Broomstick: Voicing the Witch in the Musical *Wicked*', *American Music*, 28/1 (spring 2010): 97–118.

Brecht, Bertolt, *The Rise and Fall of the City of Mahagonny and The Seven Deadly Sins*, trans. W.H. Auden and Chester Kallman (London: Methuen, 1979).

Brecht, Bertolt, *Brecht on Theatre*, trans. and ed. John Willett (London: Methuen, 1982 [1964]).

Brooker, Peter, *Bertolt Brecht: Dialectics, Poetry, Politics* (London: Croom Helm, 1988).

Brooks, Peter, *Reading for the Plot* (Oxford: Clarendon Press, 1984).

Burston, Jonathan, 'Theatre Space as Virtual Place: Audio Technology, the Reconfigured Singing Body, and the Megamusical', *Popular Music*, 17/2 (1998): 205–18.

Calabrese, Omar, *Neo-Baroque: A Sign of the Times* (Princeton: Princeton University Press, 1992).

Calico, Joy, *Brecht at the Opera* (Berkeley: University of California Press, 2008).

Calvo-Merino, B., Glaser, D., Grezes, J., Passingham, R.E. and Haggard, P., 'Action Observation and Acquired Motor Skills: An fMRI Study with Expert Dancers', *Cerebral Cortex*, 15 (2005): 1243–9.

Cannadine, David, *Aspects of Aristocracy* (New Haven: Yale University Press, 1994).

Carlson, Marvin, *Theatre Semiotics: Signs of Life* (Bloomington: Indiana University Press, 1990).

Carlson, Marvin, *Theories of the Theatre* (Ithaca and London: Cornell University Press, 1993).

Carlson, Marvin, *The Haunted Stage* (Ann Arbor: University of Michigan Press, 2001).

Cavarero, Adriana, *For More than One Voice* (Stanford: Stanford University Press, 2005).

Chatman, Seymour, 'What Novels can do that Films can't (and Vice Versa)', in W.J.T. Mitchell (ed.), *On Narrative* (Chicago: Chicago University Press, 1981), pp. 117–36.

Clément, Catherine, 'Through Voices, History', in Mary Ann Smart (ed.), *Siren Songs: Representations of Gender and Sexuality in Opera* (Princeton: Princeton University Press, 2000), pp. 17–28.

Cohan, Steven (ed.), *Hollywood Musicals: The Film Reader* (London and New York: Routledge, 2002).

Connor, Steven, *Dumbstruck: A Cultural History of Ventriloquism* (Oxford: Oxford University Press, 2000).

Cook, Amy, 'Interplay: The Method and Potential of a Cognitive Scientific Approach to Theatre', *Theatre Journal*, 59 (2007): 579–94.

Cook, Nicholas, *Analysing Musical Multimedia* (Oxford: Clarendon Press, 1998).

Cooke, Derryck, *The Language of Music* (Oxford: Oxford University Press, 1959).

Corbett, John, 'Free, Single and Disengaged', *October*, 54 (1990): 79–101.

Cote, David, '80s Rock Hits Return in a Deliriously Fun New Jukebox Musical', *Time Out New York*, Issue 707, 18–22 April 2009.

Cox, A., 'The Mimetic Hypothesis and Embodied Musical Meaning', *Musicae Scientiae*, 5 (2001): 195–209.

Cudden, J.A., *The Penguin Dictionary of Literary Terms and Literary Theory*, 4th edn (London: Penguin Books, 1999).

Daly, Ann, 'Dance History and Feminist Theory: Reconsidering Isadora Duncan and the Male Gaze', in Laurence Senelick (ed.), *Gender and Performance: The Presentation of Difference in the Performing Arts* (Hanover: University Press of New England, 1992).

Decker, Todd, '"Do You Want to Hear a Mammy Song?": A Historiography of *Show Boat*', *Contemporary Theatre Review*, 19/1 (2009): 8–21.

Dolan, Jill, *Utopia in Performance: Finding Hope at the Theatre* (Ann Arbor: University of Michigan Press, 2005).

Dolar, Mladen, *A Voice and Nothing More* (Cambridge and London: MIT Press, 2006).

Drobnick, J. (ed.), *Aural Cultures* (Toronto: YYZ Books, 2004).

Drummond, John D., *Opera in Perspective* (London: J.M. Dent, 1980).

Dyer, Richard, 'Entertainment and Utopia', in *Only Entertainment*, 2nd edn (London and New York: Routledge, 1992), pp. 19–35.

Dyer, Richard, 'The Idea of Entertainment', in *Only Entertainment*, 2nd edn (London and New York: Routledge, 1992), pp. 5–9.

Dyer, Richard, *Only Entertainment*, 2nd edn (London and New York: Routledge, 1992).

Eckard, Bonnie, 'Power of the Body: Mirror Neurons and Audience Response', conference paper at *International Federation for Theatre Research*, Lisbon, July 2009.

Elam, Keir, *The Semiotics of Theatre and Drama* (London and New York: Methuen, 1980).

Erenberg, L., *Stepping Out: New York Nightlife and the Transformation of American Culture 1890–1930* (Chicago: University of Chicago Press, 1984).

Everett, William A. and Laird, Paul R. (eds), *The Cambridge Companion to the Musical* (Cambridge: Cambridge University Press, 2002).

Fales, Cornelia, 'The Paradox of Timbre', *Ethnomusicology*, 46/1 (2002): 56–95.

Fauconnier, Gilles and Turner, Mark, *The Way We Think: Conceptual Blending and the Mind's Hidden Complexities* (New York: Basic Books, 2002).

Feuer, Jane, *The Hollywood Musical* (London: Macmillan, 1993).

Fischer-Lichte, Erika, *The Show and the Gaze of Theatre* (Iowa City: University of Iowa Press, 1997).

Flinn, Caryl, *Strains of Utopia* (Princeton: Princeton University Press, 1992).

Frith, Simon, *Performing Rites* (Oxford: Oxford University Press, 2002 [1996]).

Gallese, V., 'Embodied Simulation: From Mirror Neuron Systems to Interpersonal Relations', *Novartis Foundation Symposium*, 278 (2007): 3–12; discussion 12–19.

Gargano, Cara, 'Mimesis and Mirror Neurons: New Questions for an Old Theatre', conference paper at *International Federation for Theatre Research*, Lisbon, July 2009.

Gaylord, Karen, 'Theatrical Performances: Structure and Process, Tradition and Revolt', in Jack Kamerman and Rosanne Martorella (eds), *Performers and Performances: The Social Organization of Artistic Work* (New York: Praeger, 1983), pp. 135–50.

Gazzola, V., Aziz-Zadeh, L. and Keysers, C., 'Empathy and the Somatotopic Auditory Mirror System in Humans', *Current Biology*, 16/18 (2006): 802–4.

Goffman, Erving, *Frame Analysis* (New York: Harper Collophon, 1974).

Goodhart, Sandor (ed.), *Reading Stephen Sondheim* (New York and London: Garland Publishing, 2000).

Gorbman, Claudia, *Unheard Melodies* (Bloomington: Indiana University Press, 1987).

Graziano, John, 'Images of African Americans: African-American Musical Theatre, *Show Boat* and *Porgy and Bess*', in William A. Everett and Paul R. Laird (eds), *The Cambridge Companion to the Musical* (Cambridge: Cambridge University Press, 2002), pp. 63–76.

Grosbras, Marie-Hélène, Jola, Corinne, Kuppuswamy, Anna and Pollick, Frank, 'Enhanced Cortical Excitability Induced by Watching Dance in Empathic and Visually Experienced Dance Spectators', Poster presentation, *Kinaesthetic Empathy: Concepts and Contexts* (Manchester University, 22–23 April 2010).

Grout, Donald Jay, *A History of Western Music* (London: Dent, 1973 [1960]).

Hayter, Charles, *Gilbert and Sullivan* (Basingstoke and London: Macmillan, 1987).

Hinton, Stephen (ed.), *The Threepenny Opera* (Cambridge: Cambridge University Press, 1990).

Hirsch, Foster, *Harold Prince and the American Musical Theatre* (Cambridge: Cambridge University Press, 1989).

Hosokawa, Shuhei, 'Distance, Gestus, Quotation: "Aufstieg und Fall der Stadt Mahagonny" of Brecht and Weill', *International Review of the Aesthetics and Sociology of Music*, 16/2 (1985): 181–99.

Jola, Corinne, Grosbras, Marie-Hélène and Pollick, Frank, 'Dance with or without Music: Does the Brain Care?', Poster presentation, *Kinaesthetic Empathy: Concepts and Contexts* (Manchester University, 22–23 April 2010).

Jones, John Bush, *Our Musicals, Ourselves: A Social History of the American Musical Theatre* (Hanover and London: Brandeis University Press, 2003).

Juslin, Patrick and Sloboda, John A. (eds), *Music and Emotion: Theory and Research*, Series in Affective Science (Oxford: Oxford University Press, 2001).

Kander, John, Ebb, Fred and Laurence, Greg, *Colored Lights* (New York: Faber and Faber, 2003).

Keightley, Keir, 'Reconsidering Rock', in Simon Frith, Will Straw and John Street (eds), *The Cambridge Companion to Pop and Rock* (Cambridge: Cambridge University Press, 2001).

Kershaw, Baz, *The Radical in Performance* (London and New York: Routledge, 1999).

Keysers, Christian, 'From Mirror Neurons to Kinaesthetic Empathy', Keynote Presentation, *Kinaesthetic Empathy: Concepts and Contexts* (Manchester University, 22–23 April 2010).

Kirle, Bruce, *Unfinished Show Business* (Carbondale: Southern Illinois University Press, 2005).

Knapp, Raymond, *The American Musical and the Formation of National Identity* (Princeton and Oxford: Princeton University Press, 2005).

Kowalke, Kim H., 'Brecht and Music: Theory and Practice', in Peter Thomson and Glendyr Sacks (eds), *The Cambridge Companion to Brecht* (Cambridge: Cambridge University Press, 1994), pp. 218–34.

Kowalke, Kim H., *Kurt Weill in Europe* (Ann Arbor: UMI Press, 1994).

Lamb, Andrew, *150 Years of Popular Musical Theatre* (New Haven and London: Yale University Press, 2000).

Langley, Carol, 'Borrowed Voice: The Art of Lip-Synching in Sydney Drag', *Australasian Drama Studies*, 48 (2006): 5–17.

Lechte, John, *Fifty Key Contemporary Thinkers* (London and New York: Routledge, 1994).

Lundskaer-Nielsen, Miranda, *Directors and the New Musical Drama* (New York: Palgrave Macmillan, 2008).

Marcus, Greil, 'Comment on Mark Mazullo "The Man whom the World Sold"', *Musical Quarterly*, 84 (2000): 750–3.

Marshall, Bill and Stilwell, Robynn (eds), *Musicals: Hollywood and Beyond* (Exeter and Portland: Intellect, 2000).

Marvin, Roberta Montemorra, 'Verdian Opera Burlesqued: A Glimpse into Mid-Victorian Theatrical Culture', *Cambridge Opera Journal*, 15 (2003): 33–66.

Marvin, Roberta Montemorra, 'Handel's *Acis and Galatea*: A Victorian View', in R. Cowgill and J. Rushton (eds), *Europe, Empire, and Spectacle in Nineteenth-Century British Music* (Aldershot and Burlington: Ashgate, 2006).

Mazullo, Mark, 'The Man whom the World Sold: Kurt Cobain, Rock's Progressive Aesthetic and the Challenges of Authenticity', *Musical Quarterly*, 84 (2000): 713–49.

Mazullo, Mark, 'Response to Greil Marcus', *Musical Quarterly*, 84 (2000): 754–5.

McAuley, Gay, 'The Video Documentation of Theatrical Performance', *New Theatre Quarterly*, 38 (1994): 183–94.

McCartney, A., 'Soundscape Works, Listening, and the Touch of Sound', in J. Drobnick (ed.), *Aural Cultures* (Toronto: YYZ Books, 2004).

McConachie, Bruce, 'Falsifiable Theories for Theatre and Performance Studies', *Theatre Journal*, 59/4 (2007): 553–77.

McConachie, Bruce and Hart, F. Elizabeth (eds), *Performance and Cognition* (London and New York: Routledge, 2006).

McCracken, Allison, 'Real Men don't Sing Ballads: The Radio Crooner in Hollywood, 1929–1933', in Pamela Wojcik and Arthur Knight (eds), *Soundtrack Available: Essays on Film and Popular Music* (Durham: Duke University Press, 2001), pp. 105–33.

McMillin, Scott, *The Musical as Drama* (Princeton and Oxford: Princeton University Press, 2006).

McNamara, Brooks, 'Popular Entertainments Issue: An Introduction', *The Drama Review*, 18/1 (March 1974): 3–4.

Meyer, Leonard B., *Emotion and Meaning in Music* (Chicago: Chicago University Press, 1956).

Middleton, Richard, 'Pop, Rock and Interpretation', in Simon Frith, Will Straw and John Street (eds), *The Cambridge Companion to Pop and Rock* (Cambridge: Cambridge University Press, 2001).

Middleton, Richard, *Studying Popular Music* (Milton Keynes and Philadelphia: Open University Press, 2002 [1990]).

Miller, D.A., *Place for Us* (Cambridge, Massachusetts and London: Harvard University Press, 1998).

Mitter, Shomit, *Systems of Rehearsal: Stanislavsky, Brecht, Grotowski, Brook* (London and New York: Routledge, 1992).

Molnar-Szakacs, Istvan and Overy, Kate, 'Music and Mirror Neurons: From Motion to "E"motion', *Social Cognitive and Affective Neuroscience*, 1/3 (2006): 235–41.

Morley, Michael, '"Suiting the Action to the Word": Some Observations on Gestus and Gestische Musik', in Kim H. Kowalke (ed.), *A New Orpheus* (New Haven: Yale University Press, 1986), pp. 183–202.

Mumford, Meg, *Showing the Gestus: A Study of Acting in Brecht's Theatre* (Unpublished Diss., Bristol University, 1997).

Ndalianis, Angela, *New Baroque Aesthetics and Contemporary Entertainment* (Cambridge, Massachusetts: MIT Press, 2004).

Neumeyer, David, 'Melodrama as a Compositional Resource in Early Hollywood Sound Cinema', *Current Musicology*, 57 (1995): 61–94.

Niedenthal, Paula M., Barsalou, Lawrence, Ric, François and Krauth-Gruber, Silvia, 'Embodiment in the Acquisition and Use of Emotion Knowledge', in Lisa Feldman Barret, Paula M. Niedenthal and Piotr Winkielman (eds), *Emotion and Consciousness* (New York: The Guilford Press, 2005).

Noonan, Julie A., 'Popular Voices: Amplification, Rock Music and Vocal Quality in *Grease*', *Studies in Musical Theatre*, 3/2 (2009): 185–200.

Oja, Carol J., 'West Side Story and The Music Man: Whiteness, Immigration, and Race in the US during the Late 1950s', *Studies in Musical Theatre*, 3/1 (2009): 13–30.

Osborne, C., 'The Broadway Voice: Just Singin' in the Pain', *High Fidelity* (January and February 1979): 57–65 and 53–6.

Overy, Kate and Molnar-Szakacs, Istvan, 'Leaping Around in Our Minds', Poster presentation, *Kinaesthetic Empathy: Concepts and Contexts* (Manchester University, 22–23 April, 2010).

Parker, Roger, *Remaking the Song* (Berkeley, Los Angeles and London: University of California Press, 2006).

Pavis, Patrice, 'Brechtian Gestus and Its Avatars in Contemporary Theatre', *Brecht Yearbook*, 24 (1999): 177–90.

Peretz, I., 'Listen to the Brain: A Biological Perspective on Musical Emotions', in P.N. Juslin and J.A. Sloboda (eds), *Music and Emotion* (Oxford and New York: Oxford University Press, 2001), pp. 105–34.

Poizat, Michel, *The Angel's Cry* (Ithaca and London: Cornell University Press, 1992).

Potter, John, *Vocal Authority* (Cambridge: Cambridge University Press, 1998).

Primavesi, P., 'A Theatre of Multiple Voices', *Performance Research*, 8 (2003): 61–73.

Puccio, Paul M. and Stoddart, Scott F., 'It Takes Two: A Duet on Duets in *Follies and Sweeney Todd*', in Sandor Goodhart (ed.), *Reading Stephen Sondheim: A Collection of Critical Essays*, Studies in Modern Drama 10 (New York: Garland Publishing, 2000), pp. 121–9.

Rabinowitch, Tai-Chen, Cross, Ian and Burnard, Pamela, 'Musical Group Interaction and Empathy – a Mutual Cognitive Pathway?', *Kinaesthetic Empathy: Concepts and Contexts* (Manchester University, 22–23 April, 2010).

Rebellato, Dan, '"No Theatre Guild Attraction Are We": *Kiss Me, Kate* and the Politics of the Integrated Musical', *Contemporary Theatre Review*, 19/1 (2009): 61–73.

Rée, Jonathan, *I See a Voice* (London: HarperCollins, 1999).

Reinelt, Janelle G. and Roach, Joseph R. (eds), *Critical Theory and Performance* (Ann Arbor: University of Michigan Press, 1992).

Riddle, Peter H., *The American Musical: History and Development* (Ontario: Mosaic Press, 2003).

Rizzolatti, G., Fadiga, L., Gallese, V. and Fogassi, L., 'Premotor Cortex and the Recognition of Motor Actions', *Brain Research: Cognitive Brain Research*, 3/2 (1996): 131–41.

Robertson, Pamela, 'Feminist Camp in *Gold Diggers of 1933*', in Steven Cohan (ed.), *Hollywood Musicals: The Film Reader* (London and New York: Routledge, 2002), pp. 129–42.

Russell, S., 'The Performance of Discipline on Broadway', *Studies in Musical Theatre*, 1/1 (1997): 97–108.

Salzman, Eric and Desi, Thomas, *The New Music Theater: Seeing the Voice, Hearing the Body* (Oxford: Oxford University Press, 2008).

Savran, David, 'Towards a Historiography of the Popular', *Theatre Survey*, 45/2 (2004): 211–17.

Saygin, A.P., Driver, J. and de Sa, V.R., 'In the Footsteps of Biological Motion and Multisensory Perception: Judgment of Audio-visual Temporal Relations are Enhanced for Upright Walkers', *Psychological Science*, 19/5 (2008): 469–75.

Schechner, Richard, *Performance Theory* (London and New York: Routledge, 1988 [1977]).

Scherer, K.R. and Zentner, M.R., 'Emotional Effects of Music: Production Rules', in P.N. Juslin and J.A. Sloboda (eds), *Music and Emotion: Theory and Research* (Oxford: Oxford University Press, 2001), pp. 361–92.

Scott, Derek B., 'English National Identity and the Comic Operas of Gilbert and Sullivan', in P. Horton and B. Zon (eds), *Nineteenth Century British Music Studies* (Aldershot and Burlington: Ashgate, 2003), vol. 3, pp. 137–52.

Shenton, Mark, 'Four Seasons, Four Lives', Programme note for *Jersey Boys* London production, 2008.

Shimizu, Celine Parrenas, 'The Bind of Representation: Performing and Consuming Hypersexuality in *Miss Saigon*', *Theatre Journal*, 57/2 (2005): 247–65.

Smart, Mary Ann (ed.), *Siren Songs: Representations of Gender and Sexuality in Opera* (Princeton: Princeton University Press, 2000).

Smith, Jacob, *Vocal Tracks* (Berkeley and Los Angeles: University of California Press, 2008).

Smith, J.D., Reisberg, D. and Wilson, M., 'Subvocalisation and Auditory Imagery: Interactions between the Inner Ear and Inner Voice', in D. Reisberg (ed.), *Auditory Imagery* (Hillsdale: Lawrence Erlbaum, 1992), pp. 95–119.

Smith, J.D., Wilson, M. and Reisberg, D., 'The Role of Subvocalisation in Auditory Imagery', *Neuropsychologia*, 33 (1995): 1433–54.

Stark, James, *Bel Canto: A History of Vocal Pedagogy* (Toronto: Toronto University Press, 1999).

States, Bert O., 'The Actor's Presence: Three Phenomenal Modes', in P. Zarrilli (ed.), *Acting (Re)Considered* (London and New York: Routledge, 1995), pp. 22–42.

Sternfeld, Jessica, *The Megamusical* (Bloomington: Indiana University Press, 2006).

Stoddart, S.F., 'Visions and Re-visions; The Postmodern Challenge of *Merrily We Roll Along*', in Sandor Goodhart (ed.), *Reading Stephen Sondheim: A Collection of Critical Essays* (New York: Garland Publishing Inc, 2000), pp. 187–98.

Swain, Joseph, *Broadway Musicals: A Critical and Musical Survey* (Lanham, MD and Oxford: Scarecrow Press, 1990).

Swayne, Steve, *How Sondheim Found His Sound* (Ann Arbor: University of Michigan Press, 2005).

Swayne, Steve, 'Remembering and Re-membering: Sondheim, the Waltz, and *A Little Night Music*', *Studies in Musical Theatre*, 1/3 (2007): 259–73.

Symonds, Dominic, 'The Corporeality of Musical Expression: "The Grain of the Voice" and the Actor-Musician', *Studies in Musical Theatre*, 1/2 (2007): 167–81.

Symonds, Dominic, 'Putting it Together and Finishing the Hat? Deconstructing the Art of Making Art', *Contemporary Theatre Review*, 19/1 (2009): 101–12.

Tambling, Jeremy, *Opera, Ideology and Film* (Manchester: Manchester University Press, 1987).

Taylor, Millie, *Music in Theatre: Towards a Methodology for Examining the Interaction of Music and Drama in Theatre Works of the Twentieth Century* (Unpublished PhD. Diss., University of Exeter, 2001).

Taylor, Millie, 'Collaboration or Conflict: Music and Lyrics by Brecht, Weill and Eisler', *Studies in Theatre and Performance*, 23 (2003): 117–24.

Taylor, Millie, 'Layers of Representation: Instability in the Characterisation of Jenny in *Aufstieg und Fall der Stadt Mahagonny* of Brecht and Weill', in Gad Kayner and Linda Ben Zvi (eds), *Bertolt Brecht: Performance and Philosophy* (Tel Aviv: Assaph Book Series, 2005), pp. 159–76.

Taylor, Millie, 'Exploring the Grain: The Sound of the Voice in Bruce Nauman's *Raw Materials*', *Studies in Theatre and Performance*, 26/3 (2006): 289–96.

Taylor, Millie, *British Pantomime Performance* (Bristol and Chicago: Intellect, 2007).

Taylor, Millie, 'Don't Dream it, be it: Exploring Signification, Empathy and Mimesis in Relation to *The Rocky Horror Show*', *Studies in Musical Theatre*, 1/1 (2007): 57–71.

Tolbert, E., 'Untying the Music/Language Knot', in L.P. Austern (ed.), *Music, Sensation, and Sensuality* (New York and London: Routledge, 2002), pp. 77–96.

Turner, Victor, *From Ritual to Theatre* (New York: PAJ Publications, 1982).

Walsh, David and Platt, Len, *Musical Theater and American Culture* (Westport and London: Praeger, 2003).

Wilson, A.N., *The Victorians* (London: Hutchinson, 2002).

Witkin, Robert W., *Adorno on Popular Culture* (London and New York: Routledge, 2003).

Wolf, Stacy, *A Problem like Maria* (Ann Arbor: University of Michigan Press, 2002).

Wolf, Stacy, '"Something Better Than This": *Sweet Charity* and the Feminist Utopia of Broadway Musicals', *Modern Drama*, 47 (2004): 309–32.

Wolf, Stacy, 'In Defense of Pleasure: Musical Theatre History in the Liberal Arts [A Manifesto]', *Theatre Topics*, 17/1 (2007): 51–60.

Womack, Malcolm, '"Thank You For the Music" Catherine Johnson's Feminist Revoicings in *Mamma Mia!*', *Studies in Musical Theatre*, 3/2 (2009): 201–11.

Internet Sources

www.rockofagesmusical.com, accessed 3 August 2009.

www.watchingdance.org/research/kinaesthetic_empathy/index.php, accessed 30 May 2009.

'Is there a Tony Award for Badassery?' *The New Yorker*, 20 April 2009, www. rockofagesmusical.com, accessed 3 August 2009.

Time Out review for *Rock of Ages*: http://newyork.timeout.com/articles/ theater/73407/rock-of-ages-at-brooks-atkinson-theatre-theater-review.

Brantley, Ben, 'Grand Guignol, Spare and Stark', *New York Times*, 4 November 2005.

Massey, Neil, *Q Magazine,* June 2002, http://wewillrockyou.co.uk, accessed 4 August 2009.

Peter, John, 'Thank you for the Musical!', *Sunday Times*, www.mamma-mia.com/ worldreviews.asp, accessed 4 August 2009.

Spencer, Charles, 'Glorious Blend of Beautiful Lyricism, Magnificent Score – and Gallons of Blood', *Daily Telegraph*, 11 February 2004.

Spencer, Charles, 'An Irresistable Enjoyable Hit' *Daily Telegraph*, www.mamma-mia.com/worldreviews.asp, accessed 4 August 2009.

Sturges, Fiona, 'We Will Rock You', *The Independent*, 15 May 2002, www. wewillrockyou.co.uk, accessed 4 August 2009.

Vincent, Jeremy, '*****', *The Australian*, www.mamma-mia.com/worldreviews. asp, accessed 4 August 2009.

Whittaker, James, *Daily Mirror,* 8 July 2002, www.wewillrockyou.co.uk, accessed 4 August 2009.

Musical Scores

Bernstein, Leonard, *West Side Story*, Lyrics by Stephen Sondheim, Book by Arthur Laurents (Chappell, 1957).

Coward, Noel, *The Essential Noel Coward Song Book* (London: Omnibus Press, 1980 [1953]).

Gilbert, W.S. and Sullivan, A., *HMS Pinafore*, Vocal Score (London: Metzler and Co, 1920).

Hamlisch, Marvin and Kleban, Edward, *A Chorus Line*, Vocal Score. Book by James Kirkwood and Nicholas Dante (Edwin H Morris & Company, no date).

Kander, John and Ebb, Fred, *Cabaret*, Vocal Score. Book by Joe Masteroff (The Times Square Music Publications Company, 1968 [1966]).

Kern, Jerome and Hammerstein II, Oscar, *Show Boat*, Vocal Score (PolyGram Music Publishing, no date).

Loesser, Frank, *Guys and Dolls*, Vocal Score. Book by Jo Swerling and Abe Burrows (New York: Chappell- Morris Ltd, 1950).

Porter, Cole, *Kiss me, Kate*, Vocal Score. Book by Sam and Bella Spewak (Warner Chappell Music Ltd, 1967 [1951]).

Ratcliff, T.P. (ed.), *News Chronicle Song Book* (London: The News Chronicle Publications Department, no date).

Rodgers, Richard and Hammerstein, Oscar, *Carousel*, Vocal Score. Piano reduction by Wayne A. Blood (Williamson Music, no date).

Sondheim, Stephen and Furth, George, *Merrily We Roll Along* (New York: Music Theatre International, 1981).

Sondheim, Stephen and Wheeler, Hugh, *Sweeney Todd*, Vocal Score (New York: Revelation Music Publishing Corp and Rilting Music Inc., 1981).

Stanford, C.V. (ed.), *The New National Song Book* (London: Boosey and Hawkes, 1906).

Weill, Kurt, *Aufstieg und Fall der Stadt Mahagonny*, ed. David Drew. Piano Vocal Score (Wien: Universal Edition, 1969).

Scripts and Lyrics

Anon., *Sweeney Todd or the String of Pearls: The Original Tale of Sweeney Todd*, Wordsworth Mystery and Supernatural (London: Wordsworth Classics, 2005).

Bertolt Brecht Collected Plays, ed. John Willett and Ralph Manheim, trans. W.H. Auden and Chester Kallman, vol. 2, part 3 (London: Eyre Methuen, 1979).

Bradley, Ian (ed.), *The Complete Annotated Gilbert and Sullivan* (Oxford: Oxford University Press, 1996).

Cabaret, John Kander, Fred Ebb, Book by Joe Masteroff.

Coward, Noel, *The Lyrics of Noel Coward* (London: Methuen, 2000 [1965]).

Merrily We Roll Along, Music and Lyrics by Stephen Sondheim, Book by George Furth. Music Theatre International.

The Last Five Years, Book, Music and Lyrics by Jason Robert Brown. Music Theatre International.

Performances

A Little Night Music, Music and Lyrics by Stephen Sondheim, Book by Hugh Wheeler. Directed by Trevor Nunn, Choreography by Lynne Page. Menier Chocolate Factory, London. Attended 22 November 2008.

Billy Elliott, Book and Lyrics by Lee Hall, Music by Elton John. Directed by Stephen Daldry, Choreography by Peter Darling. Victoria Palace Theatre, London. Attended 14 August 2008.

Jersey Boys, Book by Marshall Brickman and Rick Elice, Music by Bob Gaudio, Lyrics by Bob Crewe. Directed by Des McAnuff, Choreography by Sergio Trujillo. Prince Edward Theatre, London. Attended 19 August 2008.

La Cage Aux Folles, Book by Harvey Fierstein, Music and Lyrics by Jerry Herman, based on the play *La Cage Aux Folles* by Jean Poiret which has been filmed as *The Bird Cage*. Directed by Terry Johnson, Choreography by Lynne Page. Playhouse Theatre, London, Attended 3 August 2009.

The Last Five Years, Book, Music and Lyrics by Jason Robert Brown, performed at Menier Chocolate Factory, 2006.

Little Shop of Horrors, Book and Lyrics by Howard Ashman, Lyrics by Alan Menken. Farnham Repertory Theatre. Directed by Patrick Sandford, Musical Director Millie Taylor, spring 1987.

Mamma Mia!, Music and Lyrics by Benny Andersson and Björn Ulvaeus and some songs by Stig Anderson. Book by Catherine Johnson. Directed by Phyllida Lloyd, Choreography by Anthony Van Laast. Prince of Wales Theatre, London. Attended 6 August 2009.

Miss Saigon, Book by Claude-Michel Schönberg and Alain Boublil, Music by Claude-Michel Schönberg, Lyrics by Alain Boublil and Richard Maltby Jr. Directed by Nicholas Hytner, Musical Staging by Bob Avian. Drury Lane Theatre, London. Attended autumn 1989.

Next to Normal, Music by Tom Kitt, Book and Lyrics by Brian Yorkey, Directed by Michael Greif. Booth Theatre, New York. Attended 29 April 2009.

Priscilla, Queen of the Desert, Book by Stephan Elliott and Allan Scott, Songs selected and interpolated by Simon Phillips. Based on the Latent Image/ Specific Films Motion Picture, distributed by Metro-Goldwyn-Mayer Inc. Directed by Joe Mantello. Attended 6 August 2009.

Rock of Ages, Book by Chris D'Arienzo, Directed by Kristin Hanggi, Choreography by Kelly Devine. Brooks Atkinson Theatre, New York. Attended 7 May 2009.

Rocky Horror Show, Book Music and Lyrics by Richard O'Brien, 1974.

The Toxic Avenger, Book and Lyrics by Joe DiPetro, Music and Lyrics by David Bryan Based on Lloyd Kaufman's The Toxic Avenger. Directed by John Rando, Choreography by Wendy Seyb. New World Stages, New York. Attended 1 May 2009.

We Will Rock You, Music and Lyrics by Queen, Book and Direction by Ben Elton, Musical Staging and Choreography, Arlene Phillips. Dominion Theatre, London. Attended 8 August 2009.

Wicked, Music and Lyrics by Stephen Schwartz, Book by Winnie Holzman, based on the novel by Gregory Maguire. Directed by Joe Mantello, Musical Staging by Wayne Cilento. Apollo Victoria, London. Attended 14 August 2009.

Recordings

Assassins, Book by John Weidman, Music and Lyrics by Stephen Sondheim, Directed by Joe Mantello. Recorded at Roundabout Theatre Company at Studio 54. 9 June 2004. TOFT Archive New York Library for the Performing Arts, Lincoln Center.

Aufstieg und Fall der Stadt Mahagonny, CBS Records 01-077341-10.

Berlin Cabaret Songs, Decca 452 601-2.

Cabaret, Book by Joe Masteroff, Lyrics by Fred Ebb, Music by John Kander. Directed by Sam Mendes, Choreography and co-direction by Rob Marshall. Recorded by Roundabout Theatre Co. 1 July 1998. TOFT Archive New York Library for the Performing Arts, Lincoln Center.

Carousel, Music by Richard Rodgers, Book and Lyrics by Oscar Hammerstein II. Directed by Nicholas Hytner, Choreography by Kenneth MacMillan. Royal National Theatre Production Recorded at Beaumont Theatre, Lincoln Center NYC. TOFT Archive New York Library for the Performing Arts, Lincoln Center.

Company, Direction and Musical Staging by John Doyle, Ellen M. Krass Productions, Sony BMG 88697 28577 9.

Dara O'Briain Talks Funny: Live in London, recorded at Hammersmith Apollo in 2008, Broadcast on BBC Television 19 July 2009.

Kiss of the Spider Woman, Book by Terence McNally, Lyrics by Fred Ebb, Music by John Kander, Directed by Hal Prince, Choreography by Vincent Patterson, Additional Choreography by Rob Marshall. Recorded at the Broadhurst Theatre, New York, 28 July 1993. TOFT Archive New York Library for the Performing Arts, Lincoln Center.

Oklahoma!, Music by Richard Rodgers and Book and Lyrics by Oscar Hammerstein II. Directed by Trevor Nunn, Choreography by Susan Stroman, Royal National Theatre Production, TOFT Archive New York Library for the Performing Arts, Lincoln Center.

Show Boat, Music by Jerome Kern, Book and Lyrics by Oscar Hammerstein II. Directed by Harold Prince, Choreography by Susan Stroman. Recorded at the Gershwin Theatre New York, 15 July 1995. TOFT Archive New York Library for the Performing Arts, Lincoln Center.

Unrepeatable, Eddie Izzard Polygram Video 6338723, 1994.

Index

Abba 150, 161, 162
Abbate, Carolyn 65, 81, 120
Ace of Clubs 23n44
A Chorus Line 107
Acis and Galatea 19
actor-musicianship 124–7
 actor-musician 111
 performances 125
 training 125
Adorno, Theodor 8–9
*A Funny Thing Happened on the Way to
 the Forum* 62
alienation 56–62
 see also disjunction
A Little Night Music 44, 68, 143
Annie Get Your Gun 41
Apollo Victoria Theatre 143
Aristotle (*Poetics*) 60
Assassins 1, 62, 63, 91–106 *passim*
 107–108
audience
 bonding 109
 collaboration 58
 contagion 93, 131, 140, 142, 146, 147,
 153–4, 168
 critical awareness (Brecht) 76
 expectations 62, 113, 127
 and identity 62, 64, 84, 85, 147
 incorporation 132–7
 intellectual engagement 61, 89, 126
 as interpreters 87–8, 101, 106, 107,
 108, 109
 and pleasure 89–90
 reading/understanding 58, 65, 66, 67,
 84, 89, 90, 101, 102, 109, 127, 130,
 136, 147
 relationship
 with characters 105
 with narrator 62–63

with performer(s) 60, 62–63,
 113–14, 130
suspension of disbelief 111, 113, 115,
 116
 see also empathy; distance; cognitive
 science; performance; blending;
 communitas
Aufstieg Und Fall Der Stadt Mahagonny
 73–6
 passim 77–85
Auslander, Philip 130–31, 133, 134, 138

Bacon, Francis 60
Banfield, Stephen 35–6, 38, 41, 50, 51, 66,
 68, 69, 87, 115
Baring-Gould, Sabine 21
Barthes, Roland 9, 11, 43, 71, 93, 94, 106,
 120, 167
Baudrillard, Jean 134
Beauty and the Beast 1, 134n21, 162
belt 41, 43, 44, 47, 48, 50–4
 the female 35, 41, 49, 53
Berkeley, Busby 151
Berlin, Irving 41, 78n20, 149
Blake, William 21
blending
 and the audience 109, 111–12
 conceptual 91–6
 theory 92
bliss (Barthes) *see under* pleasure 94, 96,
 102, 106, 108, 168, 170
Blitzstein, Brecht and 107
Blues in the Night 150
Bolan, Marc 29
Bolton, Guy 56
Bowie, David 29
Boyce, William 22
Brecht, Bertolt 7, 11, 12, 60–62, 73–90,
 93, 95, 107 *see also* epic; *gestus*;
 Verfremdung

Britain's Got Talent 132n15
Broadway viii 1, 4, 5, 44, 68, 87, 103n58,
 116n19, 125, 134, 138, 144, 158,
 161
Brooks Atkinson Theatre, New York 158
Brown, Jason Robert 88
Bubble Theatre Company, London 124
Buddy 1, 150, 152
burlesque 17–20, 25n55, 38n24, 102, 149
 opera 38
Burnand, Francis 19
Burston, Jonathan 144–5

Cabaret 1, 30, 91–109 *passim* 96–102,
 113, 114, 125n45
Callcott, J.W. 21
camp 6, 10, 11, 96, 106, 109, 147, 165,
 168, 171
 and bliss 71
 comedy 103, 146, 148, 152, 154, 165
 concept of 61
 dissonance 170
 effect 151–2
 high 61, 63
 meaning of 151
 pop group (Abba) 161
 reading 161
Campbell, Thomas 21
Candide 125
Cantor, Eddie 41
Carlson, Marvin 60, 73–4, 112, 167, 120
Carlton, Bob 124
Carmen 125
catharsis 109
Cats 1, 94, 138
characterisation, musical 1, 15–31
chiaroscuro 37
Chicago 94, 134
cognitive science 138–41
 and dance 92, 138–139, 169
 see also empathy: kinaesthetic
collage 94–109
comedy, stand-up 131, 132, 134
 in *La Cage aux Folles* 135
comic opera 17, 18, 25, 28, 37–9
 and burlesque opera 19
 and opera 37
 see also Gilbert and Sullivan

communitas in
 Jersey Boys 152–6
 Mamma Mia 161–3
 Rock of Ages 158–60
 The Rocky Horror Show 156–8
 We Will Rock You 163–5
Company 94, 125
corpse and corpsing 132, 132n14
Coward, Noel 23
Cox and Box 19
'culinary art' (Brecht) 76
Cumming, Alan 102

Daly's Theatre 39n29
dance 137–8
 in folk-songs 22
 and realism 6
 song and 57–8, 97, 103, 137
 telling stories through 1, 5
 see also empathy; waltz, the
Death of a Salesman 107
De Mille, Agnes 57, 95
Der Freischütz (Weber) 78n24
Dibdin, Charles 22
Dirty Dancing 30
disjunction 111–124
 audience's acceptance of 115
 in book musicals 63
 and integration 5, 55–6
 through non-chronological strategies
 73
 of performance modes 115
 speech to song 114
 and start of music 114
 in through-composed musicals 59
disruption *see* disjunction
distance 6, 7, 12, 76–7, 170
 and actor-musicians 125
 and amplification of voice 142
 between audience and performance
 62–71, 83, 86, 87, 113, 115
 comic, through parody and satire 19
 and critical awareness in Brecht 76–7,
 83
 emotional 86, 87, 115
 from empathy with 86, 89, 113
 and hearing 142
 reflexive 123

and start of music 114
from the story (*Mamma Mia*) 161
see also integration; reflexivity;
 Verfremdung
Dolan, Jill 11, 157–8, 164, 167
Dominion Theatre 163n50
Donizetti
 L'Elisir d'Amore 19
Donmar Warehouse 100n47, 102
Doyle, John 125–6, 125n46
Dreamgirls 1
Dyer, Richard 8, 10, 167

Edgar, Kate 124
Einfühlung (Lipps) 138
Elton, Ben 163n50
Elvis 29
empathy 61–4, 138–141 *see also* distance
 and audience 99, 108, 113, 115, 116,
 126, 130, 146, 147
 kinaesthetic 138, 169 *see also* dance
entertainment
 and musical theatre vii, 2–3, 5, 6, 7–13
 and neuroscience viii
epic (Brecht) 55n2, 57
 form 58, 60
 social drama 138
 theatre 60, 75–7, 80
Everard, Harriet 25n55

Fiddler on the Roof 58
film
 audiences, influence on 101
 music 6–7, 15, 64n37
 musical 1n1, 3–4, 10, 15, 27, 134, 150,
 167
Fiorello 58
Follies (Sondheim and Goldman) 51, 53n,
 62, 68n, 149
Footloose 30
Forbidden Broadway 149
Forbidden Planet (film) 124
Foucault, Michel 134
Frith, Simon 42, 141–2, 154–5
Funny Face 10

Gaiety Theatre 39n29
Garland, Judy 41, 136, 146

Garrick, David 22
George White Scandals 149
Gershwin, Ira 57
 Gershwins, the 149
Gesamtskunstwerk 58
gestus, Brechtian notion of 11, 12, 55n2,
 76–7, 120, 157
Gilbert and Sullivan 12, 17, 39
 and British imperialism 18
 and burlesque 19–20, 38, 38n24
 collaboration, first *Thespis* 20
 comic opera 17–20, 25, 28, 39
 and social situation 28
 see also Gilbert, W.S.; *HMS Pinafore*;
 Satire; Sullivan, Arthur
Gilbert, William S.
 *Dulcamara or The Little Duck and the
 Great Quack* 19
 libretti 17
 musical styles 19
 parody of nautical melodrama 23n42
 see also Gilbert and Sullivan
Gluck, Christoph W. 36
Gorbman, Claudia 6, 7, 15
Grease 51
Great Macdermott, the 18n16
Grey, Joel 101
Grundgestus see under *gestus*
Guys and Dolls 47–9, 50, 70, 107
Gypsy 1

Hairspray 134
Hammersmith Apollo 134n19
Handel, George Frideric 19, 21
Harrogate Theatre 101
Hervé (Florimond Ronger) 38
HMS Pinafore viii, 15–28, 30, 31, 39, 55,
 168
 satire in 18–28, 56, 77
Hollywood 3, 27, 106
Holm, Celeste 41
Hunt, G.W. 18n16

integration 55–60
 and audience involvement 71
 complexity of 62
 and the concept of distance 55–6
 and 'fusion' 90

lack of clarity in meaning of 4
and linear narrative 4–5
and song 59
in *Sweeney Todd* 64–71
techniques of 64
see also distance; realism
intermezzi 37
intimacy
and the audience 131, 132
and the first sense (hearing) 142
strategies for signifying 131–4
through technology 142
televisual 131
Into the Woods 62, 63, 113, 114
irony 6, 59, 73–90, 159, 168
comic 17
dramatic 75, 85, 89, 105
Izzard, Eddie 15

Jersey Boys 149–152 *passim*, 152–4
Jesus Christ Superstar 16, 28, 50, 51, 53, 138, 151n7
jingoism 18, 21
Jones, John Bush 56–8, 71, 75, 102
Joseph and the Amazing Technicolor Dreamcoat 162
jouissance *see under* bliss; pleasure and bliss

Kern, Jerome 56, 57, 149
Keysers, Christian 169–70
Kiss Me, Kate 59, 69, 114
Kiss of the Spider Woman 91–109 *passim*, 102–106
Knapp, Raymond 4, 5, 18, 25, 45, 48, 60, 61, 62, 94, 99, 101, 107, 117

La Cage aux Folles vii, 129–34 *passim*, 135–7
Lady in the Dark 57
La Fenice, Venice 36
Langley, Carol 146, 147
Lapine, James 58
laryngoscope 38
layers of representation 73
Lennox, Annie 29
Lenya, Lotte 76n10, 99
Les Misérables 1, 145

Lewes, G.H. 112
Lincoln Centre Theatre on Film and Tape Archive, New York 3
linearity 1, 59
alternatives to 91–109
see also narrative
Little Shop of Horrors 2
'liveness' 103, 130–5, 137
Liverpool Everyman Theatre 124
Love Me Tonight 44

McConachie, Bruce 91, 136, 139
McMillin, Scott 5, 59, 94, 95, 111
Mack and Mabel 125
Madame Butterfly 74
Mamma Mia 12, 134, 149, 150, 161–3
Marshall, Rob 94, 100n47, 102
Marvin, Roberta Montemorra viii, 19, 20
Meatloaf 29
Mendelssohn, Felix 19, 21
Mendes, Sam 102
Menier Chocolate Factory 135
Menopausal Gentleman 158
Merman, Ethel 41
Merrily we Roll Along 62, 73, 85–8
Meyerbeer 20
Mick Jagger and the Rolling Stones 28
Miller, Arthur 107
Minnelli, Liza 101
minstrel shows(s) 41
Miss Saigon 74
Molière 8
money note, the 52
Monkey: Journey to the West 144
montage 94–109
Moulin Rouge 137, 159
Mozart, Wolfgang A. 36
music: genres 2
African-American 35, 39, 40, 42, 45, 46, 49, 57n, 79n
ballad 19, 22, 47
rock 31
bel canto 34, 37, 38, 40, 43–50, 54
big band 1
blues 29, 34, 39–43, 45, 46, 79n, 84
Broadway vocal 1
cantorial 35, 41, 50
crooning 35, 42–9

field hollers 40
folk (-songs) 16, 19–25, 30, 31, 34, 35, 37, 43
 country blues 29, 40
 sea shanty 21–8
glam rock 29–31
glee 19, 24, 31
gospel 1, 16, 40, 44, 49
jazz 27, 36, 39–49
Jewish 30, 42, 47
madrigal 19, 24
music hall 16, 18n, 21, 23, 26, 30, 31, 35, 39, 149
opera *see* bel canto; burlesque
pop 36, 49, 50, 51, 163
ragtime 41, 46, 79
recitative 25–6
R'n'B 1
rock, 1, 16, 28–29, 34, 36, 44, 49–53, 61, 144, 150, 163, 164
rock and roll 29, 30, 51, 124, 125
vaudeville 35, 44–9, 50, 70, 99, 102, 105
work songs 23, 40
musicals
 development of 3
 genres
 bio- (*Jersey Boys*) 152–6
 Broadway 5
 comic opera 17–20
 compilation 12, 95n22, 150, 152, 156, 158–60, 163
 concept 94–6
 juke-box 149–52
 revue 6, 12, 56, 100, 102, 147, 148, 149, 152
 rock 50
 through-composed 1, 59
 meaning of 1
 non-linear 6, 7, 94, 168
musical theatre
 camp 94
 definition 1n1
 highbrow and lowbrow 2
 as literary text 3
 live, experiencing 137–8
 live and mediatised 129–31
 performances, experience of 143–5

and satire 16
study of 2–4
variety of 1
vaudeville 35, 44, 45–50, 70
see also entertainment
Must 158
My Fair Lady 1

narrative 1, 5
 alienated 12
 and coherence 55–8, 63–4, 111, 116
 dual focus 27
 information 15, 33
 linear 1, 4, 12
 and music/number 5, 6, 10, 12, 56, 59
 non-linear 62, 68
 progress 4
 as reality 10
 structure 1, 12
 texts
 dialectical 89
 over-coded 89
 reflexive or disruptive 125
 see also integration; realism
Ndalianis, Angela 159–60, 165
Nelson, Horatio 22
Newbury Theatre 125
New National Song Book (1906) 21
Next to Normal 144

O2 Arena 144
O'Briain, Dara 134, 134n19
Offenbach, Jacques 19, 38
Oklahoma! 4, 41, 44, 45, 55, 57, 59, 95, 107
Oliver 162
operetta 12, 17, 21, 35, 53
 in *Guys and Dolls* 47–9
 and nineteenth-century vocal aesthetics 36–9
 in *Show Boat* 44–7
Orfeo ed Euridice (Gluck) 36
over-coding 16, 55, 59, 63

Pacific Overtures 62
Pal Joey 57
pantomime 20, 25n55, 64n37, 131–5, 149
performance

audience response to different kinds
of 132
diegetic 1, 15–16, 48, 65, 79, 79n27,
80–88, 97–102, 124, 130, 135–6,
145, 153
live and mediatised 129, 130–31, 134,
141, 142, 147, 148
non-diegetic 111, 114, 115 *see also*
diegetic
witnessing live 120–21, 133, 138, 141,
143, 147, 148, 168
Phantom of the Opera 1, 50, 134, 137, 145
Planché 20
pleasure
and bliss 7, 9–12, 52–54, 73, 109, 119,
124, 168
and transcendence 159, 165, 168
Prince, Harold 84n40, 94, 96, 97, 103,
103n58, 115n16
Princess Theatre 56
Priscilla, Queen of the Desert vii, 129–44
passim, 145–8, 149, 151

Queen 163n50
Queen's Theatre, Hornchurch 124

reading(s) (of musical theatre)
comic and camp 161
culturally determined 93
dialectical 73
double 60, 113
empathetic 75, 116
gendered 114n11
intercultural 114n11
ironic 16
linear 95, 97
moral 84
parodic 55
post-Marxist 3
reflexive 113
romantic 27
satirical 16, 26, 55
variety of 167
see also audience
realism
and actor-musicianship 124–7
and audience 112
illusions of 111

and integration 4–7
perception of 112–16
and performer 112
psychological 6–7, 112, 119, 124, 127,
169
reality in performance 132–3, 132n15
reception 10, 29, 74n4, 118, 152, 167
modes of 159
of voice 121
reflexivity 6, 7, 12, 30, 63–6, 75, 113, 115,
119, 126, 170
of disembodied voice 146
and identity 155
and theatricality 79–86, 147, 168
see also narrative: texts
Return to the Forbidden Planet 124
Rice, Tim 16n5, 53n88
Richardson, Natasha 102
Riverdance 149
Robert le Diable (Meyerbeer) 20
Rock of Ages 151n, 158–60
Rodgers and Hammerstein 4, 45, 46n, 95n,
134n
Rodgers and Hart 44
Rose Bruford College of Speech and
Drama 125
Rose Marie 44
Rossini 36, 37
Roundabout Theatre Company 102n56,
107n59
Rowe, Peter 125
Royal National Theatre 137
Royal Shakespeare Company 137

satire 18–20
see also *HMS Pinafore*
Savran, David 2, 3, 4
Scott, Derek 18, 19, 21, 24
Seurat, Georges-Pierre 58
Show Boat 1, 16, 28, 44–7, 48, 50, 51, 55,
56, 57, 58, 107
signification 7, 12, 33–54, 69, 73, 74, 109,
119, 122, 135, 167, 170
of characters 17
genre 28, 113
of texts 18
vocal and musical 16, 31, 104, 118,
148

Sing Alonga Abba 162
Smokey Joe's Café 149
Sondheim, Stephen
 and the concept musical 95n19
 importance of 51
 and integration 58, 115
 lack of success 89
 reinterpretation of the waltz 44n49
 the works of 62–3
 see also individual works by title
Songs for a New World 149
sound painting 64–7
Stanislavsky's Moscow Theatre 33
Starlight Express 94
States, Bert O. 112, 116, 120
Strauss, Johann 38
Sullivan, Arthur
 music of 17
 musical sources 21
 and parody 21
 see also Gilbert and Sullivan
Sunday in the Park with George 58, 62
Sunset Boulevard 145
Suppé, Franz von 38
Sweeney Todd vii, 55–72, 75, 77, 114, 115, 125
Symonds, Dominic 120–21, 125, 126

Taganka Theatre, Moscow 97
technology 29, 31, 34, 42–3, 131, 142, 148
 computer 160
 digital 159
 recording 35
 the wireless microphone 43n48
The Bird Cage 129n2
The Desert Song 44
The Frogs 62
The Grand Duke 17
The Last 5 Years 73, 88–9, 94
The Lion King 1, 134n, 162,
The Marriage of Figaro 123
The Mikado 25n51
The Music Man 107, 117n
The Producers 95, 134n
The Rocky Horror Show vii, 1, 15, 17, 28–31, 156–8, 168
The String of Pearls 67
The Tempest 124

Theatr Clwyd 125
Theatre Royal, York 125
The Wizard of Oz 162
Trial By Jury 17n8
Tricycle Theatre, Kilburn 124
truth
 and artifice 147
 to the character 85
 in pantomime and variety 133
 perceptions of 138, 148
 vocal 133, 133n16
 see also realism; reality
Turner, Vincent 155, 157

Unrepeatable (Eddie Izzard) 15
utopia(s) 5, 157–8, 163, 167
utopian
 performatives 10–11
 pleasure 158
Utopia Limited 18, 22n37

variety acts 132–3
Vaughan Williams, R. 24n46
Verfremdung 55n2, 60–61
Verfremdungseffekt 76
Victoria and Albert Museum Theatre Collection 4
Victoria, Queen 18, 26
Victoria Theatre, Stoke-on-Trent 157
vocal aesthetic
 for musical theatre 43–4
 in operetta 36–9
vocal cry 71, 111, 127
 of Jesus in 'Gethsemane' 61
 of Johanna in *Sweeney Todd* 69
 and the 'money note' 52–3
 in operetta 53
 in *West Side Story* 123
vocal touch 141–42
voice 31–42
 cantorial 47
 disembodied 52n83, 119, 144–8
 the female 46
 compared with male 50
 in *Guys and Dolls* 47
 -object 119–120
 in *Phantom of the Opera* 50
 and reception 121

and technology 42–43
see also vocal cry

Wagner, Richard 37, 58
waltz, the 44–5, 48, 51, 67–8
Webber, Andrew Lloyd 16n5, 50, 50n69,
 53n88, 162
Weidman, John 96n25, 107
Weill, Kurt vii, 12, 62, 73, 75, 77, 77n17,
 88
West Side Story 105, 111–15
 and audience 116–24

We Will Rock You 12, 149–50, 163–5
Wicked 143
Williams, Bert 41
Wodehouse, P.G. 56
Wolf, Stacy 2, 3, 163

Yeomen of the Guard 18

Ziegfeld, Florenz 149

Printed in Great Britain
by Amazon

59503435R00120